Outside the Box

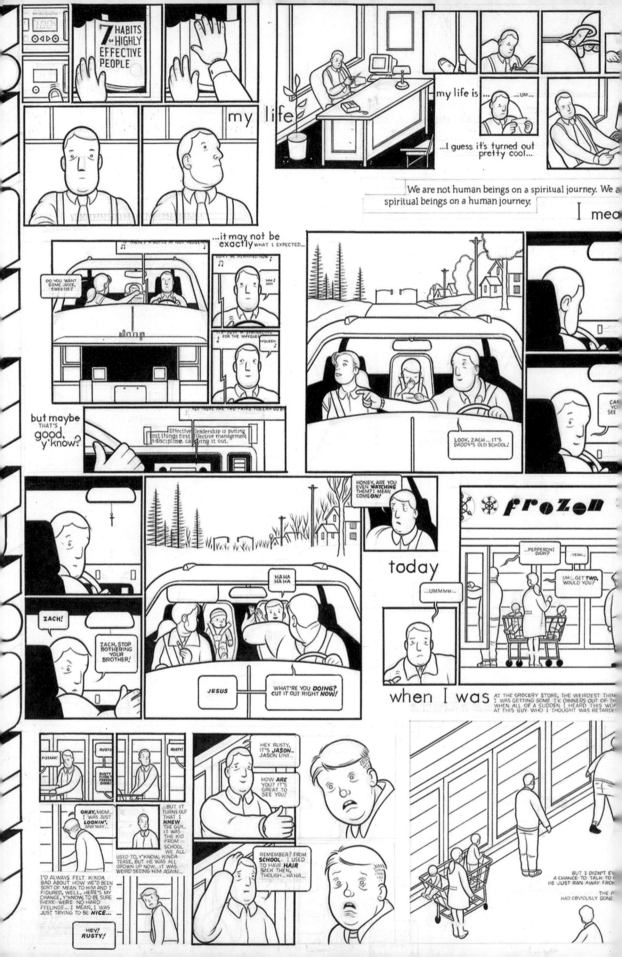

Outside the Box

Interviews with Contemporary Cartoonists

Hillary L. Chute

THE UNIVERSITY OF CHICAGO PRESS • CHICAGO AND LONDON

Hillary L. Chute is the Neubauer Family Assistant Professor of English at the University of Chicago and the author of *Graphic Women: Life Narrative and Contemporary Comics*.

The University of Chicago Press, Chicago 60637

The University of Chicago Press, Ltd., London

© 2014 by The University of Chicago

All rights reserved. Published 2014.

Printed in Canada

23 22 21 20 19 18 17 16 15 14 1 2 3 4 5

ISBN-13: 978-0-226-09944-6 (paper)

ISBN-13: 978-0-226-09958-3 (e-book)

DOI: 10.7208/chicago/9780226099583.001.0001

Frontispiece and chapter-opener illustrations: Page ii is a detail of figure 11.11 (p. 247); page xii is a detail of figure 11.8 (p. 236); and pages 16, 32, 56, 80, 98, 118, 138, 154, 176, 194, and 216 were created by Ivan Brunetti for this volume.

Library of Congress Cataloging-in-Publication Data

Chute, Hillary L., interviewer.

 Outside the box : interviews with contemporary cartoonists / Hillary L. Chute.

 pages : illustrations ; cm

 Includes index.

 ISBN 978-0-226-09944-6 (pbk. : alk. paper) — ISBN 978-0-226-09958-3 (e-book) 1. Cartoonists—United States—Interviews. 2. Cartoonists—United States—Biography. 3. Comic books, strips, etc.—United States—21st century. I. Title.

 NC1305.C48 2014

 741.5'973—dc23

 [B]

 2013025704

♾ This paper meets the requirements of ANSI/NISO Z39.48–1992 (Permanence of Paper).

For Art Spiegelman, if he'll take it.

For Daniel Aaron, a model for how to be an interlocutor.

And for Noah Feldman, whom I love.

Contents

Illustrations

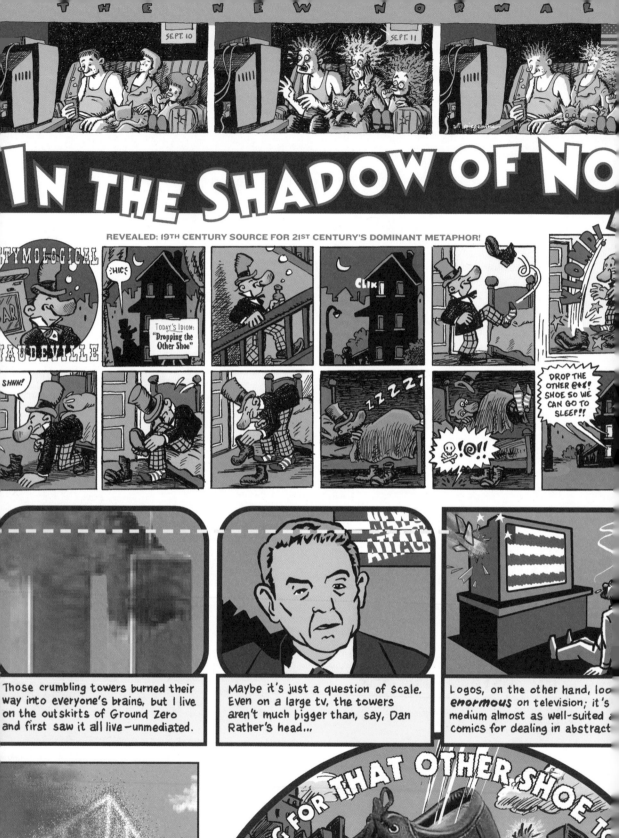

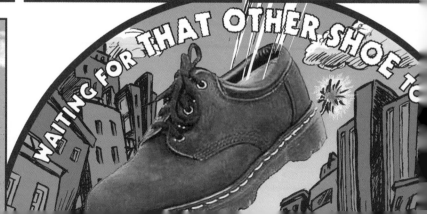

Introduction

Twenty-First-Century Comics

The form of comics is finally getting its due. As cartoonist Adrian To-
mine put it to me: "What we all twenty years ago dreamed of—for us it
kind of came true, in terms of how comic books are bought and sold
and thought of in this society." I have been writing about comics for
magazines, newspapers, and scholarly publications since 2000. These
ten-plus years have been a high point for the literary and artistic possi-
bilities of comics. An enormous number of essential, innovative comics
works have appeared—including by every one of the twelve field-defin-
ing cartoonists I interview here: Lynda Barry, Alison Bechdel, Charles
Burns, Daniel Clowes, Phoebe Gloeckner, Aline Kominsky-Crumb,
Scott McCloud, Françoise Mouly, Joe Sacco, Art Spiegelman, Tomine,
and Chris Ware.

Unprecedented interest in the form, accordingly, is evident in the
past decade from all corners of culture: from popular and academic
audiences alike, from museums and galleries, filmmakers, theater and
dance companies, and publishers of all stripes. In 2006, Houghton Miff-
lin began issuing *Best American Comics* alongside their traditional *Best
American* titles.[1] In 2009, Alison Bechdel published the first comics-for-
mat book review in the *New York Times Book Review*. Her graphic mem-
oir *Fun Home: A Family Tragicomic* (2006) is also currently enjoying
an off-Broadway run in New York as a musical (!) with an all-star team
(director Sam Gold, composer Jeanine Tesori, and writer Lisa Kron). In
2010, Spiegelman, a Pulitzer Prize winner, premiered a collaboration
with the experimental dance company Pilobolus ("Hapless Hooligan
in 'Still Moving'"). In September 2012, a lawyer who opposes the Jus-
tice Department's proposed antitrust settlement with e-book publish-

1. Five of this book's interviewees have served as guest editors of *Best American Comics*:
Chris Ware, Lynda Barry, Charles Burns, Alison Bechdel, and Françoise Mouly.

ers filed an amicus brief in the form of a comic strip—incidentally, the scholarly journal *Law Text Culture* recently published a special issue called "Justice Framed: Law in Comics and Graphic Novels." Public interest in comics is increasing as the medium develops new formats, outlets, and expectations. Comics appear in all sorts of differently marked spaces, from the secondary to graduate classroom to the courtroom to the walls of the Centre Pompidou, where Spiegelman recently exhibited the show "Co-Mix."

I began talking to cartoonists in 2005, the year I published my first interview with a cartoonist—Joe Sacco, in the short feature "Stand Up Comics," in the *Village Voice*—and the year I began working with Spiegelman on his book project *MetaMaus* (2011), which features a long interview with the two of us that we recorded over a period of years. I realized quickly that probing cartoonists about their lives and their cartooning practices was something for which I had an unceasing appetite. When I interviewed Bechdel for the first time in 2006, for a feature about *Fun Home* in the *Village Voice*, I was half mortified and half flattered to discover the following weary blog post on www.dyke-stowatchoutfor.com: "It's a good thing I've been blogging this [book] tour because otherwise I'm not sure I'd remember it. Today I had a podcast, two signings, and a long, intense newspaper interview with a woman who did her doctoral dissertation on autobiographical comics." That was me. And while I apologize to Bechdel for turning our one-hour interview into three, working on that piece about *Fun Home* did begin a long-standing relationship (Bechdel and I won a Mellon Foundation grant to collaborate on a course, exhibit, and conference, "Comics: Philosophy & Practice," at the University of Chicago in spring 2012). In terms of getting practice, I couldn't have been luckier than to have had Spiegelman as a tireless interlocutor on comics form and history when we collaborated on *MetaMaus*; my first meeting with him, scheduled for an hour, was four. We once had a thirteen-hour meeting during which he made me a grilled cheese and poured me a glass of wine for a snack, but it was otherwise uninterrupted. Listening to cartoonists, I became fascinated with the possibilities of the comics form, especially around the relationship between word and image, and the connection of time to space. It is a form that is traveling from the fringe to the mainstream quickly, and not always for obvious reasons. Many people right now want to understand and theorize what they find exciting about comics. The exhilarating feature of my interviews with cartoonists—for me, and hopefully for others—is that they capture moments of practitioners reflecting on the form *as it is being shaped* in contemporary culture.

Outside the Box collects in-depth interviews with twelve of the fig-

ures who shape contemporary comics, showcasing the "philosophy and practice" of cartooning (to borrow a phrase, once again, from cartoonist, editor, and professor Ivan Brunetti).[2] While they present a diverse range of texts and aesthetics, these five women and seven men define the parameters of today's literary comics. (While such lines can be blurry, "literary" or "independent" comics work tends to be distinguished from "commercial" or "mainstream" work in that it is less driven by genre constraints, and is not usually completed by teams of people.)

What is so riveting about the group of artists included in *Outside the Box* is how imbricated they are with each other—and yet how radically different all their work looks from each other's. Reading these interviews, a sense of community emerges, and one can begin to trace the genealogies and interconnections. These cartoonists have each done comics that stand as singular contributions, and each took the field forward in terms of force, sophistication, and craft. But their styles and sensibilities diverge. And their work positions itself variously, representing a range of goals and desires. Some of the cartoonists here work in fiction, like Clowes, perhaps best known for the timeless, tart graphic novel *Ghost World*, and Ware, whose monumental *Building Stories*, released this year, is a story the reader "builds" in her own way, from a box that contains fourteen different narrative fragments to be read in no particular order. Some artists work in nonfiction, like Aline Kominsky-Crumb, the first woman to publish autobiographical comics, starting in the 1970s, and Joe Sacco, who expands nonfiction's range with his intense, inventive comics journalism. Scott McCloud, who opens the book, is a "comics theorist," writing works about comics in comics form. And Françoise Mouly, while she herself has published comics and illustrations, appears here to offer her knowledge as one of the key figures of the past thirty years in her role as a publisher, editor, and tastemaker developing comics aesthetics from the avant-garde *RAW* magazine in the 1980s to the widely circulating *New Yorker* in the 1990s and 2000s. What unites the group is that each person helped set the terms for what comics can do today.

Some commonalities emerge: art school was not, for any of these cartoonists, a necessary step for a very illustrious career in comics. Ware never graduated from the School of the Art Institute of Chicago; in "Art School Confidential" Clowes sends up his own experience and offers the advice "Never mention cartooning in art school"; Burns's art classes in college didn't encourage cartooning as a worthy enterprise:

2. Ivan Brunetti, *Cartooning: Philosophy and Practice* (New Haven: Yale University Press, 2011). Brunetti's book inspired the title of the Chicago conference.

"Every once in a while I'd bring [my comics] in to show my teachers but never got much of a response . . . they just didn't really know what to say about it"; Kominsky-Crumb's art-school years ruined her love for creating art until she discovered comics as a kind of freeing antidote. And Tomine, a famed cover artist for the *New Yorker*, and the youngest person, at age thirty-nine, to be interviewed here, was an English major. He cut his teeth on self-publishing a comic book series, *Optic Nerve*, by himself in high school, as opposed to in an art program. (Art Spiegelman also self-published a comic book, *Blasé*, as a young teenager.) In this, cartoonists present a much different picture of the path to recognition than many of their peers in the literary world—or the "fine arts" world—whose backgrounds routinely involve MFA and other programs. (Today, however, the options available to young cartoonists are growing; accredited programs in cartooning exist, and there is even a graduate school devoted specifically to comics, Vermont's Center for Cartoon Studies.)

The context of print, and the circulation of print, is a big theme across all the interviews. Mouly takes it on philosophically: she describes her love, as many here do, for the printed object ("it's thriving," she says), and she also describes how for comics, the form's investment in print has created the divide between comics and fine art. Some cartoonists straddle this divide by exhibiting original artwork in galleries and museums, despite some generalized misgivings about how comics, a form meant to be printed, actually fares on a wall. (Although celebrated cartoonist Robert Crumb, for instance, has said, "I am not inspired by the idea of being in museums at all," he recently had a show at the Musée d'Art Moderne de la Ville de Paris.)[3] And not all the figures interviewed here share an attachment to print culture; for Scott McCloud, the print platform is not the irreducible feature of comics. To him, as he tells me, print is "a fetish."

One of the themes of discussion across interviews to notice, however, is how print and reproduction shape comics output. While I was driving in Chicago with Chris Ware a few years back, he suddenly said, "That's my Kinko's" as we passed a Wicker Park Kinko's—the site where his early work, essentially, became "work," became public, able to circulate. In Lynda Barry's fascinating account of her early years of comics making with *The Simpsons*'s Matt Groening in the late 1970s, the fact that

3. See Hans Ulrich Obrist, *Robert Crumb—The Conversations Series* (Köln: Verlag der Buchhandlung Walther König, 2006), 38; and Elaine Sciolino, "An Artist's Journey from Comic Books to Museum Walls," *New York Times*, April 13, 2012, accessed October 22, 2012, http://www.nytimes.com/2012/04/14/arts/design/r-crumb-gets-a-show-at-the-musee-dart-moderne-de-la-ville-de-paris.html.

Groening worked at a copy shop was the reason he started drawing *Life in Hell* ("He could just make copies, and then he would send us copies of his stuff, but it wasn't ever intended to sell or anything"; when Groening got a creative job, it was as a writer, not a cartoonist, for the *LA Reader*). He drew what would become his hit comic because he could easily circulate it to his friends. Barry's first book, collecting her series *Two Sisters* (examples of which are reprinted here), was entirely reproduced through Xeroxes: "Copy shops had just come out," she told me. (That copy shops are actually a fairly recent historical development may be hard to imagine.) "I just copied the whole collection," she explains. "I put it in a manila envelope and I hand-decorated the top, and I sold them for ten dollars. You know, so you just get a manila envelope and you pull it out and there'd be all the comic strips. . . . I'd take orders, and I'd go to the copy shop, and they'd copy them, and then I'd put them in and make the whole thing." These mechanisms of reproduction were key for the expansion of creative comics culture.

This is displayed throughout the volume—and it is literally displayed in a photograph that appears alongside Mouly's interview, of her own second-hand, multilith printing press, which is said to have almost killed the person carrying it up the stairs to her fourth-floor walk-up apartment, but led to the creation of *RAW* magazine. Spiegelman and Mouly, who have been married since 1977, are figures referred to often in the interviews. Spiegelman, arguably the most famous cartoonist in the world—and the rare cartoonist acknowledged as a public intellectual—is best known globally for his *Maus: A Survivor's Tale* (1986; 1991), which definitively shifted the public perception of comics and inspired a legion of cartoonists. Mouly is art editor of the *New Yorker*. One of the fascinating questions about contemporary comics is the question of the kinds of spaces in which they are today appearing: is something being lost by virtue of their unprecedented acceptance in today's mainstream and "high" culture spaces? Today's cartoonists now have more avenues open to them than ever before. This wasn't the case in 1980, when Spiegelman and Mouly began publishing *RAW*.

The "underground comix revolution," urged along by political campus humor magazines, the left-wing press, the rock poster scene of San Francisco, and Robert Crumb's influential, self-published *Zap*, which first appeared in 1968, allowed comics to exist for an adult audience meaningfully for the first time in the United States. The tagline on Crumb's first issue of *Zap* read: "Fair Warning: For Adult Intellectuals Only." Without the underground comics scene, which eschewed mainstream publishing outlets and their aesthetic and political restrictions, freeing cartoonists to experiment with form and storytelling, we would not have the con-

temporary comics scene as we know it, and certainly no "graphic novel" industry. The underground established comics as a serious form for self-expression, as a medium that could be outrageous but didn't need to be only "funny."

But Spiegelman, at least, who published in and himself published several underground titles, including *Short Order Comix*, where his famous strip "Prisoner on the Hell Planet" first appeared, felt that steam was running out of the underground scene by the mid-1970s. He and Bill Griffith (now the renowned creator of *Zippy the Pinhead*) together founded and edited *Arcade: The Comics Revue* as a venue to display the best of the underground talent and to keep focus on rigorous and interesting new work. *Arcade*, which published Robert Crumb and Aline Kominsky-Crumb, along with Justin Green, Jay Lynch, Kim Deitch, Spain Rodriguez, and others, lasted only eight issues (1975–1976). As the seventies gave way to the eighties, and a new era of publishing, two new comics magazines emerged to fill the gap left by *Arcade* and the diminishing power of the underground scene: Spiegelman and Mouly's *RAW* (1980–1991), and Crumb's *Weirdo* (1981–1993).

RAW's departure from underground comics registered clearly its format. The idea was to differentiate *RAW*, an avant-garde magazine, from previous underground publications—even serious ones like *Arcade*—by its luxurious production values. Each issue carried a different subtitle: the first (with a print run of 3,500), was *The Graphix Magazine of Postponed Suicides*. Spiegelman and Mouly wanted a large-format, high-quality "comix and graphix" magazine that would stand out at the bookstores and newsstands the way the magazine-sized *Arcade* had not. Indeed, *RAW*'s first volume was too large to be shelved with the "regular" magazines or comics; Spiegelman and Mouly endeavored to make the public take account of comics in a format it wasn't used to. They were successful. The first print run—they printed it themselves, with Mouly's printing press, in their loft—sold out. *RAW* created serious comics culture afresh; it defined and became the standard-bearer for ambitious new work—including Spiegelman's *Maus*, which began to appear chapter by chapter as an insert booklet starting in the second issue.

Tomine explains that when browsing comic shops he "knew everything in the same proximity, on the same shelf with *RAW*, was going to be potentially interesting." And both Charles Burns and Chris Ware, two undisputed titans of the graphic novel, got their start in *RAW*. Burns saw the first issue while visiting New York, found the office's address, and went and rang the doorbell, which was answered by a "frenzied" Spiegelman. As Burns tells me, "He was the first cartoonist I ever talked to. And he was the first person who really figured out what I was trying to achieve."

Burns's first piece in *RAW* appeared in 1981, and Burns gained fame through the magazine (he did his first cover for *RAW #4: The Graphix Magazine for Your Bomb Shelter's Coffee Table* in 1984). Ware's career also took off through *RAW*. At his local Omaha comic book shop, he recounts, "I came across a big magazine sticking up out of the bins that I'd never heard of before called *RAW*. Thrilled, I thought, 'Wow! That must be really filthy!' So I pulled it out and thumbed through it, but of course I was immediately disappointed because, well, it wasn't really that filthy." Spiegelman saw samples of Ware's work in a college newspaper and eventually telephoned him and asked him to submit; Ware's first strip in *RAW*, "Waking Up Blind," appeared in 1991.

RAW was a platform for young up-and-coming artists like Burns and Ware, and it also republished older comics works that had gone under the radar, such as by Boody Rogers and Henry Darger. Many of today's most acclaimed cartoonists, such as Lynda Barry, Ben Katchor, Gary Panter, Kim Deitch, and Justin Green all appeared in *RAW* (Joe Sacco was rejected, a fact he laughs about now). Significantly, *RAW* also sought to bring avant-garde comics from Europe—where Mouly had connections—and elsewhere to an American audience. *RAW* pioneered a space for the graphic and intellectual force of comics, and mainstream culture paid attention: the magazine's second-volume run was picked up by Penguin.

But while Aline Kominsky-Crumb noted recently on the radio that "what really changed comics was Art Spiegelman and *RAW* magazine, because he took it to another level of . . . high art, you might say, and took it out of the comics ghetto," Kominsky-Crumb and her husband, Robert Crumb, took turns editing the comics magazine *Weirdo*, an alternate and prominent venue, during the same period.[4] (Kominsky-Crumb was editor from 1986 to 1993.) *Weirdo* also published a stable of star cartoonists, including Crumb, Kominsky-Crumb, and Peter Bagge (who was also an editor), Julie Doucet, Carol Tyler, and Phoebe Gloeckner—a young cartoonist who had grown up in San Francisco and used to write Kominsky-Crumb fan mail as a teenager. *Weirdo*'s aesthetic philosophy was continuous with the underground comics. It didn't eschew newsprint, and it embraced a notion of comics culture as edgy and vital in part because of comics' marginality and disposability, which *RAW* was fighting so hard against. Kominsky-Crumb remembers this time in 1980s and 1990s as a "just a very rich time. There were all these people starting out . . . who had been influenced by the first generation of cartoonists in the sixties, and all these younger people coming out with work." In her view,

4. Ian Willoughby, "Special: Cartoonists Robert Crumb and Aline Kominsky-Crumb Discuss Working Together—and Much More," Czech Radio 7 (Prague: Radio Prague, June 9, 2009).

with a whole cadre of cartoonists inspired by underground comics, "you couldn't help but make a good magazine."

The underground comics community of artists and publishers was, in large part, the genesis of contemporary comics, solidifying the practice of "comics as a medium for self-expression," to use a phrase of Spiegelman's.[5] *RAW* and *Weirdo*, then, coming afterward, represent a productive fork in the road during the transitional period of the eighties and nineties, when two different aesthetic and cultural attitudes about the form both flourished. Yet there was cross-fertilization: both Crumb and Kominsky-Crumb, for instance, eventually published in *RAW*. Crumb's influence—including on just about every single cartoonist featured here, from Alison Bechdel to Joe Sacco; he is name-checked in nine of the eleven interviews in this book—was profound. Mouly recalls, "When we were putting together *RAW,* everywhere we went in the late seventies, the one common denominator that we would see in every artist's notebooks was their R. Crumb period. Whether it was Charles Burns or Gary Panter in the US, or when we traveled to France, Holland, Spain, or Italy, every cartoonist had gone through a period of being influenced by Crumb." (Video of Crumb's appearance at the "Comics: Philosophy & Practice" conference is available online at *Critical Inquiry*; significant interviews with him appear in the books *R. Crumb: Conversations* and curator Hans Ulrich Obrist's *Robert Crumb*, as well as in the *Paris Review*, in addition to Terry Zwigoff's celebrated 1994 film *Crumb.*)[6] Despite opposing orientations about the form's ideal cultural position, *RAW* and *Weirdo* expanded comics culture immeasurably in their mutual focus on stylish, experimental, and personal comics. As Daniel Clowes tells me of nonsuperhero comics work, "There was no 'the world of graphic novels' as it exists today. There was Art Spiegelman doing *RAW*, and Robert Crumb was doing *Weirdo*, and there was *Love and Rockets.* And that was it."

Love and Rockets, by brothers Jaime and Gilbert (and sometimes Mario) Hernandez, began in 1981, around the same time as *RAW* and *Weirdo. Love and Rockets* features two main story lines, one about Hoppers by Jaime (based loosely on Oxnard, California), and one about Palomar, a fictional Latin American village, by Gilbert. An ongoing se-

5. See Spiegelman's full-page image in which a woman scolds a chagrined man wielding a dip pen: "Comics as a medium for self-expression? Oh John, you're such a fool!" The 1982 image appeared on the cover of *Print* magazine (May–June 1981) and on the back of the collected volume *Read Yourself Raw*, ed. Mouly and Spiegelman (New York: Pantheon, 1987).

6. See D. K. Holm, ed., *R. Crumb Conversations* (Jackson: University Press of Mississippi, 2004); Obrist, *Robert Crumb*; Ted Widmer, "Robert Crumb—The Art of Comics No. 1," *Paris Review*, Summer 2010, accessed October 22, 2012, http://theparisreview.org/interviews/6017/the-art-of-comics-no-1-r-crumb.

ries, it is captivating not only because of its vibrant, elegant drawing and appealing density of reference (think LA punk), but further because of its emotional richness and humor, particularly in its presentation of strong female characters in both story lines. *Love and Rockets* has had a profound influence (as is particularly evident here in the interview with Tomine). And Clowes's invocation of its prominent place in 1980s culture also calls attention to the crucial role of independent comics publishers. Across the interviews here are many references to Seattle's Fantagraphics—which is famous for publishing *Love and Rockets*—and to the Canadian comics publisher Drawn & Quarterly. Without these publishers, many of the nonmainstream comics that grew out of the eighties and nineties and have so profoundly shaped the sense of possibility for artistically interesting work, would not have found audiences. Fantagraphics, founded in 1976, also publishes the *Comics Journal*, which has functioned as one of the central organs of the independent comics world (now mostly existing online, the magazine describes itself on the Fantagraphics website as one that "covers the comics medium from an arts-first perspective").

What readers of today's comics and graphic novels may not realize is just how recent comics' cultural strides have been, and how quickly shifts happen. Lynda Barry registers a kind of unease with contemporary categorizations when she tries to classify comics' evolution: "It went: underground, then funk, then punk, then new wave, then alternative, and then, then, then . . . art. I guess 'graphic novels,' graphic something, and then 'art comics,' people call them, art comics." The appellations for comics may have changed a lot over the past forty-odd years, but the strength of the form to seize attention, to invoke an intimacy with character and setting, and to offer sophisticated visual-verbal narratives has been consistent. From Kominsky-Crumb's explanation of the underground to Barry's description of alternative weeklies and Clowes's account of the "lost world" of comic book and zine culture of the 1980s and 1990s, the career trajectories on display here fill in a picture of how the world of literary comics has emerged and taken shape. Through its various accounts, from men and women, from artists in different generations, from fiction writers and first-person adherents, and from editors and theorists, this book presents a crucial recent history of a rapidly expanding art form.

Any book like this, in selecting a group, is creating a kind of canon. Some invested in comics—fans, scholars, and artists alike—place pressure on the idea that comics, a lively, mass, outsider form, should have a "canon" at all. There is a fear of a certain kind of airlessness and domestication. (As I've pointed out before, the clever title of a sem-

inar Spiegelman taught at Columbia University, "Comics: Marching into the Canon," plays on this ambivalence.) I am a professor who studies comics and is active in promoting the study of comics within the academy. I coedited the first special issue of an academic journal in my field, literature, on the subject of comics in 2006.[7] In the introduction to that *Modern Fiction Studies* issue titled *Graphic Narrative*, my coeditor Marianne DeKoven and I concluded by emphasizing "the diversity and promise of this form" (p. 778). We chose criticism that engaged collaborative work, superhero comics, comics adaptation, fictional graphic novels of both the realist and fantasy stripe, and graphic memoirs. We paid attention to publishers (McSweeney's, founded in 1998 by novelist Dave Eggers, and Milestone Media, an independent publishing company founded in 1993 by a coalition of four African American investors), and to the way comics circulate globally (through essays on the Iranian Marjane Satrapi's *Persepolis*, and also through attention to image making and racism in the Middle East—"The Israeli Anti-Semitic Cartoons Contest").[8] I also wrote, two years later, an essay about comics as literature in the journal *PMLA*, which prompted a published response that characterized my account as like "a history of television written by someone who watches only award-winning PBS documentaries" (p. 293). It was fun and rare, as I stated in my reply to Ben Saunders, to be a person who studies comics and to be accused of being too highbrow.[9]

Saunders's concern is not atypical: there are people whose dislike of an academic or literary press "canon," however loosely configured, is generated by the lack of critical attention to superhero comics and other genre work in the field. I am more interested, as I also explained in my response, in the single vision of the auteur of fiction or nonfiction comics—a Phoebe Gloeckner or a Lynda Barry—than I am in comics work created by teams of people, such as we see in the genre-driven work from companies like DC and Marvel. Yet I don't doubt that interesting work is being done there, and I hardly eschew the genre conventions with which contemporary cartoonists like Burns are working (see our intense discussion of "teen plague"!). My desire is for more,

7. See *Mfs: Modern Fiction Studies* 52 (Winter 2006), ed. Hillary Chute and Marianne DeKoven. Others have followed, including special issues of *ELN*, *College Literature*, *MELUS*, *SubStance*, *Shofar*, and the forthcoming *Comics and Media* issue of *Critical Inquiry*. There are also now peer-reviewed journals dedicated entirely to the study of comics, such as *Graphic Novels and Comics* (Routledge) and *European Comic Art* (Liverpool University Press).

8. In terms of subjects, *Mfs* offered essays on Kim Deitch, Ben Katchor, on David Mazzucchelli and Paul Karasik's adaptation of Paul Auster's *City of Glass*, on Neil Gaiman et al.'s *The Sandman*, on Chris Ware, on *McSweeney's* issue 13, on Dwayne McDuffie and M. D. Bright's *Icon: A Hero's Welcome*, on Lynda Barry, Marjane Satrapi, and Alison Bechdel.

9. Hillary Chute and Ben Saunders, "Divisions in Comics Scholarship," Forum, *PMLA* 124.1 (January 2009).

not fewer, conversations about comics taking place, with many kinds of perspectives and objects of analysis. My own interest skews to work that represents the perspective and craft of a single artist both writing and drawing. Françoise Mouly talks here about this aspect of comics having "the unique power of giving you a window onto how somebody else thinks."

I was lucky to encounter valid and interesting criticisms when I organized the "Comics: Philosophy & Practice" conference in May 2012. The conference website states, "The first of its kind, this historic conference brings together 17 world-famous cartoonists whose work has defined contemporary comics." They were Lynda Barry, Alison Bechdel, Ivan Brunetti, Charles Burns, Daniel Clowes, Robert Crumb, Phoebe Gloeckner, Justin Green, Ben Katchor, Aline Kominsky-Crumb, Françoise Mouly, Gary Panter, Joe Sacco, Seth, Art Spiegelman, Carol Tyler, and Chris Ware. About a month before the conference, the acclaimed cartoonist Keith Knight of the popular comic strips *The K Chronicles, (Th)ink,* and *The Knight Life,* wrote a comment through the conference website: "Disappointed to see no African American cartoonists on the roster. Especially in Chicago! If you need suggestions in the future, let me know." In the conference's last panel, "Lines on Paper" (titled after a famous Crumb comic that ends, "it's only lines on paper, folks!") which featured Lynda Barry, Ivan Brunetti, Crumb, and Gary Panter, race came up briefly. Moderator Hamza Walker (who happens to be black himself), addressed the panelists at the outset, "Had someone asked me not so long ago, which of these two scenarios is more likely to happen: There will be a black president at the White House within your lifetime or there will be a panel at the University of Chicago featuring you four, I would have balked." Ivan Brunetti chimed in, "But first we need the first black cartoonist up here, though."

Obviously there are prominent black cartoonists, *The Boondocks*'s Aaron McGruder and Knight among them (and those interested in Knight's work should check out the excellent interview with him in the *Believer* conducted by Chris Lanier). What Brunetti was correctly highlighting is what one might think of, broadly speaking, as the whiteness of the world of contemporary literary comics, on display, for the most part, at the conference. But when I corresponded with Knight, he was optimistic: "As far as diversity—it's happening. I've watched a huge change in the audience attending Comic Con over the years (been going since 1993) and the diversity of creators. I'm hoping the content will eventually catch up."[10] And here, in this volume, Lynda Barry and

10. See Keith Knight, foreword to *Black Comix: African American Independent Comics*

Adrian Tomine talk fascinatingly about race and racial identity in their backgrounds and work.

There are many cartoonists not able to be included here whose work I love and want to acknowledge. They include figures referred to in these pages by their peers: Brunetti, who has made a major mark with his comics, writing, illustration, and editing, particularly the two volumes of Yale University Press's *An Anthology of Graphic Fiction, Cartoons, and True Stories*; punk king Gary Panter, equally influential in his design, painting, and comics; Seth, the influential illustrator and creator behind the *Palookaville* series and the books *It's A Good Life If You Don't Weaken* and *George Sprott*; Chester Brown, of the series *Yummy Fur* and the nonfiction narratives *Louis Riel* and *Paying For It*; Julie Doucet, of *Dirty Plotte* and the classic *My New York Diary*; Jaime and Gilbert Hernandez, whose enthralling, epic, and not a little sexy *Love and Rockets* occupies a huge space in independent comics culture; Jules Feiffer, whose comic strips for *Playboy* and the *Village Voice*, alongside works like his 1979 book *Tantrum*, were trailblazing; Howard Cruse, founder of *Gay Comix* and the moving graphic novel *Stuck Rubber Baby*; Justin Green, who is widely credited with pioneering autobiographical comics in 1972 in his explicit story of OCD and sexual guilt *Binky Brown Meets the Holy Virgin Mary*; and Robert Crumb, whose *Zap Comix* changed perceptions of comics, politics, and left-wing culture far and wide. There is also the brilliant work of major underground cartoonist and now graphic novelist Kim Deitch (*Boulevard of Broken Dreams* and *Alias the Cat!*); Roberta Gregory, whose *Naughty Bits* comics featuring her character Bitchy Bitch are funny, incisive, feminist stories; Bill Griffith of *Zippy the Pinhead*, along with his wife Diane Noomin (*Didi Glitz*); Nicole Hollander of *Sylvia*; MacArthur "genius" Award-winning cartoonist Ben Katchor, whose work includes *The Jew of New York* and *The Cardboard Valise* along with radio and musical theater; Trina Robbins, who kick-started women's comics in 1970 with *It Ain't Me, Babe*; Marjane Satrapi, the best-selling Iranian cartoonist by way of Paris who has turned recently

Art Culture, ed. Damian Duffy and John Jennings (Brooklyn: Mark Batty Publisher, 2010). Recent prominent graphic novels by black cartoonists include Aaron McGruder, *Birth of a Nation: a Comic Novel*, written with Reginald Hudlin and drawn by Kyle Baker (New York: Crown, 2004); Ho Che Anderson's *Scream Queen* (Seattle: Fantagraphics, 2005) (Anderson is also the creator behind the famous *King* series); and Kyle Baker's *Nat Turner* (New York: Abrams, 2008). For more on comics and racial diversity, see Frederick Luis Aldama's edited collections *Multicultural Comics: From* Zap *to* Blue Beetle (Austin: University of Texas Press, 2010) and *Your Brain on Latino Comics: From Gus Arriola to Los Bros Hernandez* (Austin: University of Texas Press, 2009); Adilifu Nama's *Super Black: American Pop Culture and Black Superheroes* (Austin: University of Texas Press, 2011); and Jeffrey A. Brown's *Black Superheroes, Milestone Comics, and Their Fans* (Jackson: University Press of Mississippi, 2001); as well as Nancy Goldstein's *Jackie Ormes: The First African American Woman Cartoonist* (Ann Arbor: University of Michigan Press, 2008).

to film; and Carol Tyler, who recently completed a three-part series about World War II, *You'll Never Know*. People new to the form can discover, as Mouly puts it, "a really rich world."

The *Believer* magazine, where six of these interviews first appeared from 2007 to 2011, is a major force in comics coverage in the twenty-first century. The *Believer* was founded in 2003 by editors Ed Park, Vendela Vida, and Heidi Julavits, all novelists of note, and is published by the McSweeney's empire. Luckily for me, part of the monthly magazine's mission statement (available on their website) is that "length is no object." Also luckily for me, since it fits with my interest in understanding how work I admire works, the *Believer*'s credo is to "focus on writers and books we like" and to "give people and books the benefit of the doubt."[11] The *Believer* first published my interviews with Scott McCloud, Lynda Barry, Aline Kominsky-Crumb, Phoebe Gloeckner, Joe Sacco, and Charles Burns—who from the magazine's inception has been its official cover artist. *Believer* covers tend to depict the faces of persons covered in the magazine; I'm delighted that my interviews required Burns to draw his own comics colleagues like Sacco and Barry. It was an honor to interview Burns himself for the January 2008 issue, for which he finally then got to draw a self-portrait (that interview has long been unavailable until now, as the issue featuring Burns sold out).

To draw on its own language, the *Believer*'s straightforward belief in comics culture and aesthetics as a feature of contemporary art and literature is profound. In addition to securing a world-class graphic novelist as its cover artist, it consistently features cartoonists (even in features not by me!) and has a regular, full-color "Comics" column, edited by comics publishing impresario Alvin Buenaventura, offering a variety of short work. In this, the *Believer*'s aesthetic philosophy is continuous with McSweeney's in general, which again and again demonstrates its investment in format and the printed object, and which published Chris Ware's edited all-comics issue of the *McSweeney's Quarterly Concern* magazine (issue 13, 2004), along with Art Spiegelman's notebooks (*Be*

11. In this, the *Believer* has raised criticisms from the younger, thrice-yearly rival publication *n+1*, an issue that was covered in a 2005 *New York Times* profile of the two magazines. In that article, A. O. Scott sums up the situation aptly, pointing out that in their first issue, *n+1* alleges that "mere belief is hostile to the whole idea of thinking. To wear credulity as one's badge of intellect is not to be a thinker as such." Scott comments, "That is well put, but also a bit wide of the mark, and it overstates the differences between the two magazines. The *Believer*, in spite of its commitment to enthusiasm, is about something more than 'mere belief,' and *n+1*, for its part, fiercely broadcasts its own faith in transcendence, in literature and in a curiously disembodied activity called 'thought.'" See Scott, "Among the Believers," *New York Times Magazine*, September 11, 2005, accessed October 18, 2012, http://www.nytimes.com/2005/09/11/magazine/11BELIEVERS.html?pagewanted=all.

a Nose! Three Sketchbooks) and the deluxe reprint edition of Justin Green's *Binky Brown Meets the Holy Virgin Mary*.[12]

Two additional interviews here—with Daniel Clowes and Alison Bechdel—appeared in other publications; Clowes and I spoke for *Time Out New York*, and Bechdel and I spoke first in 2006 for *Mfs: Modern Fiction Studies*, an academic journal, and later, in 2012, for the *Printers Row* journal of the *Chicago Tribune*. Those two interviews for two different kinds of venues are grouped together here. What is striking is how continuous they are in tone and texture, although one is for a scholarly journal and one is for a large-circulation major city newspaper. Interest in comics bridges the academic and the popular. This ability to capture attention among different audiences is part of the huge appeal of graphic works today, which aim to be both sophisticated and accessible (as so many works in the history of comics have been). With the exception of the Bechdel double feature, all previously published interviews, which appear here in chronological order, have been expanded to include new, substantial, previously unpublished material. Some, like my interview with Clowes, are now double in size (and I am especially excited to offer an excerpt here from Clowes's very first published comics piece, "Aren't You Nervous When . . . ?," which has never before been reprinted).

The last three interviews here, with Françoise Mouly, Adrian Tomine, and Art Spiegelman and Chris Ware, have never before appeared in print. Mouly is a comics-world denizen with whom I have had conversations for a number of years (including, here, in 2008 and 2010). I interviewed the gracious Adrian Tomine specifically for this book; we met in New York right before his new collection, *New York Drawings*, was set to appear in fall 2012. In the case of Art Spiegelman and Chris Ware, whom I met on the same night in 2005 at a party for the twenty-fifth anniversary of *RAW*, our discussion took place at a ticketed event in the spring of 2008 in San Francisco, the birthplace of underground comics. Anyone interested in my one-on-one conversations with Spiegelman can discover almost 250 pages of that in the inspiring *MetaMaus*, a project about his thirteen-year process of making the terrain-shifting *Maus*. I'm gratified to conclude the volume with an interview with Spiegelman and Ware together—two masters of the form who yet come from different generations. Spiegelman and Ware employ very different

12. Each issue of *McSweeney's Quarterly Concern*, which commenced in 1998, has a different format. Famous examples include issue 33, the *San Francisco Panorama* issue, which is in the form of a complete Sunday newspaper with all its elements, and issue 36, which is a square, 275-cubic-inch box, which opens to pieces inside including fragments from a previously "lost" Michael Chabon novel. McSweeney's also worked with Ware on the iPad-specific story "Touch Sensitive," which one can download for free with the McSweeney's application.

styles, while both are profoundly influenced by comics history. Our discussion, which sheds light on the major works by these two cartoonists, including Ware's brand-new *Building Stories*, is riveted to questions of terminology, the essence of comics form, and process. Spiegelman and Ware have never appeared in conversation in print together before.

1

Scott McCloud

When *Understanding Comics*, Scott McCloud's first book and the first book to explicitly theorize comics in the medium of comics, came out in 1993, it offered the following working definition of comics: "Juxtaposed pictorial and other images in deliberate sequence, intended to convey information and/or produce an aesthetic response in the reader." However bulky, McCloud's definition set the terms of debate—which is ongoing—for the field of comics: what it is, what it can do. Last year, the *New York Times*, reporting on a "Comics and Medicine" conference (where McCloud and I were both presenters), named him a "sort of Marshall McLuhan of comics." *Understanding Comics* is a classic of the contemporary comics field—a constant reference point both within comics studies and in media (and narrative) studies in general.

Reinventing Comics, McCloud's second book, came out in 2000 and focused on the relationship of digital technology to comics. His most recent nonfiction comics work, *Making Comics*, was published in September 2006 and took him on a yearlong book tour. Rounding out a trilogy, *Making Comics* trades none of the sophistication of McCloud's earlier work in framing itself as a practical guide.

Zot! 1987-1991, collecting McCloud's award-winning strip of the same name—his take on the superhero genre—appeared in 2008. While a recent press release named him "the grandfather of comics," McCloud is only fifty-two. (He did, however, go out of his way to draw himself thicker, and with graying temples, in the last installment of his trilogy.) An active proponent of webcomics, McCloud maintains an energetic online presence and lectures all over the world on his chosen form. I sat down with McCloud in the fall of 2006 in Manhattan, previous to a *Making Comics* book signing at Midtown Comics, and I later spoke

to him again by phone as he was dining with his wife and daughters at a Cracker Barrel in Springfield, Massachusetts (a circumstance which prompted polite interjections like "Excuse me, sorry, I'm stuffing my face with a biscuit," and "Hold on, I'm taking one last swig of this Dr Pepper").

NONFICTION COMICS

HILLARY CHUTE. How has the book tour been going?

SCOTT MCCLOUD. Myself, my wife Ivy, and our two daughters, Winter and Sky, aged eleven and thirteen, are driving around the country for a year. We're going to see all fifty states, doing speaking engagements and seminars all over the place.

HC. I heard one of your daughters has been giving talks on the tour.

SM. Sky has seven-minute PowerPoint presentations about the tour itself that she's already given now in several locations, including MIT.

HC. I have to ask you, are you sick of talking about comics yet?

SM. [*Laughs.*] You know, I never get sick of talking about comics. The way I keep it fresh is I always find new things to talk about. For instance, right now I'm trying to work out ideas for story structure that I only touch on in *Making Comics*. The project I'm going to embark on next is a graphic novel, and I'd like to understand better how to really make that story work.

HC. Where did you grow up?

SM. I grew up in Lexington, Massachusetts. My dad worked at Raytheon, which did a lot of military contracting at the time, and he became a chief engineer there on the missile systems division.

HC. Didn't he have a patent on the Patriot missile?

SM. He did hold a patent on at least one important aspect of the guiding system on the Patriot missile. The remarkable thing in my dad's case was the fact that he was blind. And he managed to graduate Harvard, and he went on to have this successful career up at Raytheon. I often say he was a blind genius rocket scientist inventor, which is accurate on all counts.

I had sort of a standard suburban existence, except that all of the kids in my neighborhood were artists and weird little brainiacs, so we would have all these bizarre games. The parents in the neighborhood were all scientists and engineers. I don't even know how to say this. It's hard to describe. We did little multimedia productions, and elaborate chalkboard

drawings on driveways, and we had strange rituals with Styrofoam wig heads on eight-foot bamboo poles.

HC. How did you get interested in comics?

SM. In junior high school I met a kid named Kurt Busiek, who these days is known for his own comics writing. And Kurt was into comics but had to work really hard to get me interested in comics, because I still harbored a lot of prejudice from my younger years. At the time I was reading science fiction, and was into fine art, and comics did not impress me. I thought the art looked kind of pedestrian and the writing seemed simplistic, so I didn't go near the stuff. But Kurt convinced me to try some of his comics and eventually got me hooked. By the time I was fifteen, I had set my sights on comics as a career.

All the way through high school, Kurt and I were making comics. We did this big sixty-four-page comic called *The Battle of Lexington*. It had all these Marvel superheroes beating the crap out of each other and destroying our high school and various historic landmarks in Lexington, Massachusetts. We actually finished it up in college. One of the cool things about *The Battle of Lexington* was that as the comic went on, I went from doing all these crazy, complex, semi-indecipherable panel layouts to developing a pretty straightforward storytelling style. In the beginning I was mostly just a show-off. I wanted to play with the boundaries of the medium—something that, in the end, I came back to later. But first I had to understand what basic storytelling is all about.

HC. How did you end up at DC Comics?

SM. If there had been a comics major, I would have majored in comics, but the closest I could get was illustration. This was Syracuse University. One of the courses I took was a design course, and they trained us in putting together a production portfolio. I actually sent one to DC Comics asking if they needed any production personnel, and a few weeks before school was over I got a call from the production manager there saying yes, we do need production people, and can you come down and show us your stuff. So I took a train to New York City, I showed them the stuff, got the job, and took the train back to Syracuse a little dizzy and a little wobbly and that was it—I had a job in comics. It was just a production job—all I was doing was whiting out lines that went over the panel borders and pasting in lettering corrections, but I was happy as a clam. And a year and half later, I prepared a proposal for my own comic, and by 1984 I was drawing comics professionally.

HC. You've said that you were inspired by Art Spiegelman's 1975 piece "Cracking Jokes."

SM. There were probably three things that inspired *Understanding*

1.1. From Scott McCloud, *Making Comics: Storytelling Secrets of Comics, Manga and Graphic Novels*, 160. © 2006 HarperCollins Publishers. Courtesy of HarperCollins Publishers.

Comics, at least indirectly. One of them was James Burke's TV specials for the BBC—things like *Connections* and *The Day the Universe Changed;* another was Larry Gonick's *Cartoon History of the Universe;* and another was Art Spiegelman's brilliant little essay "Cracking Jokes," which was originally in the magazine *Arcade* and later reprinted in his book *Breakdowns*, which is going to be reissued soon. "Cracking Jokes" was a wonderful nonfiction comic, and I think Art understood the potential of nonfiction better than any of his peers.

HC. Was there anything formally going on in the piece that particularly interested you, or was it just the idea of nonfiction comics?

SM. Most people, when they had embarked on nonfiction, had done so in a sort of bitter-pill fashion, where the idea was that the message was somehow uninteresting and had to be dressed up in the form of a story. Art approached the subject of "Cracking Jokes"—which is humor theory—with the assumption that the subject was in and of itself interesting, provided that it was clearly demonstrated and explained. And so he was speaking directly to the reader half the time, and every point he wanted to make he demonstrated as he went. And that's what I've tried to do with *Understanding Comics*.

BULL IN A CHINA SHOP

HC. How did you decide to write *Understanding Comics*?

SM. As soon as I started making my own comic, I began coming up with ideas for how comics worked. And as early as 1986 I had already begun to collect ideas for a comic book about comics. But it wasn't until about 1989 that things got serious. One of the things that was happening was that my notes were getting so thick—this little file folder that I had was getting so heavy that it was actually falling off those little hooks that you have in file folders.

HC. What was the reception of *Understanding Comics* like?

SM. Well, that book had a long honeymoon. I think there were probably grumblings in academia early on because I was like a bull in a china shop on topics like semiotics. I think the poststructuralists weren't that crazy about the book because I was seemingly spouting these popularized, simplified versions of theories that others had delved into with more detail and more rigorously.

But other than that, for the most part I got a big pat on the back from just about everybody and was left alone for a few years. And then eventually the grumbling got a little bit louder and a few years in, people

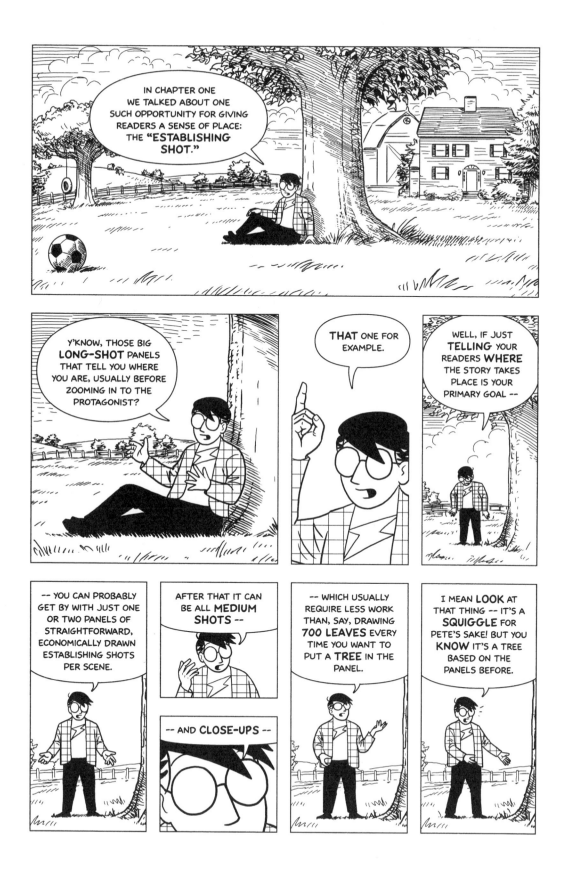

were less shy about arguing with some of the book's conclusions. And those debates have stayed at a fairly consistent murmur now for the last several years. There's a lot of unease with my definition of comics itself. There's been an unease with the whole business of classifying aspects of the art form or with experimentation for its own sake, which the book seemed to promote.

HC. Can you explain the critique from poststructuralist theory?

SM. Unfortunately, you're asking the wrong person—I'm the one who doesn't sufficiently understand it! You should get ahold of somebody who can really go point for point on why McCloud should have read Foucault a long time ago, or Roland Barthes, or many others. I've been criticized for buying into this illusion that anything can ever represent anything else—you know, the futility of representation. To say in any way that these lines on paper represent a light bulb is sheer folly! And don't I understand that? So I'm the wrong person to ask.

HC. I'm just wondering about the gist. What type of critique was it?

SM. The stuff in chapter six, "Show and Tell," about words and pictures—the separation of words and pictures and their reuniting. I think that's considered overly simplistic. My whole definition of art gets a lot of flak, although I've never heard a good alternative. But Samuel R. "Chip" Delany has a good point about the futility of definitions generally. It's the notion of the "functional description" over the idea of a definition.

Dylan Horrocks probably wrote the most interesting reaction to the book—something called "Inventing Comics." That's a terrific piece. Gary Groth [head of Fantagraphics Books and the *Comics Journal*] never took off on *Understanding Comics*—he waited for its sequel—but he's voiced displeasure about the first book and I think called it mechanistic and was annoyed by the way I seemed to want to classify everything.

HC. I remember the issue of the *Comics Journal* in June 2001 that presented the debates that were raging about *Understanding Comics*.

SM. That was the first time that I'd seen such a concerted effort to just poke and prod and dig in to the book. It was interesting to see how it could stand such a full-frontal assault. But that stuff was just delightful—I loved that.

HC. You have such a good attitude.

SM. It would be hard for anyone not to feel flattered that it merited a whole issue of the *Comics Journal*, that ten different writers were asked to try to storm the barricades and see how well the book held up. And I knew that the degree to which my ideas of what comics were became accepted was precisely the degree to which a subsequent generation would have to go in with swords drawn and try to skewer it.

HC. Did *Understanding Comics* have a place in developing the acceptance of comics as a medium and not just a genre?

SM. It's hard to say. There was this post–*Understanding Comics* thing going on in a certain sector of the comics-making community in the mid-nineties. Craig Thompson described it at one point as the "*Understanding Comics* generation." But that was a very particular slice of the pie. I mean, there are plenty of others that I think weren't influenced by it. I think many people on the web were not necessarily influenced by *Reinventing Comics*. That was a parallel thing that didn't really connect with them directly.

But I can never know who was influenced by what or to what extent. I can only point to my own influences and say, yes, this person mattered: Spiegelman mattered, [Will] Eisner mattered. Discovering European and Japanese comics mattered to me. Without those things I would have been a very different cartoonist. Or I wouldn't have been a cartoonist at all.

FUNCTIONAL DESCRIPTIONS

HC. The critic Robert Harvey stresses words and pictures together as the fundamental aspect of comics, which is very different from your conception. Can you explain your definition of comics?

SM. If, for the sake of argument, we decide there's a use to choosing a definition, then I'll stand by mine, because you have a much more interesting landscape if you look at comics as sequential art than if you look at them as a combination of words and pictures. There's a lot to be said about the ways that words and pictures interact, but there's so much promise in silence in sequential art—people like Jim Woodring have demonstrated just how beautiful that can be, how haunting. And the only thing that my definition cuts out are single-panel cartoons—single-panel newspaper cartoons like *The Far Side* or *The Family Circus*.

But what it opens up is just enormous. I'm only interested in definitions insofar as they point to possibilities. The web only got rolling in the public eye about six months after *Understanding Comics* came out. I barely mentioned computers—in fact, I don't mention computers anywhere. But I was glad in retrospect that I had framed the definition so broadly and had explicitly said that I didn't consider paper and ink to be tied to that definition. And then when there was an alternative to paper and ink, that definition was very accepting of that. We didn't have

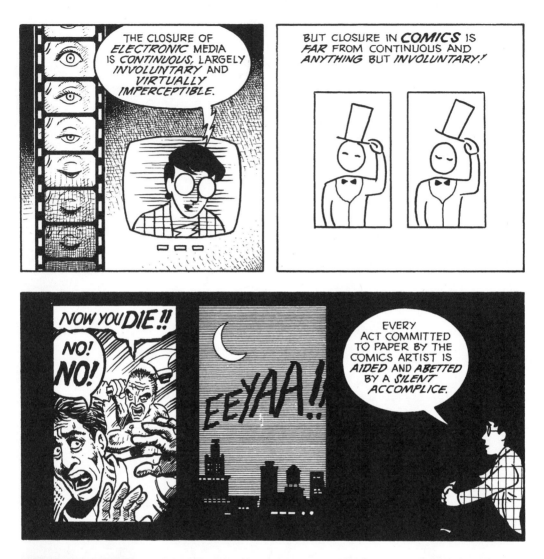

to go through those couple of years where everybody just categorically said, "Well that's not comics." I like the world of possibilities that my definition points to. I firmly believe that if you did a series of bas-relief sculptures on a wall in a museum that tell a story, then you'd be making comics—you'd just be making really interesting variations of what we think of as comics.

If you did a series of stained-glass windows telling the story of your life you'd be making comics. So if that leaves *The Family Circus* on the side of the road, so be it. I don't see that that stuff ever thought of itself as part of the family anyway. And, more importantly, it's no knock on work of that sort—single-panel work—to call it cartoons. Cartooning has a proud history. We associate it with comics because it was on the newspaper page alongside comics. But if we're going to use that as a criterion, we might as well throw in the crossword puzzle.

HC. How is the rhythm of space on a page of comics different from the rhythm of space on the page of a novel or in other media?

SM. The artist has a lot of control over what happens in the panels, but he or she is at the reader's mercy between the panels. Whereas in prose, or motion pictures, or virtually any other narrative form, you don't have that rhythm—you have more of a continuous construction going on. Like with prose, for instance, it's all of a piece; it's sort of monotextural, because the reader is continually constructing that world in his or her mind and the author is continually providing new data. Likewise with things like the persistence of vision that helps stitch movie frames together—it's a continuous process, so you don't have that back-and-forth rhythm that you do with comics.

So that's one thing. But the thing about space is that, in prose in particular, space is not terribly important. If you have a novel that runs to three hundred pages, and you decide to reprint it at a smaller trim size or at a bigger font size, that text is going to reflow however it wants, and it's still the same book. It doesn't matter. There's no reflow in comics, though. Space is vitally important, whether you're two thirds down the page or you're in a big panel at the top of the page or a little panel at the bottom of the page. That all matters. That affects the reading experience.

HC. So, in a novel, the space between chapters or on the last page of a chapter...?

SM. I think that indicates the passage of time to a degree, but I mean surely there have been editions of books in which that space was changed, modified, or even eliminated by the particular formatting choices made by the publisher. We don't consider that to be a major alteration of the book. Unless you're talking about something where there's a strong

1.2. From Scott McCloud, *Understanding Comics: The Invisible Art*, 68. ©1993, 1994 HarperCollins Publishers. Courtesy of HarperCollins Publishers.

visual component like Jonathan Safran Foer's recent book [*Extremely Loud and Incredibly Close*], where it's more like concrete poetry, where it actually has a fixed appearance and it has to appear in a certain fashion. But generally speaking, in prose it doesn't matter, and in comics it does. That lack of the option to reflow is something that I'm particularly interested in, in relation to webcomics, comics that are drawn on that expanded canvas.

HC. You used a word I found fascinating—*monotextural*—to talk about certain kinds of media. So what's the right term for comics? *Polytextural?*

SM. Or *duotextural.* In prose, it's all just been chewed down to this puree of ideas and words that just flow in a continuous fashion. I suppose you might say comics is bimodal, as opposed to monomodal. But it's just another piece of jargon we can throw at it.

HC. In your books you've talked about comics as offering a "temporal map." Can you say more about that?

SM. All comics, from *Peanuts* to *The Incredible Hulk* to *Persepolis*, are drawing a map of time. They're asking you to accept this protocol: that is, when your eye is moving across the page, it's moving from one moment to the next. That's what makes it comics. I'm interested in the fact that in printed comics—which of course is most of them—that idea that when you move through space you move through time is compromised to a degree, because adjacent moments aren't always adjacent spaces. But in all of the preprint examples of sequential art that I found, that basic idea was carried through with a lot more fidelity. That is, in pre-Colombian picture manuscripts and certain Egyptian wall painting, and things like the Bayeux Tapestry, you never really break with that idea: you stay in a single unbroken reading line from beginning to end. But we break that reading line continually with print. One of the hopes I have for digital forms of comics is that we may be able to find ways to put comics back together: back in one piece, so to speak. I've seen interesting demonstrations.

HC. One thing you've said also is that comics as a form is distinct because it can rise above the landscape of time.

SM. That's the one thing that comics has that no other form has. In every other form of narrative that I know of, past, present, and future are not shown simultaneously—you're always in the now. And the future is something you can anticipate, and the past is something you can remember. And comics is the only form in which past, present, and future are visible simultaneously. And in fact, if digital forms of comics were to allow us to put comics together in a fuller map, then that aspect and effect of comics would be amplified.

HC. Is there one example in print comics that sticks out in your mind?

SM. Just open the page of any comic, no matter how awful it is. As long as you're not looking at a two-page spread, you're looking at that principle: you're looking at panels, which, if you're reading panel two on page two, then to its left is the past, and to its right is the future. And your perception of the present moves across it. I think in *Understanding Comics* I described it as a high-pressure area in meteorology: you're pushing the warm air ahead of you and the cool air behind you.

HC. How do you see images collaborating with prose in comics?

SM. One of the eternal tensions of comics might be this dual aspiration that we have, on the one hand, to ensure that words and pictures are integrated. That they feel as if they were drawn by the same hand, feel as if they belong together—that they're flip sides to the same coin. And, on the other hand, to take advantage of the unique potential of words, and the unique potential of pictures, which often sends them in opposite directions. And that may be one of those struggles that we're always going to have, that's going to keep comics dynamic, that's going to keep cartoonists on their toes.

You could get Alex Ross to illustrate *Crime and Punishment,* and by rights you should be looking at a masterpiece if you really love that sort of artwork—or pick your favorite artist for capturing the nuances of surfaces and light. And then pick a favorite work of literature. You should be able to just slap that artwork on top of that writing, and have something wonderful. And yet it's not that simple. There has to be an integration. And you have people like Art Spiegelman writing and drawing *Maus* with a fountain pen on typing paper, trying to make sure that the whole thing had the immediacy of a diary or a journal, and there's that whole sense more of *writing with pictures* than simply showing off the surface of light. But it's not just an either-or thing. Because there is a place for beautiful surfaces and there is a place for the observation of light and form and the physical world. These things are not off-limits to comics. It's just that we have this dual allegiance to constantly tempt us.

HC. So do you think it's useful when people talk about how words and images blur together in comics?

SM. Oh, it's tremendously useful. I've never wanted to seem as if I'm downgrading the importance of comics as playing host to a seamless combination of words and images. It's very important. I give a whole chapter to it in my new book.

HC. I don't know if the idea of blurring is that appealing to me. That's why I like the idea of separate elements in a "dance," as you put it in *Understanding Comics.*

SM. I would hope that it wouldn't be a "blurring"—I like an "alternating." The dance metaphor is closer to what attracts me about that combination. The staccato rhythm of comics is really incapable, necessarily, of blurring the two. It's more like a marriage. These are two disparate entities that after a while just become one; but you can still tell where the edges of one end and the other begins: that never changes.

HC. Can you talk about pacing and the flow of comics?

SM. Pacing right now is a really interesting area because we had a kind of pacing which grew, at least in the comic book world, out of a very specific format and a specific kind of story: the superhero adventures that would last for twenty-two, twenty-four pages. The storytelling was very efficient. A lot was done in each panel. A great deal of emphasis was placed on moving the story forward. And when North American artists started creating graphic novels, they still carried with them that kind of pacing. They thought, Oh, wow, now I've got two hundred pages, I can have more, can cram more events into it. And it took a little while before people like Seth, or Chris Ware, began to show us that, no, if you have three or four hundred pages to play with, there's no reason that you can't spend two or three of those pages just showing the changing of the seasons, or water dripping on a windowsill.

HC. How does style function in comics?

SM. It sort of depends on how you define style—we're back to definitions again. There was an artist—Arnold Roth, maybe—who said that you should just pick up a pen and just start drawing. Draw anything that comes to your head. You know, porcupines and fire hydrants and nectarines. Anything at all. And just do thousands and thousands of them. And eventually you'll find that there are one or two things that all of your drawings have in common. And that's your style. You shouldn't worry about it otherwise. It's not something that needs to be concocted.

Style also, though, encompasses our worldviews: where we come from as artists, where we want to go, the sorts of things that excited us as readers, the sorts of things that we see as important, sets of concerns in the world or in art that really set us on fire. And all of that collectively, really, is just style. Generally we approach the word or the concept of style as more a series of stylistic quirks, but it's much more than that. It gets down to, really, our basic philosophy of comics. And all of that affects what lands on the page at the end of the day.

SECRET LABOR IN THE AESTHETIC DIASPORA

HC. You mention, in *Making Comics*, the idea of the "secret language of comics," which I've also seen in some of Spiegelman's stuff from the early seventies. I was wondering if you could talk a little about that, because I've actually never quite understood that phrase—I've never understood why "secret."

SM. Well, "secret" in the sense that we see the results at the end of the day, but we're not really privy as readers to all of the narrative tools that go into it. One of the first choices comics creators make is the choice of moment, and that idea of what moments to include in a story and what moments to leave out. Well, that includes a range of decisions that are made before anyone even draws the work. Nobody picks a comic up off the stands and gasps in admiration at all the unnecessary panels that were left out. You don't see that—it's secret, it's hidden—but that process does go on.

HC. I think people don't realize how much work the condensation, or the distillation, is.

SM. Right, they think in terms of drawing faces, and bodies, and costumes, and big robots. And they assume that to begin to draw a page is to take up your pencil and start to sketch. And of course it's not, because there's a great deal of work that goes on before that pencil is even touched.

HC. So it's more like the "secret *labor* of comics."

SM. Right. The secret labor, yeah.

HC. Or the "secret labor of the language of comics."

SM. Yes.

HC. What do you think about the mainstream attention that has been growing for comics as a form?

SM. There's probably going to be an equal backlash. There will be an artistic backlash, but partially it may just be a market correction. It has its benefits, and its downsides. But, you know, we survived the nineties when there was a speculator boom. And even if the fickle attention of the literati or of the general public strays in another direction, we've still got a body of work that's significant, that's well done, and should endure.

HC. What work do you like now?

SM. I like a lot of different things. I like some of the young artists that are showing up in things like the *Flight* anthologies—some of them from the web, some of them from animation. I think my favorite comic right now may be a manga-formatted comic by an artist in Nova Scotia called *Scott Pilgrim's Precious Little Life*. It looks like a neo-manga style,

but it's actually the funniest comic book on the planet right now. A lot of the younger artists I find especially interesting. It's hard to nail them all down.

HC. One thing that is so interesting in *Making Comics* is the chapter in which you describe how you actually made the book. What are the differences in how you made *Understanding Comics* and how you made *Making Comics*?

SM. Well, vast differences. I did a comp booklet of *Understanding Comics*, the same size as the printed book. I did these marker-drawn comps, complete with the word balloons and the drawings in them—rough versions of the entire book. I then made a lot of changes to those, and cut them up, rearranged them. I destroyed an entire chapter based on advice from my friends who I call my "kibitzers": people like Neil Gaiman and Kurt Busiek, my friend Jenn Manley Lee, and my wife, Ivy. I probably scrapped a good seventy pages or more. And then I went back and re-created it. And then I Xeroxed those pages to a larger size, and traced with blue pencil onto bristol board. And I had it hand-lettered by a friend. And then I went in and did the pencils and ink drawings.

With the new book, I do just rough sketches in pencils. I still do the same size comp, but it's in pencil now, and that becomes a bottom layer in Photoshop, and everything is drawn digitally from then on. Working up twenty, thirty, forty layers until I'm done. It's lettered in Illustrator, and the lettering is brought in. And that lettering acts as a window in the front through which you can see the art. And I draw the whole thing directly on my screen, on a Wacom Cintiq monitor, which is a tablet-monitor combination that allows you to draw directly on the screen. My working method is dramatically different now.

HC. Have you lost anything?

SM. I've lost the sale of the originals after the fact—I can't sell my originals because there are no originals because they don't exist.

I am the kind of artist that values the kind of control and endless ability to delete, undo, reverse, and move around that the digital realm offers me. It's not for everybody. Some are very much attached to the feel of ink on paper.

HC. Do you think that's just romantic, or do you think that's valid?

SM. I think it's a fetish, but I don't think there's anything wrong with it.

HC. Do you think it's a possibly valuable fetish?

SM. I suppose. For some people it certainly is. But we get over those things in time. I fully expect my children, when they look back, to yearn for the simpler days of their white plastic iBooks, and how pure an ex-

pression that was and how those purple, translucent, snake-necked glowing data globes that kids these days use just aren't the same.

It's an association that we find for the things that move us, but it's the images and the ideas and the words and the characters that really matter. Everything else is just window dressing.

2

Charles Burns

Charles Burns is one of today's most dramatically talented cartoonists. His comics can be funny and creepy, but they always feel trenchant, and textured, in part because he brilliantly inhabits genres like the romance, the horror story, and the detective story without simply rejecting their conventions or ironically reversing their concerns. This tension in his work seems to mirror his obsession with the relationship between external and internal states of being, surface and depth (which we recognize, say, in the theme of "teen plague" that he's returned to throughout a decades-long career). Burns gained a following in the avant-garde comics magazine *RAW* in the early eighties, and he's since published numerous book collections, including *Big Baby in Curse of the Molemen* (1986); *Hard-Boiled Defective Stories* (1988); *Skin Deep: Tales of Doomed Romance* (1992); *Modern Horror Sketchbook* (1994); *Facetasm*, with Gary Panter (1998); *Big Baby* (2000), and *Close Your Eyes* (2001). In addition to prolific illustration work, including for venues such as the *Believer*, where he has been the official cover artist since that magazine's inception in 2003, his range of projects over the years has included designing the sets for Mark Morris's restaging of *The Nutcracker* (renamed *The Hard Nut*) and contributing to MTV's Liquid Television, which created a live-action series based on his character Dog-Boy.

Burns may be most famous, however, for *Black Hole*, a twelve-issue comic-book series that made my life—and plenty of other people's—that much more interesting from 1995 to 2004. *Black Hole* takes place in Seattle in the 1970s, focusing on a group of four teenagers who all get "the bug," a fictional STD that deforms them in different ways. Rob grows a mouth—complete with teeth—on his neck; it speaks when he's sleeping. Chris sheds her skin. Keith develops tadpole-shaped bumps on his torso; Eliza sprouts a tail. *Black Hole*'s precise black-and-white images are gorgeous and frightening at once; the rich narrative is dark without being

despairing. Since the graphic-novel version appeared to acclaim in 2005, Burns has published a book of photography, *One Eye*, and completed a segment of an animated feature film called *Peur(s) du Noir [Fear(s) of the Dark]*. When I visited him at his studio in October 2007, Burns was working on the then not yet titled *X'ed Out*, the first installment in a three-part series from Pantheon that is, dizzyingly, about both punk and Tintin. The trilogy's second book, *The Hive*, was released in October 2012; Burns is currently at work on the final volume, *Sugar Skull*. Burns lives in Philadelphia with his wife, daughters, and black cat, Iggy. Not only is he a masterful draughtsman, but he also makes an excellent cup of coffee.

COVERS

HILLARY CHUTE. How did you start working for the *Believer*, any-way?

CHARLES BURNS. It was out of nowhere, just an e-mail or telephone call. From—god, who did call me?

HC. For this ongoing project, for years and years . . .

CB. Initially I thought, Oh, I'll do *a* cover. They said, "No, you'll do the cover every issue." I'm slowly learning to draw every human being in the United States. Occasionally there's a situation where there's only one blurry photograph that exists for reference, and so I've got to use a lot more of my imagination to come up with a portrait. But generally speaking there's enough information to do a fairly accurate photorepre-sentation, a photorealist cartoon.

HC. Has there ever been anyone who you've really disliked having to draw?

CB. Occasionally you have someone who you admire and respect, but maybe they're not handsome or beautiful. But there's nobody that I thought like, Oh *this* idiot. . . .

HC. "Fuck, I have to draw so-and-so. . . ."

CB. Oh, actually, that *has* happened, but I won't mention who that is.

ILLUSTRATION WORK

HC. Tell me about some of your recent commercial work.

CB. Recently I did illustrations for Cartier.

HC. The diamond jeweler?

CB. Well, I was in France. This is a campaign for a watch.

HC. Wow. You had to draw a Cartier watch.

CB. Yeah, yeah. It was an odd thing that just came in. There are people

in the commercial world who are only aware of my illustration work. And then, I would imagine, there are people who read the *Believer* who just know, "Oh, he's the guy who does the covers for the *Believer*," and have no idea that I do comics.

It's funny, I've worked for some of the most conservative magazines that you can imagine: *Time* and *Newsweek*. But it's a real wide range of things. There was that ridiculous campaign that Coca-Cola put out, this thing called "OK Soda." Did you ever hear about that?

HC. What year?

CB. It was a short-lived campaign. Ninety-four. They had myself, Dan Clowes, and one or two other artists provide images, and there were nine different cans that came out at a time . . .

HC. You didn't come up with the copy on the can, right?

CB. No. Not at all.

HC. Because I see [*leafing through illustrations*] it's really weird. "The concept of OK-ness has always existed? Think about it, but not too long?"

CB. It was test-marketed in maybe four or five cities, but it didn't do well enough. So they spent hundreds and hundreds of thousands of dollars on marketing some kind of ironic youth humor.

HC. Have you had a favorite and a least-favorite illustration project?

CB. You can never say *least favorite,* because you always want new jobs. But favorite? I did a bunch of things for Altoids. That was actually genuinely fun. As part of the ad campaign I was supposed to draw three comic strips, and I said to the art director, "Are you sure that you want me to do this? I mean, this has been OK'd?" I couldn't believe that all of it had been OK'd. There were billboards of a giant tongue sticking out with a stiletto heel poking through the tongue.

HC. It wasn't a supersanitized commercial.

CB. Yeah, very, very odd. So I didn't have to worry about: is this OK, or is that OK? I was just told, "Draw two wires electrocuting a tongue!" But out of the comic strips that I did for them, there was one that was never released. At the very, very, very last moment the head honcho in charge decided we couldn't do it. The campaign was for Altoids breath strips that are supposed to be really hot and intense—they'll burn your tongue because they're so strong. So in the comic there's a kid who's got a magnifying lens and he's burning ants, then it builds from that and he's going out and burning larger animals like a pig and a cow. And in the end, there's the big payback when he samples some Altoid strips and he's imagining a gigantic magnifying lens burning his tongue as all the animals he's tortured stand around and laugh at him.

2.1. Charles Burns's sketch from his notebook published in *Close Your Eyes* (Marseille: Le Dernier Cri, 2001), 95. Used by permission of Charles Burns.

CHILDHOOD—GENEALOGY

HC. Were you into drawing as a kid?

CB. Yeah, before I could write, I was drawing. I think a lot of it had to do with finding some way of entertaining myself. And finding some kind of internal world that I could climb into and work inside of.

HC. What was high school like?

CB. High school was like . . . there's a book I did—called *Black Hole*? [*Laughter.*] No. High school was much more benign than the way I portray it in *Black Hole*.

My family moved around a lot when I was growing up, and drawing comics was one of the things I got attention for—I may have been socially inept, but I could draw good monsters. And I would kind of force my friends to draw with me. In grade school I would force my friends to do parodies of superhero comics, and then by the time we were in junior high school, we did parodies of underground comics. And Seattle was conducive to staying in and doing artwork, because it was raining all the time . . .

HC. What work did you like?

CB. My family went to the library once a week and came back with stacks of books, including art books and collections of classic comics. My father had copies of the reprints of *Mad* when it was a comic book by Harvey Kurtzman, and I was looking at those before I could actually read and understand what the stories were all about. That had a big, big impact on me. Another thing that had a big impact was *Tintin*. In the late fifties and the early sixties an American publisher tried putting out a series of *Tintin* books, and my dad bought those for me, so I was lucky enough to grow up reading Tintin.

And then as I was growing up I'd read whatever I could find, which would include all of the major, mainstream superhero stuff. And by the time I grew disinterested in that, there were underground comics, which kind of saved me.

HC. Where did you buy them?

CB. Well, at that point even though they were supposed to be for adults, you could walk into any head shop and the guy that was selling you your hash pipe was more than happy to, you know, take your fifty cents for *Big Ass Comics* #2, which smelled like patchouli oil. You'd walk into this kind of dungeony head shop and look at their wares, and they'd have huge stacks of every underground comic available. I would always go for the Robert Crumb books. It's hard to explain what an impact his work had on me.

I was really interested in comics, but had reached a point where I was

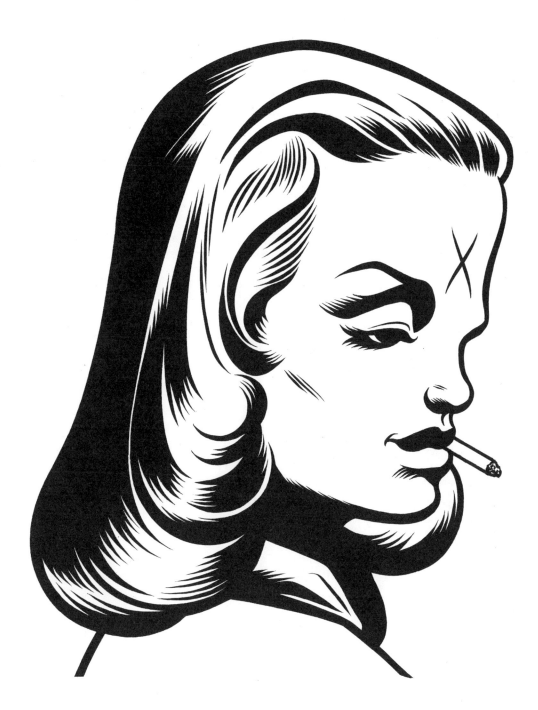

fed up with all the superhero stuff. And here was this guy who had grown up reading some of the things I just mentioned, like Harvey Kurtzman's *Mad,* and other mainstream comics, and he'd come up with something that was incredibly personal and strange, and yet harkened back to classic comics of another era.

Actually, the first thing I saw of his was a Hallmark card, because he used to work at Hallmark cards. And I remember that although it was a sweet, saccharine sort of birthday card, it was still—there was something in there that just seemed kind of strange and wrong. When I found a copy of *R. Crumb's Head Comix* at our local bookstore, I realized it was the same artist.

HC. So you always knew you wanted to do comics professionally.

CB. By the time I was in high school I was producing pieces that were not reliant on a traditional narrative at all; they were influenced by things that were in *Zap,* by Crumb and Victor Moscoso and Rick Griffin. I was trying to do pieces that looked professional—that looked like "real" comics. I would get library books about cartooning that would tell you what kind of pen and paper to use. I researched all the technical aspects of creating work for reproduction, and got the right tools and did my best to learn how to draw with India ink on illustration board.

The funny thing is I never really thought about it in terms of "professionally." I thought maybe I'd eventually get published in some underground comic or something like that, but really I was creating without an outlet.

HC. You were taking it so seriously, but it wasn't goal-oriented.

CB. It wasn't at all.

So when I was done with high school I went to college and took art classes. I had this naïve sense that I'd go to art school and something would magically happen and I would become an artist and I'd have a career. I started out at the University of Washington majoring in printmaking because that somehow seemed closer to what I was interested in than painting or sculpture or design.

In the meantime, while I was taking all of these fine-art classes, I was doing my own work on the side. I'd come home and work on comics. Every once in a while I'd bring them in to show my teachers but never got much of a response. It was never met with derision or contempt or anything like that, but they just didn't really know what to say about it.

Eventually I started getting comics published in the school paper when I was at the Evergreen State College.

HC. You went to Evergreen? I thought you went to University of Washington.

CB. Well, I went to three colleges, because I was bouncing around. I went to University of Washington, and then I went to, I think it's called Central Washington University in Ellensburg, and then I went to the Evergreen State College and was classmates with Lynda Barry and Matt Groening.

I was there for a year, maybe a year and a half, something like that. I

was working on the paper, doing comics parodies . . . [*looking through binder of college work*] Here's one I did of *The Family Circus*: it says, "Shut the fuck up, Mommy, we're trying to watch TV!"

And there was some comic I did that supposedly denigrated women . . .

HC. What was it about?

CB. An alien comes down, and he's a skeleton, a black shiny skeleton alien. It's just this ridiculous comic. So he emerges. And he's got his big giant gun that looks very phallic. It's obvious and stupid. And then it shows this girl out in some meadow, and there's a little smiling flower, and the flower has a little face, and there's a little thing that says "Sparkling good looks." And then he blasts her face off so she's a shiny skeleton that looks just like him. And then it says next to it, "Sick comic motif."

Anyway, it was taken seriously. It was a parody of that thing, that whole world. . . . But there was some letter to the editor: "Charles Burns, what horrible comics . . ."

HC. You were an art major at college, but you were never in any classes in which comics could be part of the body of your work for the class.

CB. Right.

HC. So comics was always kind of this parallel track to some other bit of art making.

CB. Exactly. It was something I was always doing. In a certain sense it was self-taught, in that I learned how to use the tools by reading books on my own. I mean, obviously there are things that I learned in school that fed into it, like photography. As far as thinking about composition—thinking about when you're composing in a rectangle—it was extremely helpful.

EARLY WORK

HC. Outside of the Evergreen paper, where did you first publish your work?

CB. I had a comic called *Mysteries of the Flesh* that was in a punk tabloid put out in the Bay Area called *Another Room*. There were a few other things before that, but not much.

HC. [*Looking through binder of Burns's early work.*] Wait. Can I turn back here? The mouth on the body . . . it's like in *Black Hole,* where the character Rob has a mouth on his neck.

CB. It's pretty clear that all this stuff has been in there from very, very early on. One of the episodes of *Mysteries of the Flesh* is about a guy who orders a pair of "X-Ray Specs" from the back of a comic book and they

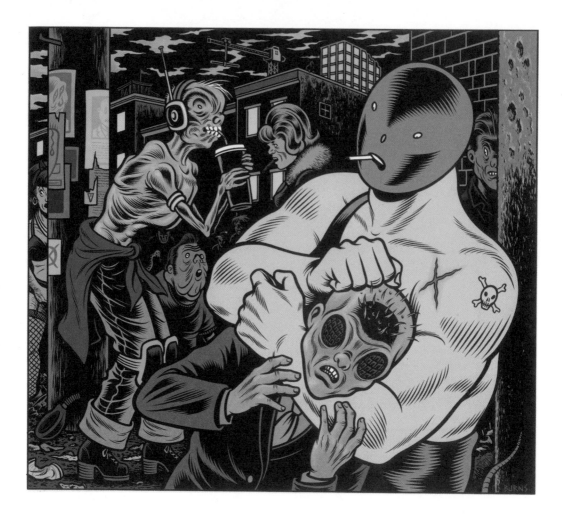

2.2. Charles Burns's color illustration (1994) of the El Borbah character. Used by permission of Charles Burns.

actually work—he can look under his skin and see more than he wants to. When his girlfriend walks in he loses it.

HC. How did you start publishing in *RAW*?

CB. I was out of school and living in Philadelphia, going up to New York, showing my little meager, sad portfolio around.

HC. Why meager and sad?

CB. It was that catch-22 where to get published, you need to be published, and at that point I just didn't have anything. So I was showing photocopies of my comics and things like that.

It was horrible. You'd call up whatever magazine and ask, "What is your portfolio day?" And you'd find the address, and there'd be a nice secretary out there: "Put your portfolio over there in the corner." And later you'd always try to figure out whether anyone had actually even touched it.

HC. Did anyone ever get back to you?

CB. At that point? No. Never. Well, actually, in Philadelphia, I got my

first commercial job, for a nursing magazine. So I did nursing illustrations.

But I was up in New York and I saw the first issue of *RAW,* and there was an address listed and the line "We're interested in submissions." So I figured out where Greene Street was and rang the doorbell. And a frenzied Art Spiegelman came to the door: "What? What? What do you want?" And he basically told me to send Xeroxes of my work, and then got back in touch with me, and we met. He was the first cartoonist I ever talked to. And he was the first person who really figured out what I was trying to achieve.

HC. And then your pieces started appearing in *RAW.*

CB. Right. In 1981 they published an abstract piece ["And I Pressed My Hand against His Face, Feeling His Thick Massive Lips, and . . ."] and *Dog-Boy.*

HC. Where else was your work published?

CB. *RAW* was the first significant place. There weren't that many places for work like mine to appear. There were mainstream comics—Marvel Comics and DC Comics—which I had never had any interest in at all. As for underground comics, there were still a few titles coming out, but hardly any of interest. There was *National Lampoon,* and they had a comics section in the back. And then there was *Heavy Metal* magazine, which republished a lot of French science fiction, fantasy, so-called adult comics, and I eventually managed to get published there. I got my character El Borbah serialized in that.

BOOKS

HC. Those El Borbah pieces were collected as your first book, right?

CB. Yes, the pieces that came out in *Heavy Metal* became a book.

HC. In terms of style, and also in terms of the content, how would you describe your work at that time?

CB. There were certain kinds of stories that I liked. I was reading a lot of romance comics, older romance comics from the forties and fifties. So "A Marriage Made in Hell," which I did for *RAW,* takes the structure of a typical romance comic and turns it on its head. But I had a genuine affection for those stories—I actually liked reading them—even though it's hard to describe why that was. It wasn't just because they were kitsch, or "so bad they're good." I liked playing with all of the romance-comic conventions, but I was also stepping back and thinking about the male and female stereotypes found in all of the stories.

I was also interested in detective stories. In my El Borbah stories I

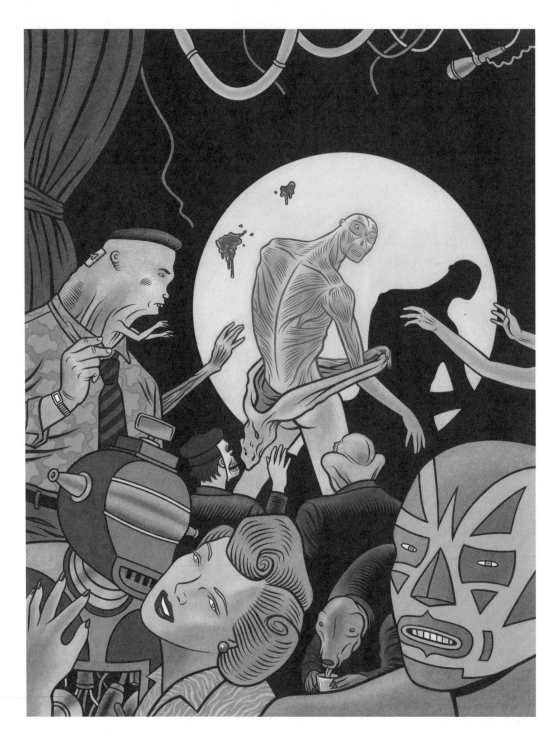

2.3. Charles Burns's
cover art for *El Vibora*
(1983), a Spanish
underground comic.
Used by permission of
Charles Burns.

came up with this ridiculous detective who pretty much solves all of his cases by accident.

HC. How did you come up with the character?

CB. I lived in central California for a while and had access to stores where migrant workers came that stocked Mexican comics and magazines, including wrestling magazines, which I loved. There were amazing costumes and ridiculous characters. One of my favorites was a masked wrestler who dressed like an executive—he had a suit and tie, and he'd arrive in the ring with his briefcase.

So I combined my love for costumed wrestlers and hard-boiled detective fiction and came up with El Borbah.

HC. What was your next book after *El Borbah*?

CB. There was a collection of little hardbound books, around thirty-two pages, which were put out by a Belgian publisher. I like thinking of a book as an object in itself, and I really loved those—a hardbound book with a cloth spine, just this nice object. I started working on a book in that series, but it didn't work out. Eventually I did a book in a similar format with Art and Françoise [Mouly] called *Big Baby*.

HC. How did you get interested in the *Big Baby* character named Tony?

CB. In a way, he's probably just a stand-in for myself as a kid growing up in the early sixties. He's a kid who's examining this very confusing adult world and trying to make sense of it and interpreting it as best he can. He's also got an overactive imagination that gets him into trouble sometimes. And he's also this little kind of mutant kid who's off in his own world.

HC. The suburbs in *Big Baby* are presented so creepily.

CB. They're a reflection of the typical American dream-home world from that time period. I lived in places that were similar to that—not typical suburbs but close enough. It was what was presented in *Better Homes and Gardens,* or whatever those magazines were, where you'd leaf through and see all the products and the food and the abundance of everything. I was always interested in that facade of the American way of life, and what was hidden behind the facade. And that's what the first story deals with: monsters on TV—the fake things on TV—and then the real monster that's living next door who's beating his wife. A kid coming to terms with made-up television horror that's kind of fun to watch, and the reality of abusive adults that's not so fun.

HC. That kind of tension is part of some of the stories in your book *Skin Deep,* too.

CB. Yes. There's a story in there called "Burn Again" that deals with a kid who has a father who brands an image of Jesus on his chest and

tries to pass it off as a miracle. God finally comes down and straightens everything out.

HC. So when did you start *Black Hole* as a continuing comic book?

CB. In the early nineties. There were a few pieces I had done before that that were similar. There was a *Big Baby* story that was in *Skin Deep* that deals with the whole idea of teenagers afflicted with some kind of disease that marks them, some kind of teen plague. And then there was a one-page piece in *RAW* that dealt with similar ideas. But actually the way that I had originally started *Black Hole* was having teenagers who die and then come back. That was the first way I was thinking about it. And the piece in *RAW* dealt with dead teenagers coming back and wandering into their parents' houses late at night and going through the motions of what their former lives were, like watching television and making sandwiches.

I have pieces from the late seventies that deal with the same kind of subject matter—some sort of disfiguration, some kind of disease that's afflicting teenagers. So that was a recurring theme that I was obviously interested in, something I hadn't fully explored. I was also at a stage in my life where I really wanted to involve myself in a much denser narrative. I realized that I had a long story to tell, and started serializing it in comic form.

BLACK HOLE

HC. Why do you think the whole disfigured-teen-with-the-veneer-of-normalcy thing has been an ongoing theme?

CB. It goes back to the idea of a facade—presenting something on the surface and then having an internal world that's different than that. Someone can look very normal on the outside and just be boiling up inside with something dark and ugly. And the idea of the teen plague is a physical manifestation of whatever is going on internally: the turmoil that's going on inside manifests itself in a way that forces the characters into a much more extreme situation.

I don't even know if it's actually true, but I've always said that I could tell a similar story without the concept of a teen plague. But for me, it was interesting. I liked being able to deal with that particular subject matter. I like the idea of a girl slipping out of her skin, or anyone slipping out of their skin. I could show you drawings I did in the early eighties of someone doing a striptease and taking his skin off. There's even a *RAW* ad I did where the character has got a skin that's stuck up on a hanger, and he is laying in bed with his raw flesh revealed. So that whole idea

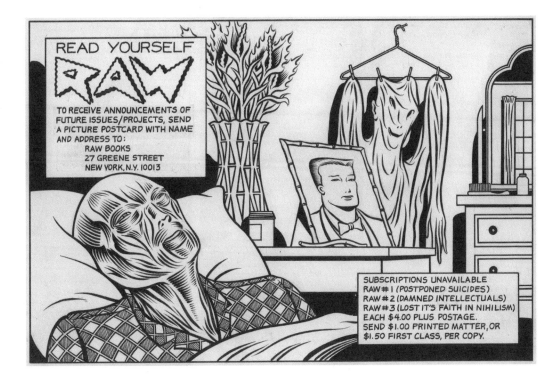

has certainly been with me a long time. I like playing with that kind of imagery, thinking about how a snake molts, slips out of its skin, and how in your life at that age you really want to reinvent yourself. I've talked to my wife about this; she moved around a lot, too, and you'd go to a new school and it was like you'd get a new chance to be a different person. Re-creating yourself: "I'm not going to wear these dopey clothes anymore. I'm gonna be . . ." whatever.

So I liked being able to play with that kind of imagery and think about how the disease manifests itself differently in different people. And the idea too that in some cases you can hide it; you can button your shirt up and pass for normal—and avoid being outed.

HC. Before, you were saying that you were interested in the normal surface and then what's going on beneath the surface as a kind of boiling, raging, or disfiguring thing. But it's kind of flipped in *Black Hole*, too, because what seems distorted is on the surface, but then a lot of those sick kids are really normal. And that's part of the real sadness of the book.

CB. Yeah, exactly. You have sick kids that just want to go home and eat dinner and watch stupid television shows—live normal, mundane lives, but they're forced into something else.

You can imagine being a teenage kid in a horrible situation and you

2.4. Charles Burns's early ad for *RAW* magazine from *RAW* #3 (1981). Used by permission of Charles Burns.

run away from home, and you're living in some place, some little tent in the woods, say, and you're scavenging enough money to survive. You can imagine that that kind of thing is possible in the real world. But on the other hand, in *Black Hole,* that is forced on some of the characters. One of the characters is sitting at school, saying, "If my parents find out I'm sick, I'll have to run away." So it's clear early on that she knows what the result would be. It's the same as some kid saying, "If my parents knew I was gay, they would kick me out" or something. "There's no way I can tell them."

HC. There are no parents in the book who accept the sickness.

CB. When I started working on the story, I had this whole plot worked out where the kids are the good guys, and the parents and teachers are the bad guys. I'm oversimplifying it, but I quickly realized I wasn't interested in telling that kind of story—I didn't want to turn it into a morality play.

And I realized that what I really wanted to do was just talk about the actual characters and their lives and not include many adults. Occasionally they're there in the background; occasionally they might present an obstacle. But at that age in my life, my parents didn't really exist either. My real concern was my internal life and my friends and what was going on there. And that's what I wanted to focus on, and not muddy the waters by dealing with the characters' relationship with their parents. I mean, it makes it very unrealistic in that sense, but on the other hand I wasn't actually interested in the parents.

HC. So you have two daughters, right? How old are they?

CB. Twenty, and my other daughter just turned eighteen.

HC. So did they read *Black Hole*?

CB. I was working on it so long. There really was this period where they would come into the studio while I was working and there were just parts that—I'm not someone who thinks, "This is dirty," you know, "sex is awful," but there are certain elements in the story that just weren't appropriate, or I didn't feel that they were appropriate for them to read or look at. You know, especially by their dad . . .

HC. The "dad" part is key . . .

CB. So I would joke about it, saying, "By the time the book comes out you'll be eighteen and you'll be able to read it." That was the joke, and that came true. My eldest daughter read it and liked it. And my youngest daughter, who is in a lot of ways much more like me, I guess, basically had the "Ewwww!" factor. She basically said, "I don't wanna read it. Because it's my *dad*." And she's the one who's interested in comics—she's got the stacks of manga. It's funny. What was great is I went to their school, and *Black Hole* was in the school library. That was good!

2.5. Charles Burns, a page from *Black Hole* (New York: Pantheon, 2005), unpaginated. Used by permission of Charles Burns.

But yeah, there were days when they would come into the studio and I would flip over the page I was working on, like, "*Yeah . . . I don't think you need to see this part.*"

HC. One of the striking things about *Black Hole* is its visual precision. To give just one example, there are the endpaper images that show all the debris and detritus on the ground. Can you explain your process and how long it took, laying down all the ink?

CB. First of all, I'm a slow, meticulous artist, and the whole process of physically making all of those marks and drawing all of those lines takes a while. Add that to the fact that I'm not creating the most popular, mainstream comic imaginable. As a result, I've always had to do illustration and advertising work as a kind of straight job in order to make ends meet. I would work for a month on illustrations and then have a month to work on my comic. I would have to buy myself some time. Ultimately, I think it was actually helpful to have all of that starting and stopping, to be able to get a little distance and then come back to it with fresh eyes.

As for the endpapers, in some cases it would take a week just to do one of those—I was literally drawing every little grain of sand and every pebble and twig.

HC. Is working at that level of detail frustrating, or is it something that you're totally comfortable with?

CB. It can be frustrating because of the time involved, but I'm comfortable doing it. Sometimes you're approaching the drawing in more abstract terms; you're thinking about shapes. You're just squinting down on the design and thinking about what you need: dark shape here, another dark shape over here—that sort of thing. So all of that has to be designed and worked out. And then sometimes I'd have to go take a walk in our neighborhood to look at the trash and debris on the ground: "OK, a plastic fork would look good in there."

HC. Can you describe your visual style? The way your pages look?

CB. There was a certain line quality that I was always really attracted to—this very thick-to-thin line that is a result of using a brush. There was just some kind of solidity to it, or a kind of richness . . . I don't know, just a feeling to it that I really liked.

So I started out trying to emulate the look of that kind of line, and took it to an extreme, I guess. Because if you compare the work that I do with the work that inspired it—more traditional comic book stuff—mine looks much tighter and much more precise in a certain way. Not more *mechanical,* but more extreme. It's also something that I arrived at slowly. In my earlier work I relied on shade patterns and cross-hatching to

2.7. Charles Burns, the endpapers from *Black Hole* #7 (Seattle: Fantagraphics, 2000), unpaginated. Used by permission of Charles Burns.

create a gray middle ground, but I gradually stripped it down to pure black and white.

I try to achieve something that's almost like a visceral effect. The quality of the lines and the density of the black take on a character of their own—it's something that has an effect on your subconscious. Those lines make you feel a certain way. That kind of surface makes you feel a certain way. That's the best way I can describe it. If you're looking at the texture of the woods in *Black Hole,* that starts to be a real element of the story, part of the character of the story. Or when Keith is in the kitchen, and he's looking into a cup that has cigarette butts floating in it … hopefully I've drawn it in a way that you'll feel his disgust, or it reflects a sense of his despair. I don't have to write "I looked down into the cup

and saw . . ." or "The room was all trashed and it made me feel crummy." I don't need to tell the story that way—that's what the artwork achieves if it's successful. Hopefully it makes you have some kind of gut reaction.

HC. You have a very distinctive style among anyone doing comics and illustration today. I've read people try to describe it. I think it can be hard.

CB. I guess so. Way back when, people said, "It's a retro fifties-sixties thing." But it's not. It's using a certain kind of line to describe light and shadow. It can be applied to something that's much more realistic, whereas I can also do something that looks much more like traditional comics.

HC. So we've been talking about the black and whiteness of *Black Hole*, but there's color in the book you're working on now.

CB. It was a real decision to want to try something in color. I have no interest in repeating myself or going back to do another version of *Black Hole*. I started telling the current story I'm working on in black and white, and I started doing it like *Black Hole* in a certain way and I just couldn't stand it. It just felt like slipping into what I already know. And I really wanted to slip into something I don't know. What I'm finding right now with color is that there's a storytelling element to it that I've never used, which is actually really fun to do. Also, part of it is that I'm doing some kind of a take on *Tintin*, and color is such a central element of *Tintin*.

NITNIT

HC. What is your new book about?

CB. I'm trying to put together my "punk" story. In a way, it's impossible to describe. It deals with William Burroughs.

HC. As a character?

CB. No . . .

HC. As a theme?

CB. We'll see. Hergé, William Burroughs . . . I'm working in a way that I haven't before in that I'm writing the story page by page, or two facing pages at time. I don't have a page count, I don't have a publisher . . . it looks like it'll be a long story.

William Burroughs was this kind of figurehead, this writer that punks embraced. So recently I've been rereading him and some ideas about cutups fit in perfectly with the story . . .

HC. You mean on a formal level, with the way your book incorporates different styles?

CB. Yes. On that level, and it's also something that the protagonist is interested in. At some point in the story he's experimenting with cutups of his own—cutting his own bad writing in with Burroughs's.

HC. Was Burroughs someone whose work you liked?

CB. He's someone whose work I read during a period in my life. And yeah, he was someone who was important to me at that stage. Some of his pieces are really, really strong, lucid pieces, and some are pretty rough to get through and pretty flat. But as an author who experimented with a lot of different formal aspects of writing, he's interesting.

HC. Does this book have a title?

CB. Not yet. *Tintin* spelled backwards is *Nitnit*. But I found out that there are two comic strips that have already used that as a title. I want at least to have a character called Nitnit, or maybe one of the punk bands is gonna be Nitnit.

HC. We've talked about Burroughs. . . . Are there other writers whose work you have particularly cared about?

CB. I'm using Burroughs specifically for this story because he really fits into that world—the punk aesthetic. But I've never been influenced by a specific writer per se. I stole a couple little pieces from Hemingway, little fragments that I used in *Black Hole*.

HC. Really?

CB. Very, very obscure, but it's in there, taken from one of his short stories. I think about Hemingway—or his stand-in—getting off the train and seeing the little black grasshoppers; they're jumping around and they're black because they had been eating the burnt foliage. And then he goes off to the hills to fish, and the grasshoppers are clean and healthy up there.

HC. Which story is it?

CB. "Big Two-Hearted River." The story's about some kid coming back from the war and trying to go back to what was his former life—trying to recapture something that was strong and good, but he's obviously—through the story, it's not explicitly told, but you can see that he's damaged internally, he's *damaged,* and you're seeing that through this very simple storytelling of him fishing. So in a certain way, that's what's going on in my new comic as well. You're seeing this kid who's in bed taking serious painkillers, starting to tell this story. And you're going to find out how he got into that position, this kid who's damaged, and looking back.

HC. Never quite able to recapture . . .

CB. Examining what he's been through, and trying to come to grips with what he's turned into. If you think about it, the ending of *Black Hole*

2.8. Charles Burns, a page from *X'ed Out*
(New York: Pantheon, 2012), unpaginated.
Used by permission of Charles Burns.

where you've got Chris who's going back out to the ocean again uses the same sort of idea—except I'm giving myself away again.

HC. No, continue, I'm deeply curious!

CB. OK, I mean, I'm just giving myself away! It's basically taking the Hemingway story that I just described, of a character returning to this place from his past, and she's doing the same thing, she's returning to the ocean. The ocean has always been this great, cathartic place for her, and she talks about it in those terms. She says: "Every time I came out here, I had this place I'd go, I'd run up the beach to this special place— my favorite place on earth but this time I can't run." She's coming back and it's clear that she's changed, but she's struggling to come to terms with that.

HC. I thought the very ending of *Black Hole* was . . . "optimistic" sounds way too bulky. To say it ends on a high note is just too basic too. But it's not a totally grim ending at all.

CB. No, I don't think so. I've had people say, "Oh, she killed herself in the end, right?" Well, I'm not going to tell you how to interpret it, but that's not how I wrote it. Because there's a sentence right near the end: "I've thought about being done with everything, but how could I?" I included that for that specific reason: she's not going out into the ocean to drown herself. There are other scenes earlier on where she's going swimming, and diving under, and thinking, I just wanna be done with everything. So the possibility is certainly there. She's turning those things over in her head, but I made it very clear that ultimately she doesn't want to kill herself. On the other hand, there's still the question of how is she gonna survive out there, how she's going to continue on . . .

HC. The book doesn't tell you. There's not an implied ending in that sense.

CB. Yes, exactly.

HC. Her attitude at that moment is surprisingly good, given the shitty situation that she's in of having the bug and being all alone.

CB. There's a situation where she's been invited to join this family for a meal, and she's really, really hungry, and she really, really wants to, but then she has this brief glimpse—a memory of the horrible situation she's just escaped from, and she just knows that she's not able to join everybody yet. But she still has enough inner strength to go out into the water—to be able to begin healing herself.

HC. And she finally buries a picture of her boyfriend, Rob. I saw that as a good thing.

CB. I mean, it is very romantic and youthful, but that's what you do at that age—you bury things, you burn things. And you ritually destroy something because you're at a turning point in your life.

HC. I missed the Hemingway references in *Black Hole* even though I love Hemingway, so I feel like I need to go back . . .

CB. It's probably good. I mean, I love the precision of Hemingway's writing, but he also has this overly romantic edge sometimes that's really revealing. It's a balancing act that sometimes he's very good at, very successful at, and sometimes he doesn't manage. But yeah, that short story's a good one. That's where he succeeds. You think about all those little black grasshoppers. That's a great, great image to think about.

3

Lynda Barry

One of America's seriously multitalented artists, Lynda Barry is the author of seventeen books. These include *Naked Ladies! Naked Ladies! Naked Ladies! Coloring Book* (1984), which offers black line-art of a deck of cards' worth of women; comics collections such as *Girls and Boys* (1981), *Down the Street* (1988), *Come Over, Come Over* (1990), and *It's So Magic* (1994); and two novels: *The Good Times Are Killing Me* (1988), a story of interracial friendship that became a successful off-Broadway play, and the gory, darkly hilarious *Cruddy* (1999) (which the *New York Times* called "a work of terrible beauty"). *The Greatest of Marlys!*—a "best of" comics volume—appeared in 2000, featuring Barry's most beloved character, a smart, spotty, bespectacled child. This was followed by the genre and form-bending *One Hundred Demons* (2002)—an "autobifictionalography" in gorgeous color, which loops through Barry's life in comics frames and meditates on themes in thickly layered collages made from everyday materials. Barry's experimental comics-and-collage "how-to" book *What It Is* (2008) was followed by the companion text *Picture This: The Near-Sighted Monkey Book* (2010). The titular character is, she explains, an alter ego of herself: "She comes over and it's like she's the kind of guest who comes a day early. When you come home from work she's wearing your clothes. She has no hesitation in drinking all your booze, but at the same time you kind of like her." Both books are based on her traveling workshop "Writing the Unthinkable," about innate and latent creativity and the relationship between images and memory.

Ernie Pook's Comeek, Barry's nationally syndicated comic strip, ran for almost thirty years; she stopped drawing it for newspapers shortly after this interview. Currently, Drawn & Quarterly is set to reissue all out-of-print titles from Barry's backlist; the first of these is *Blabber Blabber Blabber*—volume 1 of *Everything* (2011). Barry and her husband, prairie restorationist Kevin Kawula, live on a farm in Wisconsin. "We're almost

off the grid," she says. "We're like hard-core hippies. We heat with wood and cook with wood and bake our own bread and grow our own food."

I took Lynda's "Writing the Unthinkable" workshop in the summer of 2007. In early June 2008, I interviewed her over two weekend days in New York City. For the first—the morning after we both attended the "Post Bang: Comics Ten Minutes after the Big Bang!" symposium at NYU, where Lynda was the headliner—we met at Art Spiegelman and Françoise Mouly's RAW Books & Graphix office in SoHo. For the second, Lynda and I drank beer and ate eggs Benedict at 10:00 a.m. at M&G bar in the Village, where she humored me by graciously watching the French Open on television as a warm-up to talking. She is working on her third novel, *Birdis,* and teaches at the University of Wisconsin–Madison.

"THE ONLY BAD PART WAS I HAD TO BE NAKED IN ORDER TO EXPERIENCE THIS, BUT THAT WAS FINE."

HILLARY CHUTE. So you went to high school *and* college with Charles Burns [in Seattle]?

LYNDA BARRY. Mm-hmmm, but we didn't interact. I wanted to, but I was like this sort of needy gargoyle, and he honestly ran in the other direction. But he would do these murals, like when you have to go up the stairs, you know from the first floor up to the lunchroom, on the high school wall. To me he was like a—he was the best artist I had ever seen in real life, ever. I mean *ever,* and he blew my mind, and then the wildest thing is, you know the dancer Mark Morris?

HC. Yes.

LB. OK, well, I went to junior high school with him. I grew up in this neighborhood that was kind of black and Asian, and so that's where I met Mark Morris, and we were in little plays together in junior high, and he was so hilarious because he—like during fire drills he would pick me up and carry me out, yelling "smoke inhalation victim!" Anyway what was really cool was I transferred out of that school and went to the school where Charles was, because I'm part Filipino, so I was like the Filipino transfer student. Mostly because the [other] school I was in was really violent. I mean people were getting their arms broken, and cut, and beat up and . . . the main thing that they would do to girls was push them up against a wall and if you had long hair they would grab you and just cut a big thing of your hair, so you had just a big old bald spot. Anyway, I wanted to get out of there, and so I went to Roosevelt. That's where Charles was and what was wild was when Mark and Charles got together to do *The Hard Nut* [a restaging of *The Nutcracker*].

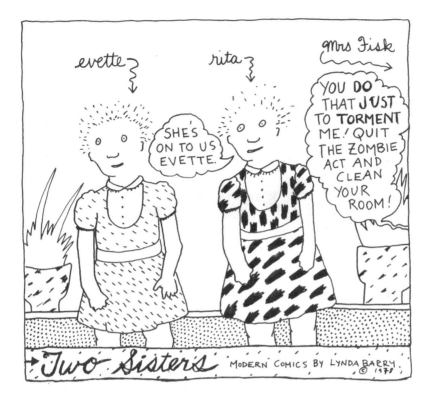

3.1. Lynda Barry, a panel from *Two Sisters* (1978), unpaginated. Used by permission of Lynda Barry.

HC. When did you know you wanted to be an artist?

LB. I liked drawing, but in my house it wasn't anything that was of any value to anybody. And I liked reading and I loved stories, but I didn't love reading and stories and drawing in that way in which you hear people talk about their past, you know? You get this feeling like there was this moment when they *knew*.

I always had an impression of myself that I just wasn't quite doing it right. Even when I went into the library, I didn't care what book I grabbed. I never feel like how a lot of writers do when they talk about their relationship with the book. It was just like classifieds ads were the same to me as anything in the library. And so when I got to college I tried really hard to be smart, smart, smart in that traditional way of being smart. And I remember I would be in these seminars and I saw people that had highlighters. You know I didn't know any of it, so I'd see that they read their books with highlighters, so then I'd read my book with a highlighter, and we'd sit down for a seminar and it would turn out that over and over again the *one* paragraph everyone had highlighted would be the one that was not highlighted [in my book]. But I was trying; I studied the history of science and the history of the Renaissance, and the way that things were at the Evergreen State College, the idea was that you studied one subject intensively.

And I was really broke and I was sitting in the lunchroom trying to figure out how I was going to stay in college, because I put myself through college, and one of the art teachers came in. I felt like I could already draw, so I shouldn't spend money on taking drawing and art classes. And so he came in and he was all flipped out and I remember exactly: I was sitting there and I was drinking this cup of coffee and just, you know, drinking more coffee and he said, "You model, right?" And I went, "Yeah!" Because I had a friend who did life-drawing modeling and I knew they got paid four bucks an hour, which was a lot of money for me then. I had never done it, but I had seen life-drawing classes. And so he says, "You model? 'Cause my model just flaked out on me and I got a class. Will you come and model?" and I'm like, "Sure!" I'm following him with my heart pounding: "I'm about to go in this room. I'm gonna take off all my clothes. . . ." And the nude modeling I had seen was in *Playboy*, right?

HC. Yeah . . .

LB. So I do it, just like, "Yes, I do this all the time!" I took off all my clothes and I climbed up on this table and he goes, "We're gonna do short poses," and I go, "OK," and so he goes, "Change," and I was doing all these *Playboy* poses, because I didn't know how else [to pose] when you're naked. And I remember him saying, "Could you make it a little less dramatic?" And so then I became this life-drawing model, and I really appreciated the income. It turns out I love holding poses. I can hold still for a really long time. Well, it's that thing I had when I was a kid.

HC. To make yourself sort of doll-like.

LB. It turned out that I knew exactly how to do it, and I loved holding very still and being in a room where people were drawing and I could watch people drawing. It was heavenly to me. The only bad part was I had to be naked in order to experience this, but that was fine. I was cool with it. But when I was modeling for Marilyn Frasca's class, I would notice that there was a whole other thing going on in the room. Marilyn would go to each person and just stand with them while they were drawing and then they would at some point look at her, and she'd go, *"Good."* That's all she'd say, and she'd let whatever was happening happen. And while I was sitting there, I started to get fascinated with this teacher, and then one day I was modeling and I just started crying because I realized I didn't want to be on the table. I wanted to be in her class.

And that next year she was teaching a class called "Images," and there were a lot of people who wanted to get into it and she let me be in it. And once I got into her class, that changed everything, because it's the class ["Writing the Unthinkable"] that you took. It's the class that *What It Is* is based on. That very idea that writing and painting and all of these things we call the arts are the same thing, that they come out of something that's

lively. I mean even, even if you think of Art Spiegelman's—if you think of *Maus,* those characters there. You can ask those same questions. You can say, you know, are they alive? Are those characters . . . is that . . . ? Are those characters alive? Well, they're not alive in the way we are, but are they dead? Hell no.

Check this out. We did have critiques, but the critiques were that you'd come and they'd put the work on the wall. We just had to sit and look at it.

HC. And not say anything?

LB. Didn't say anything, and so what you did was you learned to look. And so this idea that the work happens anyway was this revelation. I studied with her for that one year in "Images," and then the next year I had an individual contract with Marilyn and just studied with her. I did

3.2. Lynda Barry, a sketch from her college years, c. 1976. Used by permission of Lynda Barry.

start making comic strips mostly to make my friend Connie laugh, but I knew very much about R. Crumb. I was crazy about R. Crumb when I was in junior high school. I was in seventh grade when I found my first *Zap,* but I think I had a completely different experience than a lot of guys did, because the drawings of the sex stuff with the ladies really scared the hell out of me. I copied and copied and copied and copied and copied and then I would try to find those collections, but if S. Clay Wilson or those guys were in it, they would totally freak me out, because I was looking for, like, the kids' version, you know?

When I saw *Zap* I got that upsetness, that scrambled feeling, but Crumb had this thing. It was a comic strip called *Meatball,* and it was just one of his silly comic strips, but it would have little details. You know, there was this regular story going on, but in the background I remember he had this store and there was stuff for sale and there was a little tiny sign and it said, MEN FROM MARS 25 CENTS or something. I remember looking at it, and I had always liked comics and I had always copied them, and I realized you could draw *anything.* What R. Crumb gave me was this feeling that you could draw anything. But it was really hard-core because the sex stuff was very frightening.

When I look at Crumb . . . Well, let's just turn to *Cruddy,* my second novel. *Cruddy* has murder galore. It's, like, you know, it's murder fiesta, and lots of knives and killing.

HC. It's great.

LB. So does that mean that I'm a person who thinks about murder? Well, yes, as a matter of fact, I do think about murder constantly. Actually, when I'm talking to people who are driving me crazy, I often imagine they have an ax in their forehead while they're talking to me. I know that that's my personal relationship with murder and knives and blood. It doesn't mean that I need to go do that.

"I HAD THIS SERIES THAT WAS BASICALLY WOMEN TALKING TO MEN IN THE BAR, BUT THE MEN WERE GIANT CACTUSES, AND THE WOMEN WERE TRYING TO DECIDE IF THEY SHOULD SLEEP WITH THEM OR NOT."

HC. Where were your first comics printed?

LB. I had, I guess you could say, comic strips printed in my little high school paper. I did a lot of graphics for stuff, but it was in college, when I had two friends. . . . Matt Groening was our editor at the Evergreen State College, and then I had a good friend named John Keister who was the editor at the University of Washington paper in the summer, and he

was a pretty far-out editor. It's funny: Matt and John were my two best male friends. They had the same birthday. Neither of them believed in astrology.

So they were both in charge of newspapers at the same time, and I would just send crazy little comics that didn't make any sense to both of them. I would just drop them off in the mailbox to Matt. Matt fascinated me. Because he seemed so straight, but really he just loved to do anything that would piss off whatever the majority was, and at that time it happened to be hippies. If you look at his work, that's what his work still is about. I mean, even with however *The Simpsons* giant fungus has morphed, you know? Even with all these writers working on it, it's still about challenging the majority, and people in power. Matt's always done that.

I love to just make him crazy. We've always had this kind of antagonistic relationship. We had this period where we were interviewed about each other. It was before *The Simpsons* and we were both doing these cartoons. We would tell big lies about each other, like I always loved to say that Matt was really into Joan Baez, was heavily into folk music, and he lived in a yurt at Evergreen, and I would just talk about how he was really into organic food, and, you know, total bullshit. And if you look at his calendars, when he does a calendar, he always puts my birthday, but he always puts it as though I was born in '65. I was born in '56, right? So we still do that with each other. But he was really important. He printed my first stuff, and my friend John did, too, but it wasn't just that. Matt also was a cartoonist, and my friendship with him, I think, had everything to do with—along with Marilyn—why I kept drawing. One of the things about Matt is Matt really supports people who make comics. He's behind them.

I'm somebody who won't do blurbs for books at all, mostly because I have students and I mostly like to say, "Good." Matt will do them for anybody. If you can get ahold of him.... Really, you really could smash a plate of spaghetti in between two covers, and then hand it to Matt and say, "Could you write a blurb," and he would, and he would make it sound really good, and he would mean it, you know?

HC. So then what happened after he was printing your stuff, and John Keister was printing your stuff? How did it turn into a career?

LB. So then I had some comics, and I had started this little series. I think they were called *Spinal Comics,* and I was going through a bad breakup and so I had this series that was basically women talking to men in the bar, but the men were giant cactuses, and the women were trying to decide if they should sleep with them or not. It was just the same joke, over and over again ...

HC. But it's a good one!

LB. They would be, like, saguaro cactuses with a bunch of cigarettes and beers and they'd be talking to them and saying all these sweet things to them and the women would be, "You know, maybe this could work. Maybe I could sleep with this guy."

Anyhow, after I graduated from college and I moved back home to Seattle, the alternative papers had just started up, and so there was one called the *Seattle Sun*. And I think this is the true story of how people get published. I decided I was going to go in and submit my work to see if they would print it, and so I went, and like a lot of alternative places, it was in an old, gnarly house, and there were people working for no money there, and there was some woman who was in charge. She didn't happen to be there when I dropped off my work, so I just dropped it off, and I live, like, two blocks away, and I put down the phone number. I got home. The phone's ringing, and it's her: "I'd like you to come in and talk to me about these comics," and I said, "OK!" But there was something—it was weird because there was something about the way she said it that didn't sound like she was really happy about them. So I go in and I come upstairs and she read me the riot act. She said they were the most racist comics she had ever read, and I was looking at her like, "Racist?" And she thought I was making fun of Mexicans.

HC. Because of the cactuses?

LB. Exactly. I mean, you know, that's how I was, with giant question marks over my head: "What?" Something about Mexicans and women, and Mexicans and white women, and, I mean, she really was crazy. The comics had nothing to do with Mexicans, or white women, so as I was going down the stairs I hear these feet behind me and there was this dude, and he ran the back page and he hated her, and he said, "What was she just yelling at you about?" and I said, "She hates my comics," and he took me and he said, "I'll print them," and he printed them just to make her crazy. He didn't even read them.

HC. This is so funny.

LB. This is how it really happens. So that newspaper was part of the Newspaper Association of America, which was all these alternative papers who decided, "Hey, there's a bunch of us, let's—" I'm sure they all got together so that they would have a reason to have a convention and have a party, you know? And so they started sending their papers, one to the other.

And at this same time Matt had moved down to Los Angeles, and he was working at a copy shop. That's how he started making his *Life in Hell* comics. He could just make copies, and then he would send us copies of his stuff, but it wasn't ever intended to sell or anything. And he got a job at the *LA Reader*, and he had to write and he was a good writer, and he

wrote some article about . . . what was it called? "Neat" or "Dumb." I can't remember, but it was all about how lame stuff is actually cool. It was a revolutionary article, and he mentioned me in it, but like I was *someone* . . .

HC. As something lame that was actually cool?

LB. Yeah, but also he acted like I was a cartoonist of some kind of standing, which was just bullshit, but *he* was, and I was his friend. And then a guy named Robert Roth, who's a wonderful guy who ran the *Chicago Reader,* saw it and then called me, and they paid eighty dollars a month. They still pay eighty dollars a month, but at that time my apartment was ninety-nine dollars a month, and so when I got in that paper for eighty dollars a month, I was self-sufficient. I could quit my job as a popcorn girl at the movie theater, and I could just concentrate on my work.

HC. This is in Seattle?

LB. In Seattle. Yeah, I lived above a key shop; it was ninety-nine dollars a month. At the same time, whenever I was in a paper, I started pitching Matt's work, so as soon as they'd have me, I'd say, "There's this other cartoonist," and I'd send them *Life in Hell,* which was fantastic—I still love it. Whenever Matt or I got into a paper we would pitch the other person, and that's how we did it.

And then Matt knew ["King of Punk Art" painter, cartoonist, and designer] Gary Panter. So when I would come down to see Matt in LA, I would go visit with Gary, and Gary was beyond ahead of the pack. I mean, you didn't even know that you were in a race or on a racetrack or that you were a horse.

And so through those guys, that's how I ended up doing stuff. Not so much that I would have stopped, but between Matt's relationship with Gary and Gary's far-outness . . . Gary would have all these ideas and when I'd see him I'd see all these ideas, but also he'd give them to Matt, and then Matt would always report back on what Gary was doing, so between those two guys, Gary kind of through Matt, and Matt, I had a lot of support for what I was doing.

Those guys were essential also in the fact that there was an alternative comics market, besides the *Village Voice.* The *Village Voice* had it, you know; they had Mark Alan Stamaty. You know [at NYU yesterday] when they talked about the canon of American work? Stamaty should be in it. That guy, or Stan Mack or Jules Feiffer. You know when people talk about the way my dialogue is? I learned it from him. Stan Mack taught me to listen to how people really speak. In a weird way, when people always talk about the history of comics, they leapfrog over the people who are, to me, the main guys. Mary K. Brown, do you know her stuff?

HC. Not very well.

LB. She was a huge influence on me. And so there are all these car-

¡BEEG MR ERNIE POOK'S CÖMEEKS!
BY MR. LYNDA BARRY AN ORDINARY GIRL LIKE YOU

Dog vs. Cactus

GRRRR RR R RRRR GRR GRR GRRR R R

who will win?!?

3.3. Lynda Barry, a panel from *Ernie Pook's Comeek*, c. 1978. Used by permission of Lynda Barry.

toonists who aren't even acknowledged or mentioned and it blows my mind. Well, when they kicked Stan Mack out of the *Voice*, it was this scary moment and that really was the beginning of the toppling. I was living in New York at the time and I wrote a letter to the *Voice* saying I can't believe they did that, and I was in the *Voice*, and I said I know my head's on the chopping block, and I signed it gobble gobble, you know, and sure enough . . .

HC. And then they canned you too?

LB. Yep. I looked at the *Voice* yesterday, and I felt sick. I mean I felt sick to my stomach. I thought, OK, the name of the paper's still there.

HC. It is nothing even like it was in the nineties, which is nothing like it was in the eighties . . .

LB. But that's happened in almost all alternative papers. I was in sixty papers at one point.

HC. What period was that?

LB. It probably would have been the very end of the eighties, the very early nineties. There was a brief period where I was making a living, and I didn't have to flip out. I mean I was probably making as much as a really good dental hygienist, you know? But without ever having to go to dental hygienic school.

HC. Yes, or put your hands in people's mouths.

LB. And now it's hand to mouth again, but that's all right, because now my husband and I have the secret to life which is low overhead and no debt.

HC. So how many papers is the strip in now?

LB. I think five or six, if that. Yeah, it's just in very few. My prediction is that in the next two years, it won't be in any.

HC. Wow, bummer.

LB. In a way a bummer, and here's the other thing though. Once it's not in the papers, then I feel like I'll be able to really write it again.

So two things happened. First, I did this one series that got me kicked out of a lot of papers. It was called *The Monsters*. I was always used to being able to write whatever I wanted, and when I did these strips I just got—I mean, hate mail.

HC. Can you describe it?

LB. The strips were about personality types that are monsters. For instance, I'd be behind two people in a lunch line and one would reach for a dessert, and the other would say, "Are you sure that's the one you want?" I call that the doubt monster. The person wouldn't know all of a sudden. It's these unconscious things that people do to each other all the time. Just the little things that somebody will say . . . and they don't even know that they're kind of scrambling the other person, and sometimes they do know they're scrambling the other person, so I got interested in how people scramble each other. And I started making these monsters and what's weird is there's a doll now, these Ugly Dolls. They're exactly like the monsters that I did. Sometimes my monsters had missing limbs, and they looked a lot like my cactuses, actually. And then they had lots of hair on them. Some of them smelled bad.

And so it was this whole, long series, and shrinks really liked this series. I've run into people who are shrinks and they tell me that they were able to clip them out and give them to their patients. I also had people send me comic strips where they would take the comic strip and white out all the words, and then write, "We don't need psychological counseling from a stupid comic strip."

HC. That's so interesting: not indifference, but a violent response.

LB. Violent, violent response, and so I lost like half my papers, and I was already losing papers like crazy. Big companies started buying all the papers, so as soon as I would hear that a paper was purchased, I knew that I was going to be kicked out, and it happened.

What's weird is you'd be in a paper for . . . I was in a paper for like twenty-five years and then you don't even get a letter. The way I found out with the *Phoenix New Times* I wasn't in that paper anymore is I got a letter from somebody who liked my work, who said they called the *New Times*

to figure out where my strip was and they were told that my strip had been "euthanized." It's not just goodbye, thank you, you've been with us. It's like they're mean. *Euthanize*. I mean I still carry that around with me.

HC. That sounds like getting punched in the stomach.

LB. Yeah, that's what it felt like to me. So that occupation doesn't exist anymore. It does for a few people. Tom Tomorrow is somehow able to do it. For some reason he's where nobody else can stay.

"I WOULD MUCH RATHER BE IN THE YOUNG ADULT SECTION THAN IN THE, YOU KNOW, 'GRAPHIC NOVELS' SECTION."

HC. Tell me about when your first book got published. So you started being in papers, and then?

LB. Well, I actually had this book before the *Girls and Boys* book, but I published it myself.

HC. Wow, you have sixteen titles!

LB. If it counts. It was one that I did myself, and I just did it in Xeroxes. I had this series called *Two Sisters,* and it was twin girls named Rita and Evette, and people loved the hell out of that strip.

This was way, way, way back, and Rita and Evette were really popular and they were funny and copy shops had just come out, so I did a thing where I just copied the whole collection. I put it in a manila envelope and I hand-decorated the top, and I sold them for ten dollars. You know, so you just get a manila envelope and you pull it out and there'd be all the comic strips.

HC. And so it just sold by word of mouth?

LB. Yeah, or I'd actually write it in my comic strip. I'd put it on the side. If you'd like to buy something, call me on the phone. Then I'd take orders, and I'd go to the copy shop, and they'd copy them, and then I'd put them in and make the whole thing. But then after a while I couldn't draw Rita and Evette anymore. Partly it was because people really liked them and then the strip kind of just ended because sometimes they do.

HC. What was the deal with them?

LB. They were twins, and their mom didn't get them. They were odd kids, who the world kind of didn't understand. When that ended, I started doing the first strips that you see in *Girls and Boys*. That very first one, if you see it, I think it's the kids who are left at home, and a kid's jumping on the couch and saying, you know, "When mom comes home you're going to get in trouble," and the other kid says, "Mom's never coming home. She's going to marry a bum." So that was the first stuff that I did and the drawing was really kind of gnarly, too. It was really rough, compared to

Rita and Evette, which is very sort of sweet. It's not *sweet* sweet drawing, but it's sweeter.

HC. It's rounder?

LB. It's rounder. It's more really light lines. It's more, you know, like there are really decorative parts, but then *Girls and Boys* was more . . . at the time, I started being called a punk cartoonist, you know? People called it punk art. It went: underground, then funk, then punk, then new wave, then alternative, and then, then, then . . . art. I guess "graphic novels," graphic something, and then "art comics," people call them, art comics. So I started doing these comics that had trouble in them, and people were very upset and I wasn't in many papers at that time. People were very upset, because there weren't many comic strips that had a lot of trouble, that weren't funny, you know? The setup for a comic strip is four panels and that last thing should be a punch line, so when people didn't get that punch line they became very upset and they would write furious letters to the editor about how there's nothing funny about child abuse, and it's like the strip wasn't funny, it was sad. You know how my strips can be really sad?

HC. Yeah.

LB. And so there was this big trouble and at the same time I started making little comic versions. Now, you know, people make little mini-comics all the time. I would take my comics after I printed them or after they were reduced for the newspaper, and then I'd Xerox them from the newspaper, and I would make these little tiny comics and I sent them in to Printed Matter. It was a place where they sold artist-made books. It's pretty famous in New York. It was the first zine printer. I sent them some comics, and it was right when I was getting the worst—people just hated what I was doing—

HC. Because of . . .

LB. The darkness. Whoever it was at Printed Matter wrote me back this note saying, "I really like what you're doing." You know, "We'll buy." I was selling for fifty cents each, and so, I think they bought them for twenty-five cents, you know, and "We'll buy, like, a hundred of them," or something. And that little letter from whoever it was that wrote completely changed everything for me, because I thought comics were a way that you could write about really sad things, and write about long stories, but there wasn't anybody doing it. You know what I mean? So whoever it was at Printed Matter—I don't think I still have the letter; I may—changed everything for me, because they got it, and I thought, OK, well, somebody else is getting this.

HC. What year was that?

LB. It would have been the very late seventies. Because if *Girls and*

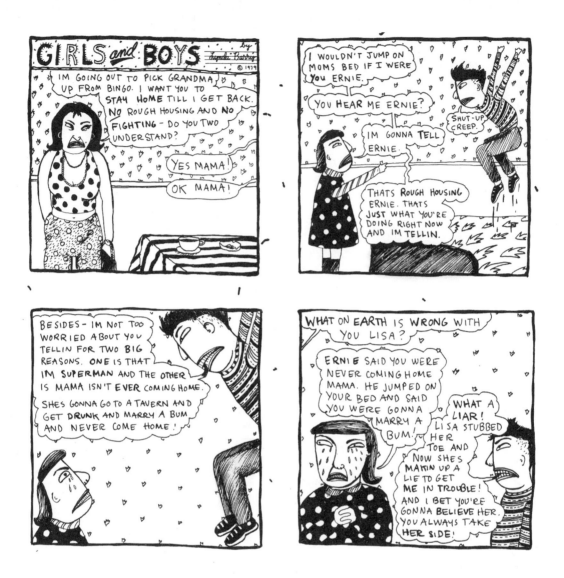

3.4. Lynda Barry, a
story from *Girls and
Boys* (Seattle: Real
Comet Press, 1981).
Used by permission of
Lynda Barry.

Boys was published in '81, it probably would have been '79, or 1980. And then the work in the newspapers, somehow people started to actually start to like it, once they understood that I wasn't making fun of the situation, but that a comic strip could contain something sad, like a song. And I realized I could discuss anything in the comics.

HC. I was surprised that some of your early books are in a YA section or got a YA label. I think, OK, so what happens in this scene? OK, someone's getting raped at this party, or whatever, and that always puzzled me.

LB. Yeah, but it's very nice for me, because I feel like I could have found it that way. It's also on the list for reluctant readers. *One Hundred Demons* is heavy. I mean, *One Hundred Demons* has some crazy, like . . .

HC. All of your work is heavy.

LB. So people say when they buy it, "This is for my son." I always say,

"How old?" "He's seven; he loves comics." "Well, just to let you know, there's incest and suicide, and drug-taking. There's, like, everything's in there." "Oh, he's very mature for his age." "All right." Because kids, they do what I did when I looked at the S. Clay Wilson, which is usually, you just make it disappear. Or, if you have a reason to go to it, you look at it for as much as you can stand and then you look away.

But I would much rather be in the young adult section than in the, you know, "graphic novels" section. In a minute. If somebody gave me a choice I would so much rather be in a place where people don't feel this pressure . . .

HC. So after you appeared at Printed Matter, you started publishing books.

LB. I did, and a bunch of other people did, too. I feel like Matt Groening's *Life in Hell* stuff is totally disregarded. We were publishing books at the same time, but his stuff was *hugely* popular. We'd do book signings together, and he'd have a line around the block, and I would be sitting next to him and somebody would come up and say to me, "Where's the militaria section?"

HC. Maybe I'm thin-skinned, but that sounds so crushing to me.

LB. It wasn't at all, because Matt's stuff and my stuff was really different, and if you're gonna have a book that's very clever and really funny and talking about people's difficult situation at work, or you're going to have a book that's about horrible things that happen in childhood, there's gonna be one that has a long line, and another one that has a shorter line. You know, it's like he was selling really full dinners and I was selling condiments. It didn't crush me at all. Not even a little bit.

HC. How did you get into this thing that you do that I think that nobody else does in the same way, which is this writing with casts of characters that include a lot of kids?

LB. It surely wasn't through the thinking process. They just sort of appeared. But I don't know how I came up with those characters, especially because it's so unlike the way I grew up. You know, with no sisters, for example. I don't know how characters come. In fact, it's one of those questions that's in *What It Is* because what I liked about *What It Is* is that I could ask questions that I didn't know the answers to.

HC. Yes, the book has a questioning mode.

LB. Where do characters come from? I have no idea. I think they come from messing around. One of the most amazing things that I ever saw was two guys who were, like, street-theater dudes, who would do scenes from Shakespeare using garbage that was just laying on the street. "Hey, we're gonna make this . . . it's the Globe Theatre," and they would really, literally pick up a cigarette butt, and a bottle cap, and then move them,

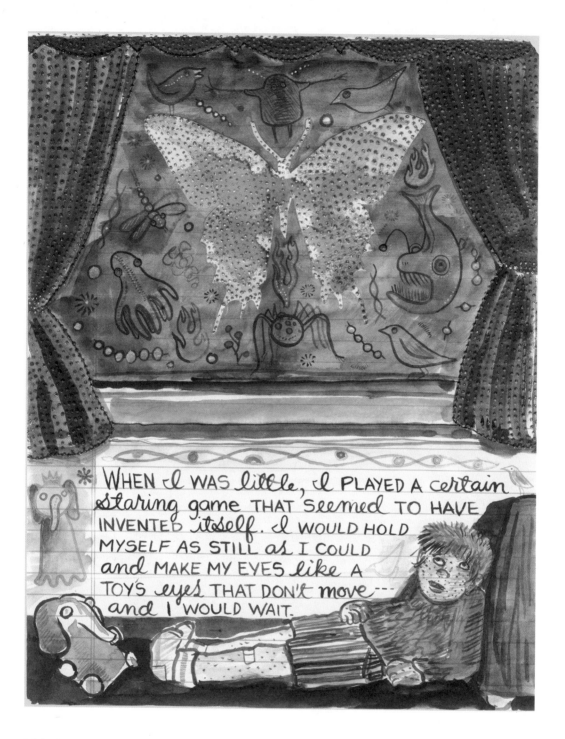

3.5. Lynda Barry, *What It Is* (Montreal: Drawn & Quarterly, 2008), 9. Used by permission of Lynda Barry.

and talk, do the Shakespeare, and you would watch them, like they really were Romeo and Juliet. There's something about human beings where they make characters really, really easy. When I was kid I was always disturbed by seeing shoes, like these tennis shoes here I'm wearing, without a foot in them, because I could see the mouth screaming. And part of my reason that I had trouble with math was that 3 always looked like it was screaming, and 5 looked like it was screaming. 3 could not be facing 5. 53—that looks like fighting to me. It terrifies me. 35's fine, because then the 5 and the 3 can't see each other. But so I had all those things from when I was kid—I guess it's animating stuff. Things become animated or I feel like I can look at anything and kind of know where I put the eyes on it.

"WEAR THESE AND YOU WILL TEAR THE PARTY UP!"

HC. I think one of the things that's so striking about your work is the way the characters talk.

LB. I am really interested in language, but not the conscious part. The thing to remember if you think about my work is that I never pencil, and I never know what the next line's gonna be, and so my whole thing is I draw until I actually hear it in my head.

HC. It doesn't feel *written* in the sense of "someone is trying to write like this." It feels like a real spoken thing.

LB. For some reason I feel compelled to repeat things that I hear people say. I remember walking through a clothing store and this man was shopping with this girlfriend or some woman, and he was like, "*Dolores! Dolores!*" and he held these pants, and he held them up, and he goes, "Wear these and you will tear the party *up!*" And I would always have to say, "Wear these and you will tear the party *up!*" 'Cause it's like, there's a singing to it.

HC. There's a heard inflection in your writing, which I think is a really amazing thing to be able to convey.

LB. And then again if I want to *think* about it: what could it be? And it's just guessing: I grew up in a bilingual family, but where the language that the adults spoke was never taught to the children. All my cousins and I, we know certain words in Tagalog and we understand certain things, but they didn't teach it to us.

HC. You just picked it up.

LB. Yeah, but I don't speak Tagalog and I don't understand all of it. It's sort of like this: "[*Mumbling*] hairbrush [*mumbling*] go to the store [*mumbling*]." That's what it sounds like to me, you know. So I think I might have had an interest in language. I know that I went from being

in Richland Center, Wisconsin, where my mom was the odd person with a heavy Filipino accent, and we left when I was four and then we moved to a house in Seattle that had . . . I don't know. There was a varying number of families, but it was an enormous number of families, like anywhere from four to eight families living in one house, 'cause they were all coming over from the Philippines, and then it went to my dad was the only one who was speaking English. So I went from a thing where everybody was speaking [*with a Wisconsin accent*] "not just English but, you know, Wisconsin," all the way to Seattle, where my dad was the only white guy, and then me and my brother who was just born, and everybody was speaking Tagalog. When that house fell apart and everybody had to scramble to find a place, we moved to a black neighborhood, which has its own accent thing going, and then it was also black and it was Asian. It was Chinese and Japanese and I . . .

HC. But not very Filipino?

LB. There were lots of Filipinos, too. I think I heard a big range of how language was spoken when I was a kid, but is that the reason? I don't know for sure, but I know that I am compelled to write down what people say and also repeat it over and over in my head.

HC. I saw a photo of you in an art exhibit by Kip Fulbeck [*part asian, 100% hapa*] with handwritten text that said, "People can't believe I'm Filipina but then I tell them I'm also Norwegian, and Norwegian blood can suck the color out of anything." Were a lot of people mixed in your neighborhood, or high school?

LB. It was kind of the poorest part of town, so anybody could buy a place, and we oddly had so many mixed families, like crazy mixes, like Japanese and Mexican, or there were a lot of black and white families. There was one lady from Germany and a black husband. A lot of military things. Japanese and white. I mean it was really interesting. In the Filipino side of my family, my mom's the only one who married someone white, so my brothers and I look just like we look, and all my cousins and everyone else looks very Filipino, and the difference this makes is unbelievable. I mean I know this is a get in through the door free anytime you want. I mean it's unbelievable to have this skin, and then to grow up in this whole other way.

My brothers and I have talked about it. My brother Mark, my youngest brother, only grew up with the Filipino side of the family. He didn't know Wisconsin. He was actually born in Seattle. He didn't know my dad very well. And when my dad left, my mom did that thing of just destroying all the photos, destroying everything, so everything's gone. There are no pictures. There's nothing, but one of my uncles, a Filipino guy, my Uncle Boy—Uncle George—he had managed to save a little film, a little Super-8

or whatever it was, home movie, so that my mom didn't destroy it. And one day I went over to his place and he had copied it onto videotape, and he showed it to my brothers and me. Of course we were just blown away, because it showed pictures of Wisconsin. It showed our relatives and Michael and I are looking at it like, "That's our childhood," and my brother Mark, who looks just like me, said, "I knew I was white. I knew it. I knew I was white," and it was just like this thing where I looked at him and I said, "I know just what you're talking about."

HC. Was your dad in the Super-8 film?

LB. Yeah, he was. My dad was in it.

HC. So there weren't any traces of your dad after he left, and then suddenly there was this Super-8? Was that kind of startling?

LB. It was the most shocking thing. You know, I cried, and cried, and cried. I thought it was all gone, and then I thought I'd never see it. And I never saw it again. I don't know where it is, and I only saw it that one night, you know? And that's fine with me, actually, but Mark—that was so funny. "I knew I was white."

HC. Are you in touch with your dad?

LB. Neither of my parents. I haven't seen or talked to them in probably sixteen years, and it's been mutual, absolutely mutual, and they've never come looking for me either, so it's been the best sixteen years of my life.

HC. *One Hundred Demons* is your fifteenth book but your first book that is at all an autobiography, and yet you call it an "autobifictionalography." Can you explain? Also, were you worried that your mom would be freaked out by it?

LB. Never, because they don't read what I do. The whole time I was growing up, like when I was in my little hula performances, or all that stuff. . . . When *The Good Times Are Killing Me* was made into a play, I brought my mom and my grandma out to see it. I flew them out to New York. My grandma couldn't figure out what I had done. And I said I wrote it, and she goes, "But I don't see the write. . . . What did you do?" Then she saw that *Playbill* had run one of my drawings, and she goes, "You made this picture." And I said yeah, so she thought I flew them out to see the picture. And my mom didn't have much of a response. She didn't say anything about it, but she did say something to my brother—and this was the only thing she's ever said about my work. He taped it, when she left it on the answering machine. She goes, "Michael, the play is good. You wouldn't think Lynda wrote it. You wouldn't think she wrote it." But you know what, in a way you want to go, "Oohh!" but I'm so used to it, it's not like it's a big surprise. I mean when you're fifty-two and it's never happened, you don't think it's gonna suddenly happen, and, so, in a weird way, I've been more free than a lot of people whose parents do read their stuff.

HC. You don't have that sense of responsibility to them.

LB. Not even *kind of*. Not even a *little*.

And autobifictionalography, all that is: when you're distilling any situation where there are a number of people who are part of it, it's going be your version of it, and I can't honestly say that my version's the same version as my brother's. My mother would have a whole other way of looking at it. And so I like putting that in there because I feel like it excuses me for that. I mean there's nothing [made up]—this stuff happened—but it might not have happened in the exact . . . they might remember it completely differently. I think the error James Frey made was with events that didn't even *kinda* happen.

HC. *One Hundred Demons* has nineteen chapters each named after a demon, and collages at the beginning of every chapter. Tell me about the "can't remember, can't forget" phrase that's part of the "Resilience" collage, because this idea is also a big part of *What It Is*.

LB. It's that whole thing about what images do. Can't remember and can't forget, that's the unconscious. I always make that joke "if I had an unconscious I'd know about it," but it's this whole idea, and Freud had it, and it's also in a lot of mythology: there are things that are driving us that in a funny way, and until we remember them, or act them out, are going to continue. Like, whole lives being directed by trying not to remember. There was a gal that I met who was terrified if she saw a pile of buttons. If she saw a pile of buttons she lost it. My belief is if she worked with images long enough, she might remember not maybe literally the thing, but she might have enough images, because I always think of images as lowering the drawbridge where stuff—memory—can cross over.

HC. So there's something about being able to visualize something . . . ?

LB. Re-experience. It's not just "visualize" it.

In our brains, they call it an electrical impulse, because they don't know how else to measure or what else to call it, but there's actually a leap. There's actually a leap across the space between the synapses. There's actually like this weird little space . . .

HC. Gap.

LB. . . . and it leaps and I feel like images are that. They're like our hyphae between each other. Because how is it that Art Spiegelman can sit down, whether he's freaked out or in a good mood whatever it is, he can draw this little picture, just, he's making marks on paper, and then pass it to someone, and you look at those marks and it transfers the experience? I mean that's pretty strange, you know, and they talk about current. Currents and currency. There's something strange that's going on there, and we take it for granted. We just think, "Oh yeah. Yeah, this is very, very normal." It's like, "No, it's crazier than hell."

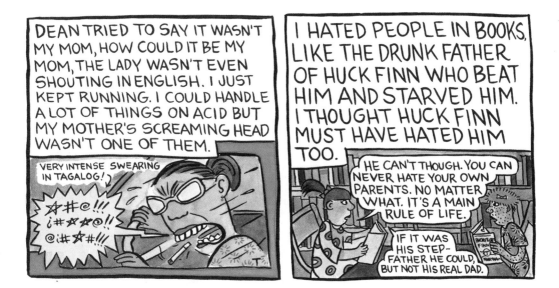

3.6. Lynda Barry,
panels from "The
Visitor" and "Hate" in
One Hundred Demons
(Seattle: Sasquatch
Books, 2002), 119, 79.
Used by permission of
Lynda Barry.

"I'M THE OPPOSITE OF A SNOB WHEN IT COMES TO READING SOMETHING."

HC. I want to ask you a few of the questions that you ask in *What It Is*. What is the past and where is it located?

LB. In our heads we have it that we're rolling into the future. There's this feeling that there's a chronological order to things because there's an order to the years, and there is an order to our cell division from the time we're a little embryo until we're dust again. But I think the past has no order whatsoever.

HC. How are images a part of that?

LB. I think that that's what you call the units, or the things that move through time. We think of time, or the past, as moving from one point to another. If you think of these images, they can move every which way, and you don't know when they're coming to you.

HC. So one of the other questions is about what's the difference between memory and imagination. What do you think?

LB. I think that they're absolutely intertwined. I don't know if there's necessarily a difference, but I don't think they can exist one without the other, absolutely not. Like that question, can you remember something you can't imagine? I like those questions that when I think about them they make my brain kind of stop. You know, is a dream autobiography? ... Is it autobiography or fiction?

HC. I love that question.

LB. Yeah, if you're the kind of person who gets interested in that stuff. The thing that I have a hard time understanding is for a lot of people,

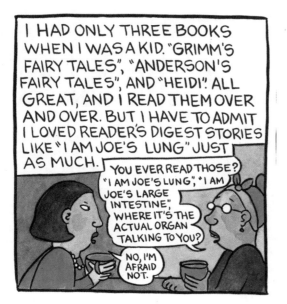

I HAD ONLY THREE BOOKS WHEN I WAS A KID. "GRIMM'S FAIRY TALES", "ANDERSON'S FAIRY TALES", AND "HEIDI". ALL GREAT, AND I READ THEM OVER AND OVER. BUT I HAVE TO ADMIT I LOVED READER'S DIGEST STORIES LIKE "I AM JOE'S LUNG" JUST AS MUCH.

YOU EVER READ THOSE? "I AM JOE'S LUNG", "I AM JOE'S LARGE INTESTINE", WHERE IT'S THE ACTUAL ORGAN TALKING TO YOU?

NO, I'M AFRAID NOT.

3.7. Lynda Barry, a panel from "Lost and Found" in *One Hundred Demons* (Seattle: Sasquatch Books, 2002), 213. Used by permission of Lynda Barry.

it's not interesting at all. Like not even kind of. It's sort of like how video poker isn't interesting to me, not even a little.

HC. So, one of the other questions is, can you make memory stronger?

LB. Yeah, absolutely. I do think memory's something you can absolutely make stronger and it's just this thing of noticing what you notice, just by doing the easiest diary in the world. We did it in the class, where you just spend three minutes a day writing down the ten snapshots [from your day].

But what's wild is the back of your mind will jump ahead of you. You think you're going to write about: I was in a car wreck, or these big things happened. So-and-so finally called me. But it'll be: potato chip bag on floor under bed. You start to realize there's the part of the day that your thoughts think is important, and there's this other part. Then you give it a chance to come forward, and you start to notice what you notice. When I'm doing that, I start to notice what I notice *while* I'm noticing it, and it makes the experience of being around richer. A lot richer. When you realize what you really notice is something superspecific, and when you start to see that—when you start to realize there's a part of you that is really active—you can either ride along with it, up on top of the bus, or you can sit in the back, with your head down, looking at your cell phone.

HC. What was it like editing the *Best American Comics 2008* volume?

LB. I'm the opposite of a snob when it comes to reading something. I'll read anything that has handwriting, and it's really hard for me to be bored or unhappy when I'm reading comics. I even love stuff that, you know, when you're reading it, you might think, this isn't really working,

or this isn't really exciting. I never think of that. I think drawing, writing, handwriting, drawing. I've done this new thing for when I pick a novel now. It used to be that I'd really sweat over what book I was going to read next. Now I have a good friend whose mom died. So they were cleaning out her mom's house, and she gave me this gigantic box of books. So now what I do when it's time for me to read is I just close my eyes and whatever book I pick, that's the book I'm gonna read, and I always end up reading the books that at first I'm going, "Oh no." Did I already tell you this story?

HC. No.

LB. The last one I just read. It's called *Breath and Shadows,* and it had kind of a floral cover, and right away it had a dwarf in it, and, like, a talking cat, and I'm like, "Oh no, no, no," but I had made the promise. It turned out to be incredible, just such a good book. I was so sad it was over. So now I realized you just don't have to be picky, because you're bringing half of the experience, no matter what, you know?

4

Aline Kominsky-Crumb

Aline Kominsky-Crumb was born in 1948 in New York. She briefly attended SUNY New Paltz before running away to Manhattan's Lower East Side, subsequently spending one semester at Cooper Union before moving to Tucson, where she earned a BFA in painting from the University of Arizona. At age twenty-two, freshly divorced, she picked up and moved to San Francisco to join the burgeoning underground comics scene, inspired by cartoonists like Robert Crumb (whom she later married) and pioneer Justin Green, whose 1971 *Binky Brown Meets the Holy Virgin Mary* inaugurated comics autobiography.

Kominsky-Crumb created what is widely regarded as the first women's autobiographical comics story with "Goldie: A Neurotic Woman," which appeared in 1972 in the premier issue of the underground publication *Wimmen's Comix*. This earned her the title, as she puts it, of "the grandmother of whiny tell-all comics." In a *New York Times* review of Kominsky-Crumb's recent gallery retrospective, Roberta Smith writes, "Ms. Crumb excels at the drawn-and-written confessional comic, which she helped establish in the 1970s, along with the graphic novel." Kominsky-Crumb continued to publish her work in underground titles such as *Wimmen's Comix, Manhunt, Lemme Outa Here!, Dope Comix*, and *Arcade*, among others. She edited the acclaimed *Weirdo* for seven years and founded the comic books *Twisted Sisters, Power Pak, Dirty Laundry*, and *Self-Loathing Comics* (the latter two with Robert Crumb).

She has published four books: 1990's *Love That Bunch* (named after her alter ego, "The Bunch"), 1993's *The Complete Dirty Laundry Comics* (with Robert Crumb), 2007's *Need More Love: A Graphic Memoir*, a 384-page life narrative that showcases Kominsky-Crumb's range as a visual artist in many different realms in addition to comics, and 2012's *Drawn Together*, a collection of her collaborative work with her husband, pub-

lished by W. W. Norton. The couple's comic strips have been appearing in the *New Yorker* since 1995.

I interviewed Kominsky-Crumb on the telephone on July 27, 2009. I was in my office in Cambridge; she was in her tall—nine-level!—stone house in Sauve, France (and within range of her husband, who piped in a few times). About a month later, she received me at her home, where she and Robert each have studios (she actually has two). Kominsky-Crumb not only walked me through her large and diverse body of work, much of which lines the walls of her home, but also prepared me home-cooked meals—including chocolate cake—and took me to her vigorous exercise class. The last night Aline and Robert and I were joined by her daughter, the cartoonist Sophie Crumb (of *Belly Button Comix* and the book *Sophie Crumb: Evolution of a Crazy Artist*). Kominsky-Crumb, along with Sophie, regularly shows her work in an art gallery in Sauve that she runs with several other artists.

"ART SCHOOL KIND OF RUINED [PAINTING] FOR ME."

HILLARY CHUTE. What was it like growing up in Woodmere, Long Island?

ALINE KOMINSKY-CRUMB. Horrible. When I was growing up, my elementary school was 95 percent Jewish. [*Kominsky-Crumb is Jewish.*] And it was all these really upward-striving, crass, nouveau-riche Jews, just incredibly competitive and totally materialistic. Into clothes, they all had nose jobs, and if you didn't have every single thing, the latest thing, that second, you were a total loser. It was just really, really harsh. There was nothing else of interest going on. It was just the most boring place you could imagine, and fascist in its social conditions and constraints. But when I was fourteen I started sneaking into Manhattan, going to the Village, going to museums and looking at art and everything. I started painting when I was eight years old. That was something that kept me going.

HC. You took art lessons when you were little and then your parents stopped paying for them.

AKC. They thought it was stupid. Which made me think it was good.

HC. And your grandfather had been a painter?

AKC. My father's father was a painter, but I never met him. One day after my father died and I was cleaning out the house, I found these two paintings in the garbage. They were painted by my grandfather, so I took them. I still have them now. My mother was throwing them away. [*Laughs.*] "Eh! Get rid of that junk!" They were from the 1920s. He wasn't a serious painter, but they were kind of interesting.

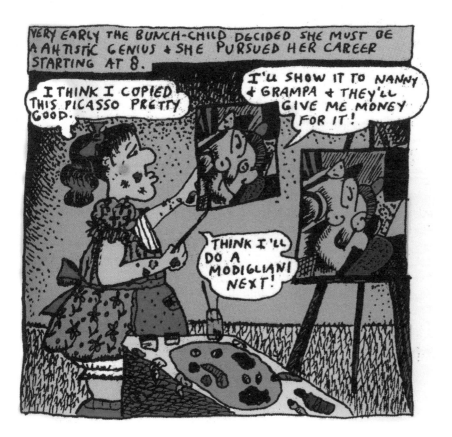

4.1. Aline Kominsky-Crumb, a panel from "Why the Bunch Can't Draw," *Power Pak* #2 (Princeton, WI: Kitchen Sink, 1981), unpaginated. Used by permission of Aline Kominsky-Crumb.

I had no exposure to any culture. My parents and my whole family were just into making money. That's all they cared about. The thought of being an artist was completely stupid to them, though they said I could be an art teacher.

HC. Did you always feel like you wanted to be an artist?

AKC. I drew a lot to relax. Maintaining my sanity in some way. It just became an important aspect of my coping mechanism very early on. So I didn't think about it that much.

HC. When you were in art school, it was during the abstract expressionist moment, wasn't it?

AKC. From eight years old all through high school, I had my own style and my own vision, very strong, and I was really quite developed. Then I went to art school. It completely confused me. I didn't know what to do, and everything I did was bad, and they didn't like my work. I completely stopped developing in my own way, and I just got lost. So I started doodling on the side in notebooks, making humorous drawings and writing things down. That was sort of how I eventually went into drawing comics. I gave up painting then because I couldn't see what to do with that. Art school kind of ruined that for me.

But it also made me appreciate comics. Right around that time, when I was in art school, I saw the first *Zap* comic and I couldn't believe it. I just couldn't believe it. And shortly after that I saw [Justin Green's] *Binky Brown Meets the Holy Virgin Mary,* and that was just the ultimate thing for me. When I saw Justin's work, I knew how I could tell my story. When I saw *Zap Comix* I was completely impressed by them, but those guys were so good that I couldn't imagine myself doing what they were doing. It was too good; it was too hard. But when I saw Justin's work, it gave me a way to see how I could do it. It helped me find my own voice, because it rang so true for me. The drawing was so homely and it was so personal, and I thought it was the greatest thing I'd ever seen in my life. I realized I just wanted to do something like that. I didn't care, I didn't think about who would read it or why they would, but I just wanted to do something like he did, for myself.

HC. I read that he was studying painting too, abstract expression-ist painting at the Rhode Island School of Design. It's interesting that you both had that abstract expressionist background, and then went to comics.

AKC. Well, probably because we couldn't relate at all to the abstract expressionists. It just didn't do it for us, at all. Both of us were tortured and had a need to express ourselves, and were searching for some way to do it.

Robert [Crumb]'s work was really interesting because he had an as-pect of the old comics from the twenties that we all loved, that were really familiar, and felt like home. It was very reassuring, but it was also charged with this total psychedelic vision. It touched something so deep. We felt, "Oh my god," you know, "this is it." And it definitely set off a whole other set of possibilities, I think, for a lot of people. It was definitely a supercharged moment there. Robert's work and everything that came after it changed graphic art forever. It changed fine arts, too. But it really changed the way everything *looked,* you know, instantly. He influenced an entire generation in France, too, and everything that came after as well. We didn't even know that was going on. They were pirating his work over here all through the seventies and we didn't even know it.

"THERE WAS A BAND CALLED TWISTED SISTER; THEY STOLE OUR NAME."

HC. Will you tell me about how "Goldie," your first comics story, came about?

AKC. Well, my maiden name is Goldsmith. They used to call my fa-ther "Goldie," so it went back to my father. And also since I didn't like

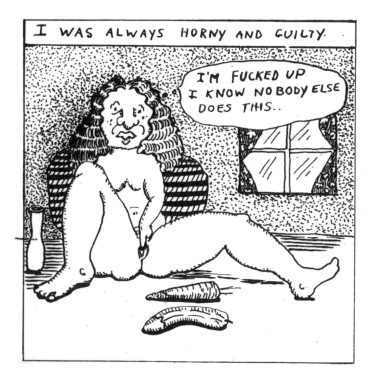

I WAS ALWAYS HORNY AND GUILTY.

I'M FUCKED UP I KNOW NOBODY ELSE DOES THIS..

my father very much, I sort of hated that name, and my character was a part of me that I felt was repulsive, and the name sort of fit that character.

HC. I was so struck that in one panel, there's that scene where your dad's coming towards you, saying, "C'mere," and you're imagining him with this erection and it's really gross. And then in the next panel, there's an image of the Goldie character masturbating. And that's what is so appealing to me: even though you're grossed out by your father's sexuality, you're not victimized by it. It doesn't keep you from being sexual yourself.

AKC. It's true. I was grossed out by my father, particularly, and he made me feel ugly, but I still really wanted to have my own sexual thing. I wanted to have fun, and I wanted to experience everything. So I wasn't turned off . . .

Putting that ugliness out there liberated me from it in a way, too. Because part of me didn't feel that. It was something put on me. So it was sort of an exorcism to get rid of that. Underneath I always felt very optimistic, like that wasn't really me. There was something a lot better going on. I always felt strong, and I always felt that I would get away from my family, away from that horrible place and those horrible values, and I would have wild adventures and find out what was really going on. And I did.

HC. What happened with *Wimmen's Comix*?

AKC. It started off because at that point, anything was being pub-

4.2. Aline Kominsky-Crumb, a panel from "Goldie: A Neurotic Woman," *Wimmen's Comix* (Berkeley: Last Gasp, 1972), unpaginated. Used by permission of Aline Kominsky-Crumb.

lished, and since there was never a woman's comic before, everyone thought, "Oh, that's a good idea." So Trina [Robbins] got that together. There weren't even enough artists. . . . I moved to San Francisco just at that time, and someone introduced me to Trina so I got in the book; anybody that was willing to do anything got in the first book. I met Diane Noomin [creator of *Didi Glitz*] on the bus—I saw her drawing in a sketchbook. I said, "Oh, you wanna draw a comic?" She said, "Yeah, why not?" So I said, "Come on, I'm going to a meeting." And she just got off the bus and came with me. And then she got into it.

HC. That's a very adorable story.

AKC. You know, we were just looking for anybody. But after a while, it became this "women's art collective," in quotes, and Trina was the head of it. Basically that group was divided into feminists who were anti-men, and powerful women who wanted to do what they wanted to do, but also liked men and wanted to have sex, too.

HC. So it was about sexuality.

AKC. It was about what you considered having power over your life.

HC. Did Trina have any substantial things to say about your aesthetic? I mean, was it sort of like an ideological difference *and* an aesthetic difference?

AKC. Trina was very down on autobiographical comics. She discouraged me from doing it when we first started doing those comics together.

HC. What did she say?

AKC. She just said, you know, "Who wants to read about your personal daily things? That's not interesting. People want, you know, to be uplifted in their work, and . . ." [*Robert Crumb speaks in the background.*] Robert's trying to say something. What, Robert? Yeah, that's right. Trina said, "Who wants to read about whether you're worrying about being fat and ugly?"

HC. *I* do, actually . . .

AKC. Well, so do I. It turns out, actually, people do want to read about that. If you think about what kind of comedy people like—like Larry David, and all this reality stuff that's come since then—that *is* what people want to read about. But at that time, people had different attitudes. Graphic novels hadn't become an art form yet. Underground comics were a transition period from old-fashioned traditional comics to what you have now.

And Trina couldn't understand why I would draw myself on a toilet. I would completely deconstruct the myth or romanticism around being a woman—all that stuff. I was just vulgar and gross and everything. I enjoyed pushing that in people's faces. For me that was somehow satisfying.

HC. How did you decide to make *Twisted Sisters*?

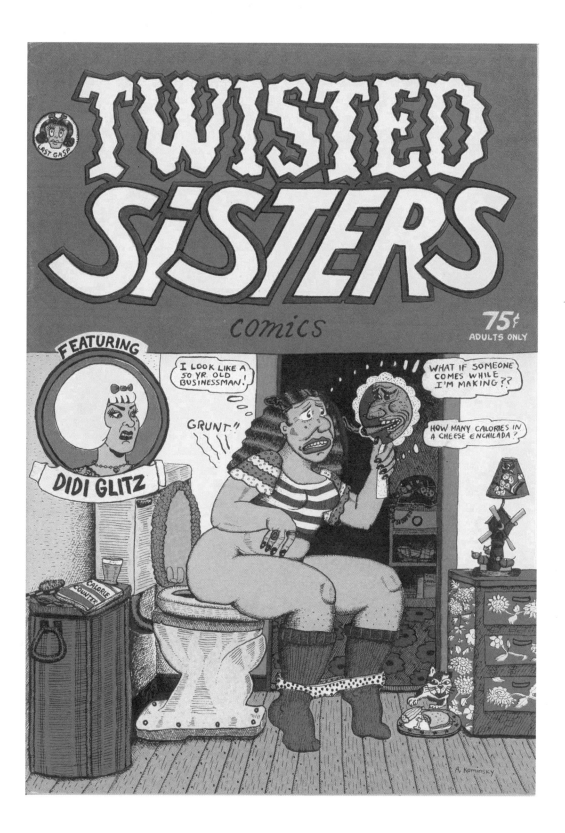

AKC. Part of it was because Diane and I were disgusted with the *Wimmen's Comix* thing. We both were really alienated and felt left out of a lot of the comics, and they were really treating us horribly. We felt a shared vision that was much more compatible than we did with any of the other women in the group at that time. So we decided to do our own book, where we wouldn't have to put up with all that political correctness and all that crap. We didn't have to censor each other. We each wrote about a hundred names and we came up with that name together. There was a band called Twisted Sister; they stole our name.

HC. I loved them when I was a little kid.

AKC. Well, anyway, they got it from our comic.

HC. Was there a response to the cover?

AKC. It came and went unnoticed, to tell you the truth. But years later, I remember [cartoonist] Peter Bagge said to me, "You know, I just looked at *Twisted Sisters* and I realized: you drew yourself on a toilet! I mean, how could you do that?"

I said, "I guess the reason I did it was because, when I started drawing comics, I thought, Oh, this is neat, because it's really nice to read comics on the toilet, and I'm glad I'm making art to read on the toilet, so I guess that's why I put myself reading comics on the toilet." [*Laughs.*] I didn't think of it as being unique for a woman to draw herself on the toilet; it just seemed natural to me. But the comic—really, there was no impact. We had no feedback; it sold hardly any copies. Nobody cared, nobody liked it, and that was that.

Every single thing I did was like that. I had no success ever. In any terms. I never had, you know, universities asking me for my opinion, or to give talks. I never had any kind of feedback from the fine arts scene or the comics world. Nothing. [*Laughs.*]

HC. Well, that gives your work a certain purity, right? It's really being creative without external forces bearing down on it . . .

AKC. Maybe if I had, for some weird reason, made it into the mainstream culture, somehow that might have ruined it. Robert got screwed up by being famous really early. It was really hard for him after that.

HC. But then after *Twisted Sisters* you did your own solo comic, *Power Pak,* so you really were undaunted.

AKC. [My work] never sold, so even my publishers . . . they'd always be really disgusted. And Gary Groth was good enough to publish [my book collection] *Love That Bunch,* but that's just because the Hernandez brothers and Peter Bagge made him publish it because they really like my work.

HC. Why do you think people didn't like the book?

AKC. Because people who read comics are used to looking at certain

kinds of slick presentation that is very formulaic. There's a certain hieroglyphics that they're used to reading, and it could either be cute, or adventurous, or heroic, or historical, but they're used to it looking a certain way. And then people who are used to looking at fine art are looking for other things. And my work sort of falls in some weird crack there. I'd just say that most comics fans are really looking for something else. And people that would appreciate my work as art would not read comics. It's a small esoteric group of people that would relate to it.

HC. What was the issue with finding a printer for that book?

AKC. Men thought some of the things I drew in there were so disgusting, that they couldn't . . . they were Christian printers, and no one would print it.

HC. Fantagraphics was using a Christian printer?

AKC. They were at that time, yeah, because they just wanted the cheapest printer. You know, a lot of printers were Christian. What could you do? They went to the cheapest printer they could go to, I guess, and these guys refused to print it. They went to a couple of printers, actually. And to their credit, they kept persisting until they found someone that would do it. Because, you know, men doing porno is fine. But women—the way I drew degrading, ugly sex and everything is really a turnoff to men. They hate it.

HC. This is a question that's always actually deeply puzzled me about comics. Because it's not like there isn't other "pornographic" stuff that gets published all the time. So why did you run into trouble, and why did Phoebe Gloeckner run into trouble with printers?

AKC. I think because we're women drawing that. And really strong, powerful, subversive ways of looking at sex and male-female relationships—I think it's very disturbing. Because it's not status quo.

HC. So the issue is not just picturing genitals—it's the way it's pictured?

AKC. It's very critical of men, and the women are in charge, like you say: not victims. The opposite. It's very threatening, I think. Both Phoebe and I made the whole thing seem very unsavory, but in a way that sort of throws it back in men's faces, or, you know, is very hard to look at.

HC. I'm interested in your role as an editor and as a tastemaker in general. You were the editor of *Weirdo* from, what, '86 to '93? And you founded *Twisted Sisters* and *Power Pak* and *Self-Loathing* and *Dirty Laundry*. I mean, that's a major role in comics.

AKC. I lived way out in the country, and that whole time I did all that work by myself with Robert, way out in the middle of nowhere. It's very personal work, and if it was in any way influential, it's, you know, probably because I'm this typical baby boomer, raised in the suburbs of New York,

who was a hippie and went through this personal journey that maybe a lot of other people could relate to.

And maybe because I took a few steps back from it I was able to comment on it. When I was editing *Weirdo,* there were no other vehicles for new work that existed at the time. I got so much work, so many submissions. You couldn't help but make a good magazine. I had to turn down really good things. It was horrible. And a lot of people got their start in that magazine. You know, like Julie Doucet, I put Carol Tyler in there, Dori Seda....

HC. And Phoebe Gloeckner, right?

AKC. Phoebe, yeah. I met Phoebe when she was fourteen, because she found my work under her mother's mattress. It was just a very rich time. There were all these people starting out at that time who had been influenced by the first generation of cartoonists in the sixties, and all these younger people coming out with work.

"WHAT ELSE COULD YOU DO BUT EMBRACE YOUR YOKO-NESS?"

HC. You started collaborating with Robert in your comic book *Dirty Laundry* in the early seventies.

AKC. When the first *Dirty Laundry* came out, I got hate mail that you wouldn't believe. I have two lines memorized which I can recite to you. One was: "Maybe she's a great lay, but keep her off the fucking page." And the other one was, "Keep her in the kitchen. You do the cartooning." It actually spurned me on to be even more outrageous and impose myself even more, you know. That's when I started calling myself "Yoko Buncho." [*Laughs.*] What else could you do but embrace your Yoko-ness?

HC. What do you think the issue was? Was it that these were the fans who really responded to the craft part of Robert's work, and they saw your work as not as crafted?

AKC. Yeah, of course. He was such a genius, and they were such devoted fans. The fact that I would dare to put my flat scratching on the same page with a master like that, they thought that it was incredibly nervy. They just couldn't believe that I would dare to do that. Even some of Robert's friends really thought I was, like, very pushy and . . .

HC. Just like Yoko?

AKC. Yeah. Just like Yoko. Exactly. I am not exaggerating.

HC. Well, it seems like you influenced him to do more confessional stuff. Is that true?

AKC. I did. That's true.

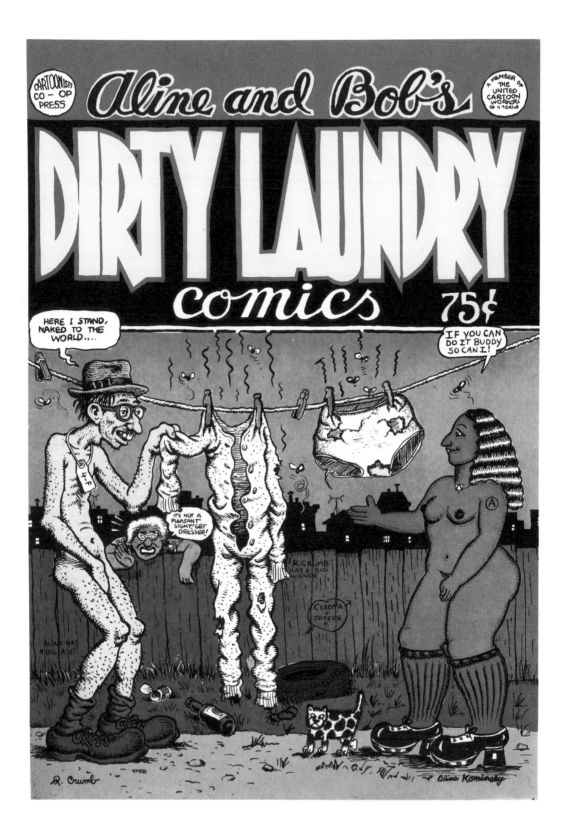

HC. What's the difference between the *Dirty Laundry* stuff and then the less sexually-explicit *New Yorker* stuff?

AKC. Well, the *New Yorker* thing we got down to this almost George Burns and Gracie Allen routine. We go into character when we work.

HC. Right.

AKC. He feeds me the straight lines, and I take all the pratfalls, you know? *Dirty Laundry* kind of gradually developed that. The first *Dirty Laundry* we did just to amuse ourselves, and then someone published it. And then we got into it more, and started thinking of it more as making coherent and entertaining stories.

We started doing the *New Yorker* stories as journalists, going to Fashion Week and Cannes and stuff like that, and it was really fun. Then we started doing things like that story about the tape dispenser ["Our Beloved Tape Dispenser"]. We're doing a story now about our vacuum cleaner. What we had to go through to get a vacuum cleaner in France. That's something that's revealing about life here. It's kind of a good story. When we do those comics we get into another role. It's like being a stand-up comic. I'm not digging deep into my painful childhood that much. It's way more pleasurable to work on.

HC. I think the sexual stuff in *Dirty Laundry* is amazing, too.

AKC. Hm.

HC. It's very explicit, but it's this consensual thing. There's something sort of amazing about all of the representation of sexuality in a couple.

AKC. I can't judge that at all. I have no idea.

HC. I've never seen anything like it before.

AKC. What other husband and wife have ever done a comic before? Nobody. There's no other couple that has ever done it, so of course you've never seen anything else like it. And then our daughter's in it, too. I mean, what other family has done comics before? Nobody. There's nothing to look at that came before, and there's nothing after it as far as I know, either....

HC. Has your mother still not seen your work?

AKC. Well, after the film that Terry Zwigoff made [*Crumb*], she was deeply hurt and everything.

HC. Why did she see it?

AKC. I told her not to see it. But all of her friends saw it and she was so humiliated she had to go see it. She didn't talk to me for three months. But after that she didn't want to really cut off from me. I said, "Look, you know, I did a lot of work that's really harsh and everything when I was in my twenties. That's how I dealt with a lot of things. That enabled me to get over it. But I would never do any work like that now, so can we just put it behind us?" And she said, "Yes, let's do that."

She looks at my work in the *New Yorker*. The work I do now is not offensive to her. Since we work for the *New Yorker* and Robert does things that are acceptable, you know, she's forgotten about it. But she was very hurt at the time of the movie. She didn't see any of my work up until then. I was able to hide it from her. Because why would she see underground comics, you know? She thought I painted and I was teaching painting classes, and I taught exercise class, and I did some comics, but she didn't want to know about it. It was just some underground hippie nonsense, so she didn't really worry about it. Until it was, like, shoved in her face.

I felt guilty about it, because, you know, when Terry made that film, I thought no one would ever see it. First of all, I thought he'd never get enough money to even finish it. And then if he did finish it, I thought it would be in a few small art theaters. Even in the film, he says, "Well aren't you scared your mother will see this?" I said, "No, my mother would only see a film if it came to the mall or the gym." And it did. It did. All her friends saw it and said, "Oh my god, how could your daughter do that to you?" She had to go see what they were talking about.

HC. I forget, does the film show that big image of her with the sharp teeth that you drew [in the story "The Bunch Her Baby and Grammaw Blabette"]?

AKC. Yeah, exactly. I'm holding it up and saying, "Yeah, this is my mother. *A-ha-ha-ha-ha.*" And Terry says, "Aren't you scared she'll see that?" I said, "Nah," as if I didn't care. You know, it's really mean.

I was in Bali last year, and I decided to make some batiks out of some of my weirder comics images. So I actually made a batik of that head. It looks like a weird African voodoo head. It's so out there. It's almost not human. A lot of times I think when I draw her she almost looks like an alligator or some kind of weird creature, not a human. And sometimes I think that when I draw myself, it's almost not human, also. It sort of becomes something else, it's like a creature, you know.

HC. What does she think about your *New Yorker* work?

AKC. My mother never thinks it's funny, and she never gets it. She said, "Why did you write about that machine? I don't understand? What was so unusual...?" You know what I mean? And then when I did a story about having had face surgery ["Saving Face"], my mother was horrified by that. "How could you tell everybody that? You're supposed to hide it! No one can tell! You look gawgeous! Why would you wanna tell that?"

HC. What did you say?

AKC. I said, because I want to liberate people so that they can feel free to talk about it and not feel bad about stuff they decide to do. If I do it, then anyone else can do whatever they want, you know? Who cares? Why should it be a moral issue for somebody else? And, I said, if I do a

liberating piece about that . . . that was, to me, one of the most radical things I ever drew, and I got very little reaction from it.

HC. Why do you think?

AKC. I think that a lot of people, and I know this for a fact, think that Robert draws the whole thing, and they don't even know that I draw myself in there.

HC. That seems insane to me. One of the things that I love about your collaborative stuff is the way the two obviously different styles interact with each other . . .

AKC. I was with Robert and someone at the airport in New York came up to us and said to him, "Why do you draw your wife so ugly? She's so beautiful!" And I said, "It's me that draws that, not him. Just go back and look at it. You'll see, it says: By Robert Crumb and Aline Kominsky-Crumb." He said, "Oh! Isn't that cute?"

HC. Huh . . .

AKC. And for the story about my face, the *New Yorker* did this thing. You know when they sell it on the newsstands, they have that overwrap that has headlines, about what's going be in it?

HC. Yes . . .

AKC. For that headline, it said, "R. Crumb on His Wife's Face." You know, I think it's amazing that the *New Yorker* would ever have my work in there. And maybe if they really knew I was in there, they wouldn't want me in there! I think it's really great. You know, to me it's poetic in a way, it's perfect.

"I FEEL LIKE I'M DRAWING IN BLOOD."

HC. Tell me about your memoir *Need More Love*.

AKC. The publisher [MQ Publications] went out of business the night that my book came out. I was in the middle of a talk at the New York Public Library when they went out of business. But that's a long, long story.

That book, for me, exists in the twilight zone. But as a result, I've gotten more feedback on that book than I've ever gotten from anything else I've ever done. It seems to go around in these weird ways. I've gotten so much feedback on that book, which I never made a cent on, and has never been officially distributed or anything. [*Laughs.*] Some other publishers have wanted to republish it and I don't want to. I just want to leave it exactly as it is, because now it's like a guerrilla art statement.

HC. I love the multimedia autobiography aspect of it, where there are comics, and there are prose sections, and then there are your paintings . . .

AKC. That was completely experimental for me. I had an idea of doing this, like you say, collage, multimedia, enhanced comic: to have more text,

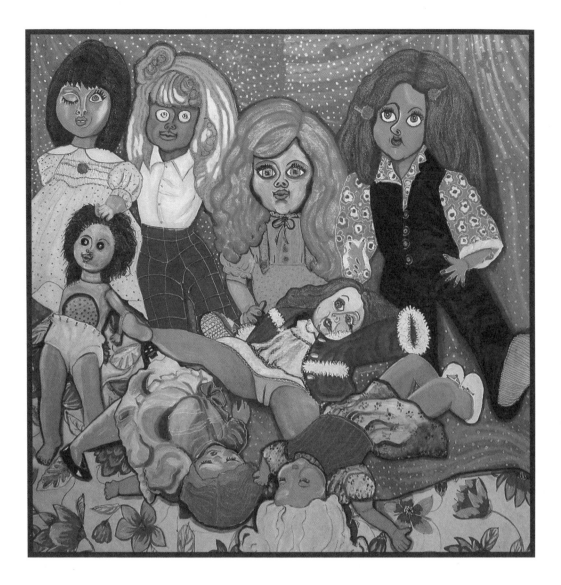

and then to explain some of the comics I had already done, and then also to add the painting, and all my other artwork, which is a very important part of my life which has never been seen, with the comics. I wanted to put it all together to sort of complete the picture.

HC. Can you describe your multimedia artwork? I love your shrines and sculptures.

AKC. That was influenced by a long trip to India, where I thought people made beauty out of nothing. So I decided to make beauty out of garbage. I started looking through the dumps in India and I made collages out of garbage; I made eight collages while I was there. And the local people, out in this rural village, were looking at me like, "This nutty American, why is she going through our garbage?" And I said, "Well, I'm

4.5. Aline Kominsky-Crumb, *La Crise*, 2005. Still life painted from found dolls. Used by permission of Aline Kominsky-Crumb.

gonna make artwork out of it." I decided I would have a little art show. I was with another artist friend, and she was making stuff too, so we had a little show in front of our hut after two weeks. That was the best art opening I ever had. The people came, and they were lighting incense and saying, "God gave you this gift, this art gift, look what you did, you made a miracle out of garbage."

HC. That's so flattering.

AKC. It was the most appreciated I ever felt as an artist, ever. Nothing ever came close. That inspired me to keep wanting to make more shrines out of junk, so I started going to the flea market. People would be selling bags of, like, Barbie parts and stuff like that. I started using a lot of things that were just the plastic garbage of our society, especially the stuff kids get. Trying to turn that into sacred objects.

HC. How would you describe your style in comics?

AKC. [Laughs.] Lack of, my lack of style.

HC. I don't think you have a lack of style.

AKC. I'm just scratching in the most, I don't know, emotional, raw way. I've done hundreds of life drawing classes and all kinds of stuff, but none of it seems to affect the way I draw when I'm drawing comics and writing about myself. I'm so emotionally charged when I'm doing that, I can't really control what comes out. It just comes out in a very direct form. In a way, I'm lucky that I can access that. In another way it's horrible because I can't refine it or improve it and make it look more, like, acceptable. My paintings are more visually appealing in a certain way. People are sometimes surprised when they see my paintings. I mean, they're crazy-looking, but they're not as tortured.

HC. Your comics aren't torture to draw, are they?

AKC. Yes, they are. It's almost like I feel like I'm drawing in blood. It's just really coming directly out, and there's a certain amount of pain in that. It's sort of like George Grosz. You think he was laughing while he was drawing that grotesque stuff? It comes out of a dark place in me, definitely. When I paint, it doesn't. My painting comes from a much lighter, more decorative, aesthetic side of me.

HC. What do you think it is about drawing?

AKC. It's not drawing, it's the writing. It's raw because I'm writing about myself, and I'm revealing things to myself as I'm writing. You recall things that you've forgotten. It's coming out in the line. So the drawing isn't pretty or accurate; a lot of it has little to do with what reality looks like. It's an emotional reality. It takes a lot out of you. I find I do it less and less. If I do stuff with Robert, like where we work together for the *New Yorker*, that's kind of fun to do, because we're just playing around.

But some of that deeper, really painful stuff I drew earlier in my life was very difficult to do.

HC. I remember reading an interview with you where you said that the kind of aesthetic that you liked in comics is one where you can see the struggle.

AKC. Yes, exactly. That's what moves me in people's work. Other people are looking for work that's kind of pyrotechnical and fabulously technically amazing in some way. Some people just want to be dazzled by the skill of the artist. But if there's not an emotional engagement to me, I find it completely boring.

The artists I like are German expressionist artists—you know, the kind of art where I feel that the person is really spilling it all out there. And all through history there have been artists in every period that were more like that than the others. Frida Kahlo's paintings are more moving than Diego Rivera's because they're more personal. Some people have both, and they're really lucky.

5

Daniel Clowes

Known for his biting humor and incisive cultural commentary in addition to his fluid, confident line and aesthetic range, Daniel Clowes is a cartoonist, illustrator, and screenwriter. Born in 1961, Clowes grew up near the University of Chicago and attended the university-run Lab School (recently famous as the primary school of Sasha and Malia Obama), before moving to New York City's Pratt Institute, where he earned his BFA in 1984. Clowes satirizes art school brutally, and hilariously, in his comic strip "Art School Confidential," which was adapted as a film in 2006.

Clowes got his start as an artist with seven issues of his comic book *Lloyd Llewellyn*, whose stylish private investigator protagonist was always dropping into bars and getting in trouble. In 1989, the year he began his influential second series, *Eightball*, Fantagraphics released his first book, *#$@&! The Official Lloyd Llewellyn Collection*. *Eightball* ran from 1989 until 2004, and earned numerous awards. In 2001, Clowes's graphic novel *Ghost World* (1997), about two girls graduating from high school, was adapted into a film by Terry Zwigoff. Clowes wrote the screenplay and was nominated for an Academy Award. *Ghost World*, both in comics and film form, struck a chord with many for its moving portrayal of teenage friendship.

Clowes's books include *Lout Rampage!* (1991), *Like a Velvet Glove Cast in Iron* (1993), *Pussey!* (1995), *Orgy Bound* (1996), *Caricature* (1998), *David Boring* (2000), *Twentieth Century Eightball* (2002), *Ice Haven* (2005), *Wilson* (2010), *The Death-Ray* (2011), and *Mister Wonderful* (2011), which collects his comic strip that was serialized in the *New York Times Magazine* in 2007. Clowes's contemporary Chris Ware has called *Ice Haven*, which tracks the goings-on of a town in the wake of a kidnapping, "one of the most powerful works of comics fiction ever."

In 2011, Clowes won the PEN Award for Graphic Literature. In April 2012, Clowes's first major solo exhibition opened at the Oakland Museum

of California; it opened at Chicago's Museum of Contemporary Art in June 2013. In conjunction with the show, Abrams released a beautiful, full-color monograph of Clowes's work, *The Art of Daniel Clowes: Modern Cartoonist*. Clowes is also a frequent contributor of covers to the *New Yorker*. We spoke by phone—Clowes was at home in Oakland, California— in April 2010, shortly before the release of *Wilson*, his first graphic novel with all-original work. Portions of this interview first appeared in *Time Out New York* online and in print. I tried to resist asking him his sign, but I failed (we're both Aries).

HILLARY CHUTE. So you grew up in Chicago?

DANIEL CLOWES. I grew up in Hyde Park, which is the weirdest neighborhood in the world. It's a bubble. I mean, I grew up thinking that racial inequality was a thing of the past. Like I truly had no idea what the rest of the world was like. It's like this sort of leftist wet dream of how things could work out. When I go back to Chicago, I can't believe what a great city it is. It's so different than what I grew up with that it's deeply alienating and upsetting to me personally, but on an empirical level I have to say it would be the perfect city to live in. Mayor Daley has done a pretty amazing job just in terms of the design of the city.

HC. So you feel emotionally attached to the ugly version of the city?

DC. I'm totally into the ugly version. When I was a kid, I would go downtown on a Sunday afternoon, and literally there would be nobody within sight except for zombie-like homeless people. And I just thought that was great, that you could walk through the streets of this huge American city without seeing a soul. It felt like an apocalypse movie or something.

HC. In your book *Wilson*, the protagonist's father is a comp lit professor. Were your parents professors?

DC. My grandfather [James Cate] was a big deal professor in the forties through the seventies, and my mom was not a professor [*laughs*]. She was an auto mechanic. She tried to be the opposite of my grandfather.

HC. Was he friends with all of the literature luminaries at Chicago?

DC. He knew Saul Bellow, who was there at the time, and he was good friends with John Hope Franklin, who was in the history department, and he knew Ed Levi, and I'm guessing he probably knew Justice John Paul Stevens, the Supreme Court justice who's retiring. My grandfather's best friend was Norman Maclean, who wrote that book *A River Runs Through It*. He was our dinner guest every Friday night. I basically lived with my grandparents most of the time because my mom was busy trying to run a garage.

HC. You went to Pratt, right?

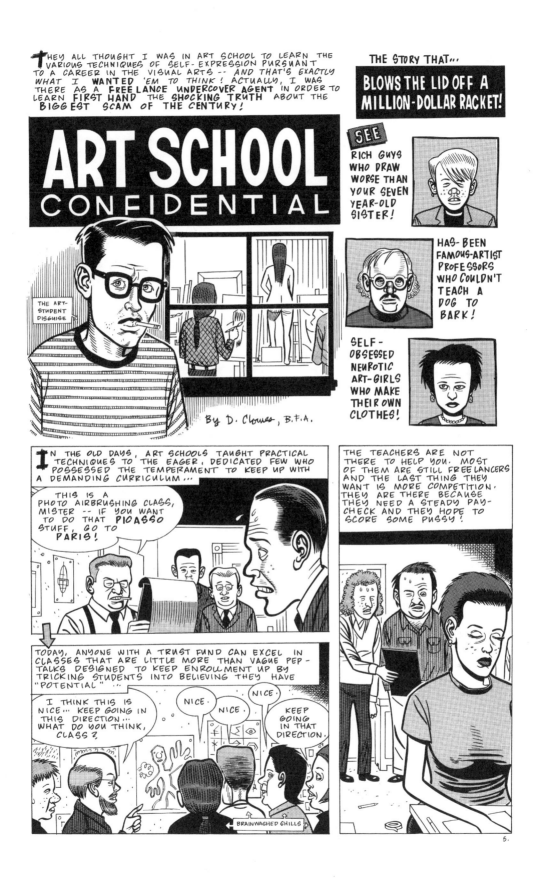

THEY ALL THOUGHT I WAS IN ART SCHOOL TO LEARN THE VARIOUS TECHNIQUES OF SELF-EXPRESSION PURSUANT TO A CAREER IN THE VISUAL ARTS -- AND THAT'S EXACTLY WHAT I WANTED 'EM TO THINK! ACTUALLY, I WAS THERE AS A FREELANCE UNDERCOVER AGENT IN ORDER TO LEARN FIRST HAND THE SHOCKING TRUTH ABOUT THE BIGGEST SCAM OF THE CENTURY!

THE STORY THAT...

BLOWS THE LID OFF A MILLION-DOLLAR RACKET!

ART SCHOOL CONFIDENTIAL

By D. Clowes, B.F.A.

THE ART-STUDENT DISGUISE

SEE

RICH GUYS WHO DRAW WORSE THAN YOUR SEVEN YEAR-OLD SISTER!

HAS-BEEN FAMOUS-ARTIST PROFESSORS WHO COULDN'T TEACH A DOG TO BARK!

SELF-OBSESSED NEUROTIC ART-GIRLS WHO MAKE THEIR OWN CLOTHES!

IN THE OLD DAYS, ART SCHOOLS TAUGHT PRACTICAL TECHNIQUES TO THE EAGER, DEDICATED FEW WHO POSSESSED THE TEMPERAMENT TO KEEP UP WITH A DEMANDING CURRICULUM...

THIS IS A PHOTO AIRBRUSHING CLASS, MISTER -- IF YOU WANT TO DO THAT PICASSO STUFF, GO TO PARIS!

TODAY, ANYONE WITH A TRUST FUND CAN EXCEL IN CLASSES THAT ARE LITTLE MORE THAN VAGUE PEP-TALKS DESIGNED TO KEEP ENROLLMENT UP BY TRICKING STUDENTS INTO BELIEVING THEY HAVE "POTENTIAL"...

I THINK THIS IS NICE... KEEP GOING IN THIS DIRECTION... WHAT DO YOU THINK, CLASS?

NICE

NICE

NICE

NICE

KEEP GOING IN THAT DIRECTION

BRAINWASHED SHILLS

THE TEACHERS ARE NOT THERE TO HELP YOU. MOST OF THEM ARE STILL FREELANCERS AND THE LAST THING THEY WANT IS MORE COMPETITION. THEY ARE THERE BECAUSE THEY NEED A STEADY PAY-CHECK AND THEY HOPE TO SCORE SOME PUSSY!

DC. I did.

HC. And did you hate it?

DC. Actually, at the time I enjoyed it. But I had a friend who sort of dropped out halfway through, and I remember I saw him at a bar and he said, "It just occurred to me one day all I really have to do is put up my paintings in my room, and have my friends come over and talk about the paintings and that would be the exact same thing [as art school]." And I thought, wait a minute, that can't be right, and yet, he was absolutely right! [*Laughs.*]

HC. Did you know you wanted to be a cartoonist before, or did you figure it out when you were at Pratt?

DC. I actually went to Pratt with the idea of being a cartoonist of some kind.

HC. So you figured it out at the Lab School!

DC. I figured it out maybe even before that. My mom tells me that's what I said I wanted to do when I was four.

HC. When did you get good at drawing?

DC. Not until long after I was at Pratt, actually! [*Laughs.*] I had an epiphany in my junior year at Pratt when I realized: everything I've learned is wrong. I realized I had learned all these cheap techniques of comics because that's what I was kind of drawn to. But I didn't know anything underneath that. There was no drawing or design or anything underneath these stupid comic inking techniques. So I just stopped. And I started over. I got a Rapidograph pen, which is just this constant weight pen; there's no variation to it at all. And I started drawing as simply as I could with that, and I thought, "I'm going to start again from ground zero and just work my way up," and that was the best thing I ever did.

HC. What year was that?

DC. That would have been 1983 or 1982. I was probably twenty-one or so.

HC. So what was your first published comics work?

DC. It was a feature in *Cracked* magazine called "Aren't You Nervous When . . . ?"

HC. Has it been collected anywhere? I haven't seen it.

DC. No, never. I did a lot of work for *Cracked* magazine, right when I started, when I was about twenty-three or twenty-four, and they used to never give the artwork back. They put it all in a warehouse. And at some point, I finally realized, hey, there's no reason that I can't get this artwork back. So I wrote to a friend of mine who was still working there, and I said, "Can you get this stuff back?" And he said, "Yeah, it's all down in Florida, but next time I'm down there I'll find it." It turned

You see MIKE WALLACE walking up to you

Your PARENTS start enjoying today's music

Your NEIGHBORS always sleep by day

The RESTAURANT you ate at is closed down

out *Cracked* had been bought by the *Midnight Globe*, and they were located in Florida.

HC. I don't even know what that is.

DC. It was like a *National Enquirer* imitation. Remember when there was that anthrax scare [in 2001]? One of the anthrax scares was at the *Midnight Globe*—someone had sent anthrax to the *Midnight Globe*—and they had to burn the entirety of their warehouse, including my artwork.

HC. This story is crazy!

DC. I luckily had a few things I had managed to not give them over the years, and I have the printed copies, which look horrible.

HC. So everyone got their artwork burned.

DC. Cool, eh? Thanks to the still yet-uncaught anthrax guy. I was like, fuck Osama bin Laden! This guy is the real terrorist! [*Laughs.*]

HC. How did you hook up with *Cracked*?

DC. I had a roommate at Pratt who was kind of an amazing guy who could talk his way into anything. And one day he noticed there was an opening for, like, an assistant gopher at *Cracked*. And he said, Hey, I'm going to get this job! And within three weeks, he was like the editor in chief. [*Laughs.*] It was pretty great.

When he brought in work by me and my other friends, there was a

5.2. Daniel Clowes, opening panels from "Aren't You Nervous When...?," Clowes's first published piece, *Cracked* magazine (November 1985). Used by permission of Daniel Clowes.

publisher who really knew nothing at all about the magazine—he had just bought it. And he wanted to show that he knew what he was doing, so he went through the pile of artwork and he picked out two or three people, and he said, "These are no good—don't use these guys." And one of them was me. I was really discouraged. I thought, Oh man, this was my big break. And there was really no rhyme or reason to it. My friend the editor said, "Just make up another name and submit new stuff." I did that, and the publisher said, "Now this guy—this guy's great," and I was in from then on.

HC. *Cracked* is the genesis of so many weird stories.

DC. *Cracked* is a weird thing. Even as we were working for it we knew that it was the world's worst magazine. We hated it when we were kids, and yet we still sort of begrudgingly bought it, because we loved *Mad* so much, and we just couldn't wait four weeks for the new *Mad*, so we'd have to have something, so we'd buy *Cracked*. It was like low-grade methadone. [*Laughs.*]

HC. So what happened in between *Cracked* and deciding to do your own series *Eightball*?

DC. Well, *Cracked* wasn't like my dream job. It was great to be actually paid to do comics stuff when I was twenty-three or whatever, but I really wanted to do *comics*. But at that time there was no "the world of graphic novels" as it exists today. There was Art Spiegelman doing *RAW*, and Robert Crumb was doing *Weirdo*, and there was *Love and Rockets*. And that was it. All the rest of comics, it was just the lowest ebb of like, you know, twentieth-generation superhero nonsense. It felt like a dead world. And so I didn't even really know what I wanted to do. In my spare time when I was working for *Cracked*, I did a ten-page story that was with this character Lloyd Llewellyn, and it was sort of a detective, 1950s thing. It was sort of like a crazy, Charles Burns-ish kind of thing.

I thought, I should send this out to publishers and get some feedback. And I sent it to two or three publishers and never heard a word. And then I saw there was this publisher Fantagraphics, and they were in Delaware or something at the time, and I saw that they published the *Comics Journal*, and I thought, "Oh, maybe they'll write a little critique for me so I can move to the next step." So I sent it to them. And then a week later I get a phone call: "Oh yeah, we really like this, we'd like to give you your own monthly comic book."

HC. That's great.

DC. It was sort of great, but it was like winning the prize way before you were ready to. I thought, "I'm going to be honing my craft over the next ten years and then I'll get my own comic book!" But then it was too easy. Now I feel weird that I didn't go through all the paying-my-dues that I should have. And when I actually had to do the comic, that's when

I really learned what a nightmare it was. [*Laughs.*] Because Fantagraphics made me think, "You really have to get this out every other month or you'll be a dismal failure!" So I did that, just working day and night, and of course it wasn't really what I wanted to do, either.

HC. It wasn't?

DC. Not really, because they wanted it all about Lloyd Llewellyn. They said, nobody buys anything unless it's about a character, and you've got to have your character, and so I sort of believed that, and after about five issues I felt, "Oh man, I'm so sick of this guy," and the story started to be completely unrelated to him, with him sort of tangentially involved. And then it got canceled. Amusingly, it got canceled for low sales. And if it were still being published with those exact same sales, it would probably be their number-one selling comic book now. But back then, things were not so grim.

So that's when I decided to do *Eightball*. I thought, if I'm going to be a failure at this, I'm going to at least do the thing that I really want to do and go out in a blaze of glory. I did *Eightball* and I slowed down and did it the way I wanted to do it.

HC. And then your first book was a Lloyd Llewellyn collection, right?

DC. That was the first one. And there was an early *Eightball* collection right after that.

HC. One of your early books is *Pussey!*, which makes fun of the comics world.

DC. You know, when it first came out, it was a big deal. That was the thing everybody talked about, and that's what got me all the attention. Because nobody had ever done anything like that.

HC. You mean about comics?

DC. Now it's such a part of the culture to do things about nerds. You know, that's something that's done in every medium now. But at that time, nobody wanted to make fun of that crowd. And I was so resentful of being kind of stuck in that world. I just felt like the comics I was doing had nothing at all to do with the marketplace I was being thrown into, and I'd find myself having to go to these comic book conventions, and sitting next to some guy who was drawing, like, twentieth-rate superhero comics, and he'd have a line out the door, and I'd have *nobody*. I thought I was doing stuff that would draw as big an audience as some really specific weird superhero, and yet, no. I was wrong. [*Laughs.*]

HC. So then what happened?

DC. Somehow there were enough of us—there was me, and the Hernandez brothers, and Peter Bagge, and Charles Burns, and a few others—that we created our own little audience. And the people who now go to MoCCA [the Museum of Comic and Cartoon Art comics festival] and

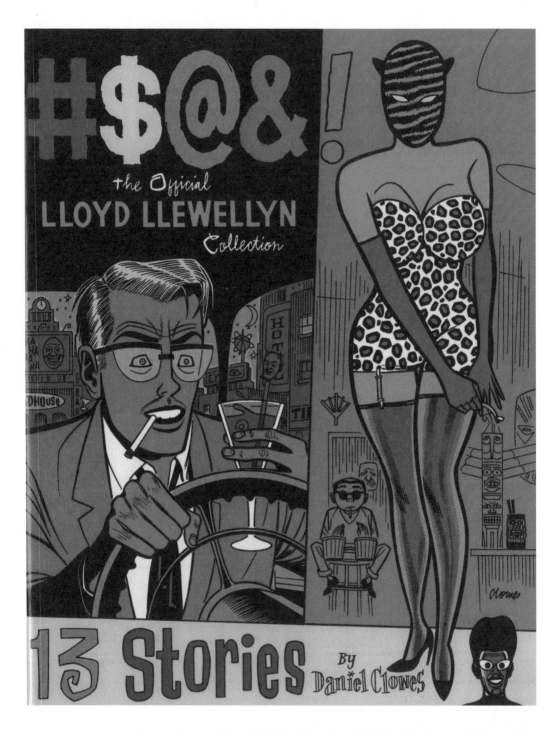

shop at Desert Island [in Brooklyn] and all that, that's sort of where that crowd came out of. And they were kind of indie-rock college student types, who somehow stumbled onto these comics. I mean, it was not easy to do back then. You'd have to actually go out and buy it rather than download the torrent.

HC. Isn't there a character in *Pussey!* that's kind of like a joke Art [Spiegelman] character? Were people pissed about stuff like that?

DC. You know, I never met any of those guys until so long after that that I think it had kind of diffused a lot by then. But I'm guessing they were kind of pissed when that came out.

HC. What do you think about the fact that you're always being accused of having misanthropic characters, especially, say, in *Ghost World*?

DC. I would hope that if you really read the work carefully, that wouldn't be all you took away from it. Because certainly that's not my intention. And I often don't see the parts that people find especially grim and depressing. I usually find whatever I'm doing to be funny. And often I'm surprised when people say, "I was so depressed for two weeks after reading that comic." Not me. When I work, my wife hears me upstairs laughing at my own stupid jokes. [*Laughs.*]

HC. Well, I always thought stories like "I Hate You Deeply" were really funny, like deeply funny.

DC. That's like when you're twenty-five years old and you adopt these kind of extreme opinions just because it's amusing in a discussion with your stupid friends.

HC. I was really surprised when after the *Ghost World* movie came out, so many reviewers talked about the characters Enid and Rebecca as, seriously, almost abnormally misanthropic.

DC. Me too.

HC. Had they never been around teenagers or teenage girls?

DC. I think that's because they only write through the language of film, and through a teenage girl film experience. And so compared to Jennifer Love Hewitt or whoever was popular at the time, they were pretty deeply cynical, I think, but compared to every girl I know, they're Pollyanna-ish. [*Laughs.*] I read lots of reviews where people said, "Nobody actually acts like these two girls, this was purely a fabrication," and I thought, well, I could show you many living exemplars.

And I've read a lot of reviews where people thought the intent of the book and the movie was to make fun of how shallow girls like that are.

HC. Oh, it's deeply the opposite! You're famous—to me at least—for drawing really believable girl characters.

DC. Well, that's nice.

HC. And then your last two works, *Mister Wonderful* [which ran in the *New York Times Magazine* in twenty installments] and *Wilson* both feature middle-aged-man characters.

DC. They're two very different versions of the same guy in a way. With *Mister Wonderful*, the woman at the *New York Times* called me up and asked me if I wanted to do a comic strip, and we were just sort of

5.3. Daniel Clowes, the cover of *#$@&!: The Official Lloyd Llewellyn Collection* (Seattle: Fantagraphics, 1989). Used by permission of Daniel Clowes.

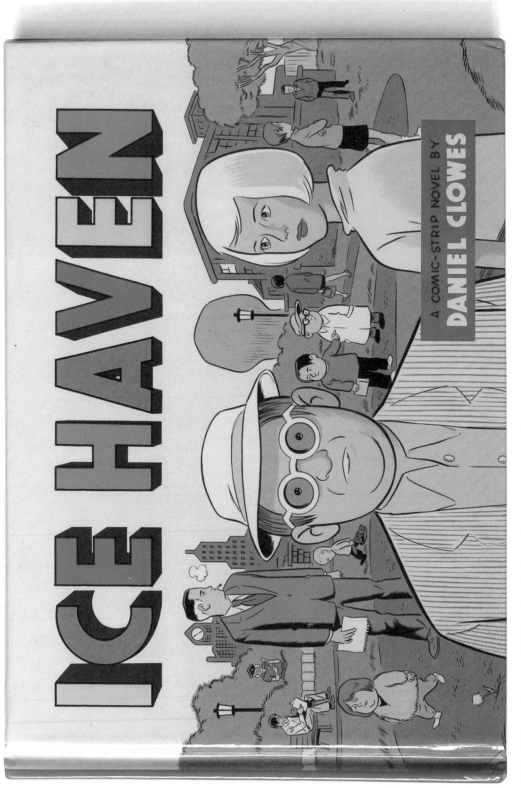

5.4. Daniel Clowes, the cover of the first edition of *Ice Haven* (New York: Pantheon, 2005). Used by permission of Daniel Clowes.

talking about different ideas there could be. At some point in this conversation I said, "I should do a romance story." And of course I was imagining a fifties-style, teen romance kind of a thing. And then I thought, well, what would that mean for my imagined reader of the *New York Times Magazine*? I tried to create the guy I thought was the optimal reader for the *New York Times* magazine, and it was this guy Marshall. And then I thought, what would his love story be? And that's how that began.

But Wilson was a wholly different genesis. It just came out of a completely different experience.

HC. How did you come up with the character Wilson?

DC. My dad was in the hospital, dying of lung cancer. And he was, you know, on his last legs, and he was just sort of *there*, and I was sitting with him for a couple weeks, and I finished my book [that I was reading], and I had nothing else to do, so I got out my sketchpad, and I thought, I should try to draw some comics or something, and I was trying to actually write something that I would draw later. All of sudden I just started drawing these funny comics—this character sort of popped into my head. In the first drawing he was this scruffy bearded guy, and the next thing I knew I filled up this entire sketchbook with hundreds of comic strips with this guy, all done in the most crudely doodled, unprintable form. And I just thought, this is my way of coping with this. And then when I got home later I felt completely as though I knew this guy and there was something there and I couldn't shake it. And I couldn't go back to working on anything else I was working on and it kind of just took over. Which is what happens. You have to go with it.

HC. How did you decide to have different styles throughout *Wilson*?

DC. Originally I was going to do it all in the same style, and I couldn't decide what style to pick [*laughs*], so I kept trying out different styles, and then it became part of the DNA of the book. It was unimaginable then that I would pick a certain style that felt like it accurately reflected this person.

HC. I loved that part of the book, and I loved that part of *Ice Haven* too. They are graphic novels but seem to play with the structure of what people expect a graphic novel to be or to look like.

DC. When I began, it felt like I was just going to do a book of jokes. Before I started working on it, I had spent almost a year writing this big long important graphic novel, that was all kind of planned out, and it seemed like I was really swinging for the fences on this thing. And it became so un-fun to think about. I used to just dread getting out of bed in the morning, because I thought, "Oh god, I've got to work on this *graphic novel*" and it just seemed so awful. And I felt like that was what everybody's doing in comics. Everybody's writing the great American

5.5. Daniel Clowes, *Wilson* (Montreal: Drawn & Quarterly, 2010), 10. Used by permission of Daniel Clowes.

graphic novel and it just seemed so horrible. I thought, I really just want to do something silly. And do something that would actually be fun for somebody to read. That was my goal with *Wilson*. You would pick it up in the store, and you'd bring it home, and you would actually feel like opening it and reading it. I often get comics and graphic novels and it takes me three weeks before I can force myself to read it.

HC. But it's funny that you think of it as being funny, even though it is funny, because on the other hand it's really bleak too.

DC. [*Laughs.*] That's what I keep hearing!! My wife read it . . .

HC. This one is the bleakest of your works, although not the saddest, if that can be a distinction.

DC. I hope there's some empathy for this guy as well as utter contempt.

HC. I liked that he's reading *McTeague*!

DC. Oh, thank you! [*Laughs.*] That was the thing I left blank the longest in the book. I really had to come up with the *perfect* book that this guy would read, and [Frank Norris's] *McTeague* hit me as the perfect book. It's my wife's favorite book. That's a book where when you describe the story, it sounds *so* great. You know, an unlicensed dentist in turn-of-the-century San Francisco. . . . It's pretty untoppable.

HC. Part of what is so interesting about *Wilson* is the form: seventy-seven discrete chapters, or sections.

DC. I thought any subject that popped into my head, I could do a Wilson strip about. That was the appeal. I liked the idea of having a Charlie Brown—you know, a character you could just use for anything. It felt like he had this internal self-sustaining humor mechanism where he never quite learns from anything. Then I hooked into the idea of actually trying to tell a story, kind of in between the comic strips, with this guy. I was reading a bunch of *Peanuts* collections at the time. The book I had actually read in the hospital was Charles Schulz's biography that David Michaelis wrote a few years ago [*Schulz and Peanuts: A Biography*].

HC. Did you like it?

DC. I don't know how accurate it was, but I thought it was really moving. Schulz was very similar to my dad, and so I was very connected to that generation.

HC. How was he similar to your dad?

DC. They were both sort of Midwestern guys. They went to the same church. My dad had a gray crew cut.

HC. The same church?

DC. Not the same actual church building, but this very weird church group that my dad belonged to as a kid, that's kind of an odd thing, I believe. And just very similar temperaments. These sort of passive-aggres-

CUTE DOG

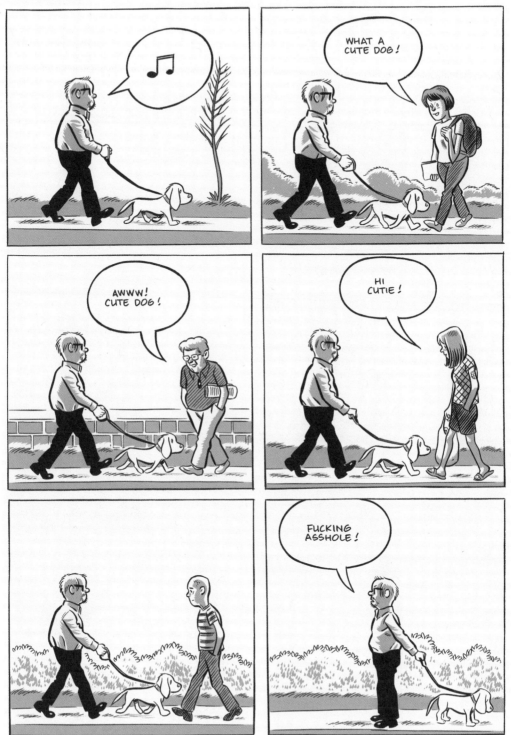

5.6. Daniel Clowes, *Ice Haven* (New York: Pantheon, 2005), 4. Used by permission of Daniel Clowes.

sive but quiet and Midwestern retiring types who were master craftsmen in their own way.

HC. Is there any part of Wilson that is you-like? There seem to be obvious connections like Chicago and Oakland…

DC. He's certainly got my history to some degree. I'd sort of like to keep that as vague as possible, because some of what he's about is exactly me and some of it is the opposite of me. I mean, everything is made up for the most part. There's a grain of truth to it all, and everything is made up. That's why I never wanted to do autobiography, because it's so much easier to make things up. And things work out so much better in the story than if you did autobiography.

HC. Is it true that *Wilson* is your first graphic novel with work that wasn't published anywhere else?

DC. Yes, amazingly so.

HC. How did you decide that you wanted to make it a "graphic novel" object?

DC. I felt like the whole comic book thing is over. Like we can't go back to that anymore. Now that you have to charge six dollars or whatever for a comic book, it's not the same thing as it was. It just seems like an affectation at this point in time.

HC. *Wilson* is more than twice the size of *Ice Haven*. How did you decide to make it so big?

DC. I liked the idea of *Ice Haven* as this little travel book or something. I wanted it to look like a postcard. *Wilson*—I just wanted everything about it to be sort of easy to read. I wanted it to just have the feel of a kid's book, almost—sort of heavy, weighty. I wanted it to feel like it could take a bullet— like you could hold it in front of your chest, and it's like, *the bullet didn't make it all the way through!* It's really the thickest board I've ever seen on a book. I told Chris Oliveros at Drawn & Quarterly, "I want the thickest board you can get me." I thought, there's something so great and strong about it. I felt like in a world where everybody is downloading books, it was saying, "I'm a book, damn it—deal with me." No e-book is going to look like this.

HC. I just wanted to say that the Harry Naybors comic book critic character in *Ice Haven*…some of what he's saying is actually pretty good! You're not totally making fun of him. I was reading it again yesterday thinking, this is actually a really articulate, apt description of comics.

DC. He's sort of right, but he's somewhat ridiculous. At a certain point when I was writing him I realized, I've done the most pathetic thing ever. I've created my own critic who really likes my work. Then I thought, I should be more charitable to this guy! Why do I have any bad feelings towards him?

HC. I loved that part of it.

DC. I always thought if I made a movie of *Ice Haven* I'd have to change him to a movie critic. But that's not as funny. Comics critic is much funnier.

HC. Art [Spiegelman] once said something about Chris Ware's work that I thought was interesting, which is that he said Chris's work is about a sensibility.

DC. Hmm, which sensibility is that?

HC. I didn't ask him what he meant, but I was just interested in the idea of a work being about a sensibility.

DC. I don't know that you would ever sit down and create work with that as your guidepost. I think the sensibility emerges if you're doing the good stuff, doing your best stuff. I certainly know when I sit down to re-read all my comics, I'm overwhelmed by how much more personal they are than I ever thought they were.

HC. When you were doing them you thought of them as less personal than you do now, reading them in retrospect?

DC. Yes. I think you start out with ideas and you try to be sort of fearless and put in everything. And then the process of actually sitting down and ruling out the paneled borders and drawing the lettering—all that stuff is very impersonal, the technical part of just trying to figure out how to tell the story and to get the story to be told in visuals. And you remember that part, because that's the hard work, the endless sitting at the board work. It doesn't seem the same as the initial stage where you're actually thinking of what ideas you're going to present in the strips, and so you kind of forget that it comes from that place.

HC. You mean you get so absorbed in the production aspect of it that you kind of forget how personal the content is?

DC. Yes. I mean, maybe that's like a defense mechanism for me, so I turned it into this process of: now I've got to just draw this guy! Got to get the background right! And all that stuff. It's a way to distance yourself from what kinds of emotions are in it.

HC. So now that you've finished *Wilson* and you've put aside the great American graphic novel, you're working on *Mister Wonderful*, the book of strips that was first serialized in the *New York Times Magazine*. Did you like serializing in the *Times*?

DC. That was a lot of fun. It was sort of the perfect thing right at that moment. To have this finite thing that had a weekly deadline, that I knew would be over after twenty episodes—that was the perfect thing to drop into my lap right at that moment. I tried to make it really simple. It's all in one night, it's a guy on a date. . . . I tried to make it so that if you missed three episodes, you could still pick up again what was going on.

HC. I feel like each week ended with actual suspense!

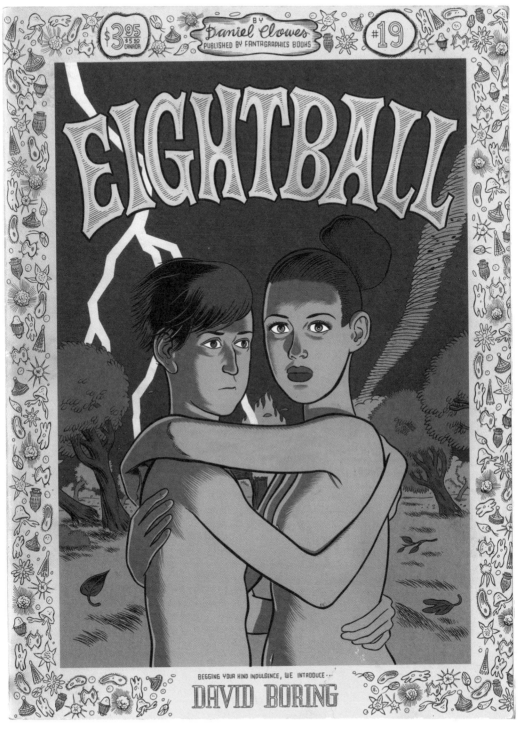

5.7. Daniel Clowes,
the cover of *Eightball* #19
(Seattle: Fantagraphics,
1998). Used by permission
of Daniel Clowes.

DC. I worked hard on that. Stuff like that you get so little response to. There were three or four people who every week would write me e-mails with little comments. The *New York Times* didn't add a comments section when it was online or anything like that, so you just hear *nothing*.

HC. That's really annoying, because they have comments sections for most every article, and there are like ten hundred irritating comments.

DC. I probably would have killed myself if there were comments like that. There's actually nothing that depresses me more, ever, than to read any comments section. Of anything. I actually force myself to never ever look at comments.

HC. But I like "Letters to the Editor."

DC. That's because they actually, like, call up the people who wrote the letter, and fact-check their name, and these are people who are actually going to stand by what they're saying. . . . It's not just some anonymous twelve-year-old.

HC. Right, with some tacky "handle."

DC. Right.

HC. Is that what they call it, your online name?

DC. That's what they called it back in the CB days—[*laughs*]. During my trucker years . . .

HC. Are you going to do any more issues of *Eightball*?

DC. I'm sort of into the books now. For years I was really into the comics, and the books were more kind of an afterthought, and now I've moved into being interested in doing the books, and it's fun for me to do books, and to think about books, rather than comics.

HC. Your book *The Death-Ray* was technically an issue of *Eightball* in 2004, right?

DC. That was an issue of *Eightball*, but it was kind of a really weird thing to do. I should have just done it as a book, and you know, people would have actually read it.

HC. How much did it cost? I bought it, but I can't remember.

DC. I think six bucks.

HC. That's cheap.

DC. That's why it's just insane from my standpoint, as a guy trying make a living doing comics. It's like here, take this for free.

HC. I loved that it was kind of in between a book and a comic book.

DC. Yes, that was sort of the last time in history that that felt like something you could do. You know, just to have a comic like that and people would read it as a comic. But it's very hard to explain that thing to anybody who's not in the world of comics. I have such trouble explaining my career to people who are just sort of aware of *Ghost World* or *David Boring* and *Ice Haven*. You say, "Well, it was originally in *Eightball*," and

they don't know what that is and they just don't get any of that stuff. That whole world we were in, it seems so, so lost. The whole world of zine culture and doing your own little comic pamphlets and that stuff. It's very hard to explain to someone who was born in 1990 what that's all about. [*Laughs.*]

6

Phoebe Gloeckner

Phoebe Gloeckner began her career as a medical illustrator who published comics on the side in volumes such as *Twisted Sisters: A Collection of Bad Girl Art* and also did experimental illustration for work such as J. G. Ballard's *The Atrocity Exhibition*. In 1998, she published her first book, *A Child's Life and Other Stories*, a comics collection that has at its center several hard-hitting semiautobiographical stories featuring a character named Minnie. Her next book, *The Diary of a Teenage Girl: An Account in Words and Pictures* (2002), takes place in 1970s San Francisco and focuses on one year of fifteen-year-old Minnie's life—a year in which she starts an affair with her mother's predatory boyfriend, gets kicked out of several schools, runs away to join Polk Street's gay and drug subculture, and draws many comics. *Diary*, the most unabashed record of teenage sexuality I can think of, is a remarkable formal object, roughly half Gloeckner's actual diary from the time and half narrative she formed as an adult. The story moves forward in both prose and comics sections, seamlessly alternating back and forth, while also featuring many spot and full-page illustrations. (The *New York Times* wrote that Gloeckner "is creating some of the edgiest work about young women's lives in any medium.")

Gloeckner's current project is another formally experimental take on young women's lives, but it focuses on the murders of women in Ciudad Juárez, Mexico. Gloeckner first traveled to Juárez in 2003 to research her "graphic reportage," *La Tristeza*, which was commissioned for the volume *I Live Here*, edited by the actress Mia Kirshner (Pantheon, 2008). Gloeckner started off drawing scenes of murder. She eventually developed a three-dimensional sculpting and modeling technique whereby she poses dolls that she creates—they are felted wool with wire armatures, and have styled hair and meticulously detailed clothes Gloeckner sews—in scenes in elaborate quarter-scale sets. She photographs them

and then digitally integrates the doll faces with human features. The images are at once fascinating and highly unsettling. Currently an art professor at the University of Michigan, Gloeckner was inspired to embark upon a larger project focusing on the Juárez–El Paso border area. She has visited Juárez more than a dozen times in the past several years, and made close connections with the family of a murdered girl, Maria Elena Chávez Caldera, who remains the inspiration for her forthcoming book.

Our conversation took place in her Ann Arbor studio, where she builds and photographs her sets—and where her three-legged cat, Pipsqueak, hides out—for two days in December 2009. Gloeckner's studio occupies the top floor of her house. We were frequently joined by her then eleven-year-old daughter, Persephone, who improved my life by initiating me into the world of *Twilight* (Phoebe calmly sewed doll clothes as we screamed at the screen). I caught up with Gloeckner again in New York City at a performance of *The Diary of a Teenage Girl*, a 2010 play adapted by Marielle Heller, who also stars as Minnie. Phoebe noted that she had seen the play four and half times already, and wasn't sick of it. "Diane [Noomin, editor of *Twisted Sisters*] asked me tonight, how can you watch this? Don't you feel destroyed? Because she was really affected by it. Every time I see it I forget that it's my own reality, and to me it becomes someone else's story that I'm experiencing."

"WHEN I WAS IN MY TWENTIES, THAT WAS HOW PEOPLE RESPONDED TO MY WORK, LIKE THEY THOUGHT I WAS A SLUT OR SOMETHING."

HILLARY CHUTE. In the introduction to *A Child's Life*, you write about how you had this sense that no one would ever really see your work. You could do these "shameful" comics because no one would ever see them.

PHOEBE GLOECKNER. I was too young to be a hippie or anything. I read underground comics as a child because my mom had them. It was a weird period, because hippies were kind of out of style. I was getting into punk rock and it was like "dirty hippies" was one of the things you didn't trust. Comics were kind of a hippie thing. And the underground comics were not as popular as they had been, and head shops were kind of closing, and they were the only places you could get underground comics. They were selling pipes and stuff and I would just go buy some

comics. There were all these sex comics, and the guy behind the counter would always be looking at you like, "Oh, you're going to get this comic, huh?" So it was weird, because none of my friends read comics like that, because they just weren't popular to people our age, and they were obscure enough that they weren't readily available, even in San Francisco, at that time, and it was way before [independent comics publisher] Fantagraphics or anything like that.

HC. Right.

PG. My mom started dating a cartoonist, and I knew Crumb, so I knew cartoonists, but they were a different generation. I equated them kind of more with my mom, you know?

HC. Did you always draw comics?

PG. I was always drawing. But doing comics was the first time I was doing some finished thing: you make a progression from just drawing to making a story—you're writing as well, and it starts involving other faculties. Then I was [published] in a comic book. It was weird because I knew no one would see it that I knew, because no one read comics that I knew. I felt like I could do this in a bubble and still feel this sense of accomplishment. I wasn't risking anything, because no one was going to see it, so I could do anything I wanted to.

HC. So then what happened with *A Child's Life* coming out as a book? What changed?

PG. This publishing company came to me and wanted to see my portfolio for medical illustration, so I scheduled a meeting—it was North Atlantic Books. In the meantime they just mentioned to somebody that I was coming. And that person said, "Oh, Phoebe Gloeckner. She does really good comics." And they didn't know who I was. So when I got there they looked at the medical illustration, and the publisher says, "You know, we've been toying with the idea of getting into comics, maybe publishing something, and someone told us that you were a really good cartoonist." And he said, "Would you be interested in publishing a book?" And I said, "Are you kidding me?"

HC. Did you feel then that the content of your work was shameful?

PG. I felt, I guess, defensive about—you know, I always felt like in my work, I'm actually not repeating things. It might look to people like, "Oh, this victimization bullshit," and to me it was never about victimization. I might even tell what appears to be the same story, but in my head it's totally different. If anyone was going to bother to read all of *A Child's Life*, they would understand any particular story in a different light, and probably in the way I wanted them to understand it in the first place. But what would happen typically would be someone would read one story

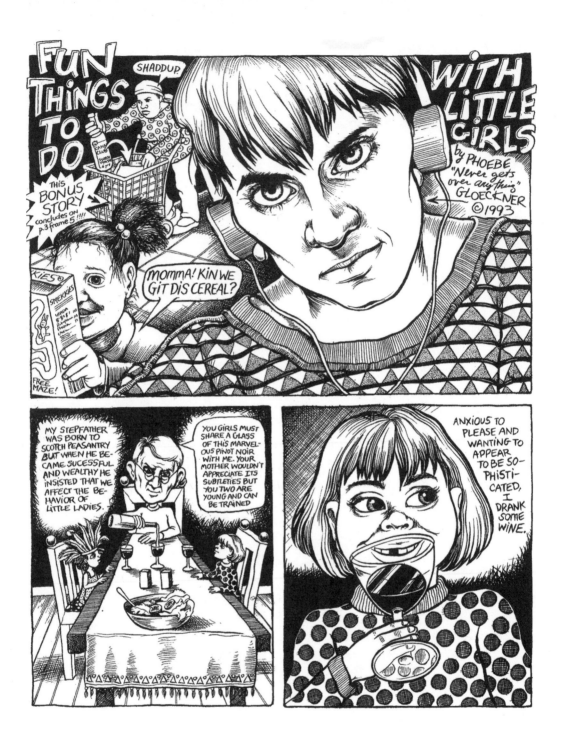

and think it was all about sex, and then look at me like I was some kind of [*noises*], you know?

HC. What do you think about your work being labeled obscene or pornographic?

PG. I think my work is not at all pornographic. I think that I'm just

drawing life, and at the times where sex is important to depict, I depict it. I never felt at liberty to pick and choose anything else but what seemed important, and I don't judge it, but I certainly have felt judged a million times. I guess I've become inured to it. I've been accused of doing things just to be provocative, which is bullshit.

But one time this pornographer·guy bought a painting from me, and it was a version of this image that is a cross-section of a blow job. I had done this painting for *The Atrocity Exhibition*. So I had a really large painting, and it was in color. So there's this pornographer who used to employ cartoonists and stuff to do dirty comics. *Screw* magazine.

HC. Al Goldstein.

PG. Al Goldstein. Right. So he wanted to buy this painting. He took me out to dinner and then he was paying me and he said something to me like, "I don't know whether you really like giving blow jobs or you really hate men," and I don't know what I said, but then, when he was paying me, he just gave me one hundred-dollar bill at a time, and he was paying me, like, three thousand dollars. I don't think I've ever been paid that much for anything, and he did it one [bill] at a time so it was taking forever and everyone around us was staring, and he knew it. And then he goes, "Do you feel like a hooker? People think you're a hooker."

HC. He sounds so creepy!

PG. Well, it was kind of amusing. But in a way, especially when I was in my twenties, that was how people responded to my work, like they thought I was a slut or something, so I just kind of didn't ever show people anything.

"AT ONE TIME GROWN-UPS READ BOOKS WITH PICTURES, RIGHT?"

HC. How have people in your family responded to your work?

PG. They don't want to hear about it, and my mom . . . she can get real mean and real paranoid, and she threatened to sue me after *A Child's Life* came out. She said, "I'm going to sue you," and she would call me late at night and say things like that, and I couldn't sleep. I used to have dreams. I'd wake up in the middle of the night . . . like she was sneaking in my house and trying to kill me with a knife. Things like that.

HC. I read an interview with her ["The Two Phoebes: Diary of an Artist and Her Mother" in *Metropole*] and I was struck that her response, when she was asked about some of the things that happened in your adolescence, seemed fairly unsympathetic.

PG. She had terrible responses. I mean, nothing was ever her fault, and

6.1. Phoebe Gloeckner, panels from "Fun Things To Do With Little Girls" in *A Child's Life* (Berkeley: Frog/ North Atlantic Books, 1998), 66. Used by permission of Phoebe Gloeckner.

nothing is her fault, and she didn't take responsibility for many, many things. What happened was that when I did tell her, she was angry at me, more than at [her boyfriend]. . . . But I've come to accept the fact her brain is like that.

I remember when I was really little, like, when I was five or six, I would look at her and feel like, "She doesn't love me." And I don't know why I thought that. I just remember understanding that she doesn't understand how to love, and luckily my grandparents—I really felt love from them, and I lived with them a lot.

HC. Did you ever feel like you were the adult in the situation?

PG. Well, no. I mean that's what people say. "The child becomes the adult." No, because I knew I wasn't an adult.

HC. You just wanted her to be more of an adult.

PG. She just couldn't be, and I think I understood that on some level. I wish she had been more like a mom, like taking care of us, but I think I understood that she wasn't capable.

And I mean since I was sixteen or something, she would say things to me like, "Look, when we go someplace, just pretend you're my sister. You're old enough now, you know, I'm too young to be your mom."

HC. Oh no.

PG. It was almost like, you know, I've had enough of pretending to be a mom. Let's just give it up now.

HC. And she felt maligned by your work?

PG. You can't worry about "What's Mommy going to think?" when you're writing a book. First of all, you have to distance yourself. Because you know even if it's true somehow, you are totally fabricating this story. You have to put it on some narrative structure. You have to mix points of view and do all this shit, which in the end makes it something less than real and more than real. I mean, you are trying to make someone else experience something, and it's artifice.

HC. Since you're talking about aesthetic distance, one thing that's so striking about your work is that there is a lot of formal inventiveness from work to work. The form of *The Diary of a Teenage Girl* is unbelievable. There's the diary part, there are the one-page illustrations, and then there are the comics interludes, and then there are the bits and pieces of other comics. How did you come up with the structure?

PG. It was really hard, because, well, the trouble with my work, it's true—I don't like to repeat myself formally. I get really anxious and bored and I feel like I've hired myself to do something.

HC. That's funny. . . .

PG. Just imagine. You have this fucking diary. It's burning a hole

I have a towel around my head and Noxzema on my face.

in your head. It's sitting in your closet for twenty years. You want to do something with it. So then it becomes this precious thing. You don't want to touch it, because it's like "the words of the past," you know?

And so for a while I was trying to preserve it, yet thinking, This is not right. If somebody reads this, there are forty million characters in it, and they're not going to understand. You know, you suddenly see all these problems. It didn't read as anything. So no one's interested in your juvenilia just because it's sitting there, you know, unprocessed. Who cares?

So then I started thinking. You know, I love really old books. I have this edition of Émile Zola. Here it is [*pulling old Zola book from shelf*]. Anyway, it was twenty-five francs in Paris in one of those by-the-Seine bookstores. I love these books. Books for grown-ups always had pictures.

HC. The illustration is amazing.

PG. Yes, but the point is not the illustrations themselves, but rather at one time grown-ups read books with pictures, right? It's interesting. So then I was thinking, OK, I love those books. I'll just have single-page illustrations. And there are more than twenty in *The Diary of a Teenage Girl*.

But the relationship of a single illustration to the text is just by nature

6.2. Phoebe Gloeckner, a drawing from *The Diary of a Teenage Girl* (Berkeley: Frog/North Atlantic, 2002), 163. Used by permission of Phoebe Gloeckner.

6.3. Phoebe Gloeckner, from *La Tristeza*, part of the volume *I Live Here* (New York: Pantheon, 2008), unpaginated. Used by permission of Phoebe Gloeckner.

redundant. It doesn't really contribute to pushing the narrative forward. It might show you what somebody looks like, but you've already read about what that person looks like. It's clarifying in a way, but it's usually an interpretation of an author, because the author usually doesn't draw the picture. It's some sort of something that's removed. And I was thinking, Well, in that case, these illustrations are kind of useless, and it was getting me mad. And then I was remembering all these other things that I wanted to be in the book that I thought were important. I wanted to do sections as comics to fill in the blanks without someone telling you what happened—more of an omnipotent point of view. You know, because with teenagers, it's like, "Me, me, me, me."

HC. There's sort of a visual voice in the comics that almost seems to interject. It's almost like the older self and the younger self having a conversation.

PG. The challenge was to make it seem somewhat seamless.... I wanted the comics not to feel inserted. I wanted the book to be read linearly. I mean, I guess people might skip to the comics. Lots of people complain there are too many words. But it didn't bother me, because I wanted the words to be there, and then all the other stuff—it just had to be there, too.

HC. Right, and there are also floating illustrations, and the text goes around them.

PG. I had to learn how to put the book together myself as a designer. It probably would have looked better if somebody who was an experienced designer had done it, but my concern was that the reading had to flow, and things had to be on the right page in relation to the text. It was too much work for a designer to be working with me as I was doing the book. ... Originally I had a designer and it drove her nuts.

LA TRISTEZA

HC. Since we're talking about linear narratives and how to read, *La Tristeza* has such an interesting narrative form. Can you describe how you wanted someone to interact with that? Because it is really nonlinear.

PG. OK, so this is not a linear narrative. It's not ever a linear narrative.

I did this, and what is it about? I mean, it doesn't even matter if it's about Mexico. I think it was me responding to just the sheer number of people who were killed, and then trying to look at it individually. It was this thing struggling with having been kind of artificially placed there. The way it's written ... I mean, maybe you recognize it—you know, I didn't speak Spanish, and so I was constantly looking on the web for more stories of what was happening, and then I would translate it in

6 OF JANUARY
THE DISCUSSION BOARD OF MEXICO
SEX TOURIST

In Juárez life is cheap and
girls are sexy. On one of my
last evenings in the city I
walked behind Juárez Ave. and
saw a beautiful girl. She was
young, in her early twenties,
and we were attracted to each
other. She offered me a blow job
for only 20 USD, and I was in
the mood for a good shot that
cheap. Blow jobs are safe and I
like to see my cum on a girl's
face. So I told her OK but only
without a condom. We went to a
room and she went down in front
of me. She massaged my balls and
let my dick slip in and out of
her mouth. At the moment I came,
I grabbed her hand to let her
swallow, and the last drops fell
on her face. She smiled at me...

May you have a safe and happy
whoring experience in the
fleshpots of Ciudad Juárez.

Google, and the language was so weird. It's like that's how I learned to think of Spanish, not as Spanish, and not as English, but as this [other] language.

HC. That slightly messed-up, Google-translated language.

PG. But it also sounds to me kind of like a Victorian language. Certain prose in Victorian English. It reminded me always of some kind of stilted, slightly wrong sound. And I just grew to love that language. Some of the pieces of writing in *La Tristeza* are actual stories that I took from the papers, and then others were changed a bit, or rewritten, because I was grabbing stuff, you know. It was somehow working.

HC. The white boxes that have text in them seem like a documentary level of the narrative, but the text doesn't synthesize, or it doesn't always explain the nearby image. With the text and the images, I was trying to—my brain just sort of automatically wants to . . .

PG. Put them together.

HC. But they're not necessarily together. The evidence, the documentary stuff, is presented, but not in a necessarily explanatory way, so then your mind is sort of working through.

PG. [*Pointing to the page with the words "Your blood has even gotten thicker so your wounds bleed less" over an image of a body*] You know how you get spam, like bullshit spam, like "Make your penis larger"? Anyway, usually I just throw the spam away, but sometimes there is all this text in there, and anyway, I was reading it and that was embedded in some spam, and I was thinking, *whoa*. It was just making such an impression on me, I couldn't forget it, and so then it just seemed to be part of this.

HC. Why did you decide to start making and using the dolls?

PG. I made a living doing medical illustration. You get hired for the same thing over and over again if you do it once. So I was drawing a lot of eyeballs, and drawing a lot of penises and sex-manual-type things. Illustration might be fun for a while, but then it gets kind of boring because there's not that much variation. So I was doing this joy-of-sex-toys book [*The Good Vibrations Guide to Sex*] right at the time I went to Juárez, and they had sent me this huge box of sex toys, like whips and dildos, and things that light up, and butt plugs. They wanted me to draw them and do all this stuff. So anyway, I got back from Juárez, and I had all these police reports, and I just remember reading one about this girl who had slowly bled to death because they had raped her with a splintered two-by-four, anally.

I didn't like that thought of bleeding slowly to death after having something shoved up your ass. It just was not pleasant, and then I was drawing these pictures of these butt plugs, and the text was something

like, "They come in this package of five, and they're all different sizes, and what you can do is start with one, and have it up your butt for two hours." I'm not even thinking about it judgmentally; I'm just drawing it. And making it look all soft and fuzzy. And then the directions were to increase the size of the butt plug, and even wear it to work, but why? I don't know why, but anyway, because you want to, right? I was drawing that at the same time as I was reading this police report. I just started to feel like literally I was having a nervous breakdown. It was something about those two things. So I was trying to draw. . . . I felt like I had to draw the murders. I had to show the murders, because the girls experienced them. I couldn't just not show it.

And I kept trying to draw these things, and I wasn't drawing from real life. You know, you have to imagine it, so your brain is kind of churning like, Oh, how does it look? And your brain is doing some kind of weird 3-D thing, like trying to get the picture, and I just started feeling like I was going to throw up. I really couldn't do anything for a month. I couldn't draw anymore. I couldn't do that sex manual. I just felt like I was going crazy.

HC. What was it like trying to draw the murder scenes? You were saying that you had to have an image of it in your mind.

PG. I've seen a lot of surgery and dead people, but there's some point where you kind of just cut off. You're no longer empathetic to it, because you can't be. You can't really survive and feel it, but then sometimes you'll have these flashes. It's just like existentialism. Suddenly you realize you're flesh. And those moments where you really realize what the experience is for the other person, it's horrible. But you're not conscious of it the whole time, because you can't be. Your brain doesn't let you be, so it's terrible, and I guess the doll thing, I just—I felt like I was killing people by drawing them being killed, and I couldn't do it.

HC. That's so interesting—what do you mean?

PG. If you're drawing someone being raped, you have to imagine raping them. You also have to imagine being raped. You also have to imagine your friend or your daughter being raped. You also have to imagine your brother raping somebody. All these things are in your head, and it's like, "Who is it? Who does this? Why?" I guess if you're writing or drawing it's like you become all of the characters.

Anyway, I always read photo novellas, because you can learn a language that way, colloquially. You see what's going on because you see the pictures. I thought, Well, I could just make one with dolls. It'd be really quick, and then it wouldn't have to be in my head so long, and the dolls could be all bloody and die, and I don't care, because then I could just wash them off, and they won't be really dead. As if they would be alive.

They wouldn't be alive, because they're dolls, but it doesn't matter. I was just trying to make it easier, so then I started experimenting with dolls. The regular dolls that I had liked turned out just so hideous because, I had seen much of that—artists taking dolls and then using them in photographs, and . . . yeah. It didn't look good to me.

HC. Had you ever done this kind of sculpting, three-dimensional-type of work before?

PG. No. In the beginning, I wasn't quite making that leap. I was not making the dolls de novo. But I didn't like how they looked. And then when I got to the University of Michigan, they gave me fifteen thousand dollars start-up. So then I said, "Oh, I'm going to buy some power tools."

MARIA ELENA

HC. How did you decide to focus on one girl for the project about Juárez you're working on now?

PG. When I first went down there, we met all these families of girls who had been murdered, and it was really hard for me. My older daughter at that time was a young teenager, and I was thinking, All these other girls were that age, and so you can't help but relate immediately to these mothers who are bursting into tears. And besides that, there was just this incredible poverty. Some of the families were so poor that we were sitting in the house [and] there's this dirt floor. There's no plumbing. There's no water. There's electricity tapped from some wire someplace, and there's a sandstorm blowing wind, so you can't go outside, and the wind is coming right through the house, because it's just discarded wood with cardboard tacked on the other side, like old boxes, and they had lived there for, like, ten years. It's like nothing improves.

At the most I had thirty pages to do the story, and I felt like I couldn't possibly address all the things I was thinking and feeling in those pages. And so I decided that I was going to do something longer. I don't want to do that kind of short thing—encapsulate life. You have a little slice of life of this poor suffering person and you feel like you know everything, but nothing ever happens. Nothing comes of it. I wanted to go back to Juárez. I wanted to really somehow be a lot closer to it than I was. The separation really bothered me.

And I decided to focus on this one girl for the longer story. The reason I chose her was because we had met a lot of people, and a lot of families, and most of them came and showed us pictures of their kid. They would save newspaper clippings talking about when she was missing, and some of them even had videos and things, and lots of things to tell, stories to tell, report cards, everything. And this one girl, her parents

6.4. Phoebe Gloeckner, cover illustration from *The Atrocity Exhibition* (San Francisco: Re/Search, 1990). Used by permission of Phoebe Gloeckner.

had nothing. They had no picture of her, not one picture, and then finally her mother said, "Well, we do have one picture, but the police took it to make the missing poster, and they didn't give it back to us." So the only picture they had of her says *missing* right across her forehead. It was a Xerox copy.

HC. That's so heartbreaking.

PG. They didn't save any of her stuff. I mean, they had twelve people living in one room, and, you know, they might always live almost that way.

The police weren't doing anything. So I really thought, "Well, gee. If I just find these people, maybe, you know, we could figure out what really happened," but then of course that didn't happen. I didn't figure it out, so it's not like a neat little thing that wraps up in the end, and everybody knows what happened. This last June I was there. I was going to interview this guy who was originally a suspect. Anyway, this guy I was going to interview was shot when I was there two blocks away. I was going to interview him that afternoon.

HC. This is a serious, in-the-thick-of-it, investigative journalism project.

PG. But I can't say any names really. I can't, so it's not like that.

HC. Right, but part of it is. The procedure part of it is like that even if the result isn't journalism in a typical fashion.

PG. It is like that, definitely.

HC. You're out there interviewing people who are getting shot and tracking down subjects with cameras who haven't been interviewed by the police. You're doing all of this journalism work.

PG. I am. It's not obvious, but all my work is like that.

"I WOULD JUST THROW THE TRASH ON THE FLOOR."

HC. Will you explain your procedure of working with the dolls and the sets that is part of both of your Juárez projects?

PG. So you see this floor? It's canvas with glue and sand mixed up and put on there. This has changed around a hundred times. I used to have loose sand everywhere, and then I was building little houses, but the cat started shitting in the sand, so then I had to glue the sand. I would come up here and there would be sand on the floor, and every time I had some trash I would never think about throwing it in the trash can. I would just throw the trash on the floor. Because in Juárez, it's like there's trash everywhere, and because on the outskirts they never have trash collection, and the sand covers it, and the wind blows and the

trash is exposed, and it's all over the place. So I was trying to cultivate bunches of trash.

This guy [*picking up male doll inside a constructed set*]. He's a bad guy. You don't see it, but he's got a big dick in here with a wire in it, because he raped somebody, and I don't know if I'm going to show that scene or not, but it has got to be there. Just because I know it's there it makes him more threatening. I don't have to be rude and show you his dick.

HC. What? You were talking about it.

PG. OK, let's see it. It's not that big, but it's just there. There's the little balls underneath it. And some of the dolls have vaginas so they can be raped.

HC. So you had to teach yourself how to sew—not only the clothes, but the bodies, too. The hair is complicated. Everybody has specific, different hair . . .

PG. I didn't know how to sew at all. Hairdos—I mean, that's kind of fun.

HC. The full reconstruction process is so fascinating.

PG. I mean for me it was just essential because I have to be close to it.

HC. Where do the photographic faces in your work come from?

PG. I use my face sometimes. I'm superimposing things, but there's a lot of distortion involved. It ends up looking on the doll like maybe it's not so distorted, but I try to make it so that it's conformed to the face of the doll.

HC. So you set up the scene, you pose the doll, and then you have this photograph, and then how do you actually get the final image?

PG. OK. Let me show you [*opening up image files on the studio computer*]. I don't love this picture, but I'm working on what [Maria Elena's] boss is going to look like. The guy whose house she cleaned.

HC. What's his name?

PG. His name is Hector. So I was working on his face. So this is going to be his face, what it is going to look like. You know in Photoshop, you can keep the layers intact. That's Arthur, my husband, and so he's playing that role, but I distorted his face.

HC. This is exactly what I wasn't understanding before.

PG. I put his hair in a headband so it's back. It's an ugly picture, a terrible picture. Not flattering. I was telling him what to do, and he'll very nicely do it. But then his face is too long and narrow and I don't want it like that, so I made it wider and then I started blending things, distorting them, and actually . . . oh, look at that. I was putting cataracts in his eyes.

So I'm just adding things there at that point to make it look more like this old man. Hector's mouth is much bigger and his eyes are smaller and his chin is beadier and I distorted the color to match the doll's more. It's not quite done yet. You can see it because it's not quite blended into the

doll, and the hair's not done or anything. But this is just an example: OK, so what's this character going to look like, and is Arthur the right person to be that? How much am I going to have to fuck with his face to get it to be like I want it to be? It's not something that is just automatically put in.

HC. Right, you don't just slap the face onto the body in the program.

PG. Right, you wish! You have to make it look like it's integral to the image. It's not quite there yet, but I think he looks like this asshole I want him to be.

And if the faces are not distorted, it doesn't look good, because the image doesn't have that kind of unreal thing. I don't know if it's always obvious that they're changed, but they're changed a lot. Like sometimes I even use eyes from one person, and a nose from another person.

HC. How do you feel about having people you love in your family be the bad people in the story?

PG. It's OK. I mean, the thing in this book for me is: what happens when somebody dies? My nephew died two years ago; he was sixteen. He was here for a week visiting, and I asked him if he wanted to be a character, and he said, "Yes." My nephew was having chemo. He didn't have any eyebrows or anything, so I had to give him the moustache and eyebrows. We had a really good time, but it was sad. And as I'm working with his face or drawing a picture or something I feel kind of like he's talking to me. I mean not a hallucination.

"HOW MANY LIVES ARE AFFECTED BY ANY ONE MURDER?"

HC. So what is the form of the book ultimately going to be?

PG. Well, it's like *The Diary of a Teenage Girl*. I have all this stuff. And I'm still struggling with the final form because I'm doing some animation.

HC. So it's going to be a printed book, but there's animation, too?

PG. I have a Kindle. I got it when it first came out. I'm fascinated with how books are going to be, because I really think they're going to be different. Just face it. But the machines to see the books are not quite right for what I want to do.

In the book, it might be that you would have a couple pages of text and one picture, and then, you know, maybe it's just a picture, but as you're turning the page, you see someone move a little bit. Are they still alive? And then maybe you could, like, pet their face and it goes into the scene of what just happened, or it's animated.

The Diary of a Teenage Girl has these different elements visually. But this new project cannot be a book with a CD. No one would look at that.

It would have to be something as seamless as possible, but not a film, because what I like about the [form of the] book, however it is, is that you control it when you're reading it.

HC. I think that's key, especially with a work as traumatic as this is.

PG. Yes, and I just don't want to tie it up neatly and end it. And also the words are important to me. In a film it's like you no longer have control of that. You don't focus on words in the same way.

HC. Yes, I mean, it's in time in the sense that you just sort of cede to the film . . .

PG. I want some element of time in this, but I want to mix it up in my own terms. I want to control it. I don't know if I would be able to do this. I'm thinking not, although I have all these elements, and I continue to work. Next month I'm working with these people to do this kind of animation where I have my actor and the dolls. That's why I'm working on these new armatures, because I want to get a doll that moves better, so that they can be keyed together, like the doll will have points on it, but they'll digitally align to points on this person's face, so we can get it in real time more easily, and have the dolls animated, but the face will be following, you know?

HC. So the face will be a human face, in the vision of the final product, but it will still be the doll moving. The doll body moving with the human face.

PG. Right, so it will be a similar effect.

Most likely I'm not going to find anyone who would be able to do with it what I want to do. I mean, companies are coming out with better interfaces for books, but ideally . . . I think they should make a Kindle or whatever it's going to be called, with something you can turn, and I don't know exactly what I'm talking about, or how they would do it. But I think when you're making a book, especially a comic book, you actually use this element of surprise.

I want for someone to be able to scroll through the whole thing, and there would be a half page, or a full page. I want to be able to use the relationship of pages to each other intentionally, one way or another, to work for the story.

In the Kindle right now, it does have virtual pages, but you don't have two pages together, although you could. I guess there are other ways to get around it, but it just seems like those electronic books have a ways to go before you can do what I want to do with it.

HC. So you'll have the images with the dolls, and text, and animation—what are some of the other parts of the narrative?

PG. I have this whole other part of the project that is going to be shot as a photo novella. The murdered girl's sister, Brenda, is part of that. She

was thirteen when her sister was murdered. Now she's about twenty, and she has three kids, and a totally different life.

HC. Did she mind doing these reenactments, based on things that actually happened?

PG. These are not based on real things. It's kind of like a foil to the story, because when you read Spanish comics, or ones in English, or the photo novellas, they're all really dramatic. Or the things on TV. I watch Spanish TV all the time. Everyone is beautiful, and everyone is cheating or loving or something.

It was hard to get Brenda to be real dramatic. She was laughing, saying, "Why am I doing this?" But it will work in the end. You have to idealize it because that's what's done and that's what feels right, because I'm not making fun of her. I'm making her *la romantica*.

But all these stories that feed into it are part of the confusion, because when you look at Juárez, you look at, OK, what? By the end of the year, it will be, like, twenty-five or twenty-six hundred people who have been killed. That's a hell of a lot of people. None of these murders are solved. How many lives does that represent? If you kill a person, you know she has a family. She has this [*pointing to pictures of Brenda*]. How many lives are affected by any one murder? And there are all these stories, and there are all these stories that contradict other stories. It's just a whole city of stories. What happened to this person or that person?

So it's like this story is just yet another story, and it adds to the confusion, but also it adds to the clarity in that it creates this ocean of story, really. It's what it feels like to me there, because there are no answers. Everyone is a suspect. You don't know who's doing what, and if you do you don't tell anyone, because they're going to shoot you. I mean there's really that sense that you can't trust the cops, and you can't turn anyone in because they live next door, and have eight brothers, and you know, it's like everyone's related to everyone else.

HC. Do you see this work as connected to your first two books?

PG. I see it as really connected. Working on it feels very similar, even though it looks very different. My relationship to the detail is that thing which is both distracting and essential.

And I'm always doing it whether someone wants me to or not; I feel like I have to do it. I'm always taking pictures. I'm always doing this, but what I'm going to make of it is another question. What's important to me about my work, or doing whatever I do, is that I just want to know: What is it to be alive? What is it?

HC. But what's so interesting is that it seems like this work in part is about you trying to figure out what it's like to be dead, too.

PG. Oh, it is, yeah.

HC. There's also a certain flinchlessness. That's not even a word, but you don't seem to flinch delving into the past.

PG. No, I don't. I feel like I'm really lucky, because I can create pictures. It's not giving me any real power, but it feels like power. I feel like I'm making a world. Even if it's a picture I'm using off some newspaper, I make it so it's mine. I don't know what that means, but I guess for me it's necessary because any world that you're making in a story, you kind of have to live in it.

Joe Sacco

Comics journalist Joe Sacco was born in Malta in 1960 and subsequently lived in Australia, Los Angeles, and New York before settling in Portland, Oregon. In 1991 and 1992, Sacco spent two months in Palestine and Israel, interviewing about a hundred people on both sides of the conflict for his American Book Award–winning *Palestine* (2001). His next two books focused on the Balkans. *Safe Area Goražde* takes place at the end of the Bosnian war, and *The Fixer*, set in Sarajevo, jumps between 1995 and 2001. Sacco's comics are characterized by a painstaking attention to visual detail, especially evident in his breathtaking, wide views of refugee camps and swarming village streets.

Footnotes in Gaza, Sacco's second book on the Middle East and his first with a mainstream publisher (Metropolitan Books, 2009), runs over four hundred pages and, as with his previous work, its word-and-image narrative is built on his interviews with witnesses to the war. A seven-year project, *Footnotes in Gaza* investigates two massacres of Palestinians in November 1956 in the wake of the Suez Canal crisis: one in the town of Khan Younis, in which a presumed 275 people were killed, and one in the neighboring town of Rafah, in which a presumed 111 people were killed. Little has been written, especially in English, about either event, and Sacco conducted extensive research of UN and other documents and hired Israeli researchers to go into archives in Israel. He captures the testimony of the many living survivors he tracked down from both events.

Sacco has done numerous shorter comics reporting pieces for venues including *Time,* the *New York Times Magazine, Details, Harper's,* and *VQR*. When I sat down with him in the winter of 2010 at the Thompson Hotel in New York City, where we drank minibar bottles of whiskey, he conjectured about his next project, for which he wants to travel to India. He also mentioned one of his longtime ambitions, a work provisionally titled *The Gentleman's Guide to the Rolling Stones.* "I'll get the India thing done and

see how I am," he told me, "but then I'm going to do my Rolling Stones book, damn it!" Sacco has since published his piece on India, "Kushinagar," in the French magazine *XXI* and online at the *New York Review of Books*. It also appears in his collection *Journalism*—which was released in June 2012 along with Sacco's dazzling collaborative book with reporter Chris Hedges on poverty in America, *Days of Destruction, Days of Revolt*. He is currently working on a project about Mesopotamia, and in 2013 published *The Great War*, which depicts the first day of a battle in World War I. The Rolling Stones may have to keep on waiting.

"NOW WHAT HAPPENS TO THE DEAD?"

HILLARY CHUTE. Were you in a total zone working on this last book?

JOE SACCO. When I was working, yes, I was in a total zone. But, I mean, I have a life. I have a social life. I have a girlfriend back in Portland. So . . .

HC. I wasn't implying you were some freak who never saw sunshine.

JS. That stuff really helps. It's important. But, yeah, I was in a zone. I think I needed that momentum. In the beginning I was also trying to complete something about Ingushetia, I went to Iraq, I did a story about detainees, I did another story about Iraq, you know, a lot of things were going on. I needed to be in one space and just keep with it until the end. I'm sure if you looked at the dates on each page of the book, the last part happened at a much more furious pace than the first part.

HC. The research sounds exhausting. And four years of drawing

JS. It was. But, I mean, any cartoonist can tell you that.

HC. *Footnotes in Gaza* seems even more brutal than your other books, just in terms of what you're drawing. There are so many bodies in this book. What was it like drawing that? Even the part with the bull was, for me, almost unreadable.

JS. There's an early scene in which a bull's being taken out, and he's basically given the coup de grâce in the street, and that made my head swim. I've never seen anything like that. It was very difficult to watch. I mean, I was queasy. I wanted to confront the reader with those images, but then show the reason for it. I mean, it's shocking if you're a Westerner, seeing kids with blood on their hands, and putting them up and making blood prints on the wall. It was for me. My nephew would have keeled over and fainted, you know, if he'd seen something like that. But I want to show it, and also that there's a tradition behind it. A number of families have bought this bull together, they're working on it together. They all have to share in the butchering of the animal. Whether they know how to do that or not, they're still all participating. Then they divide the meat and give a third of the meat to the poor. What starts as sort of a hard event to watch ends up

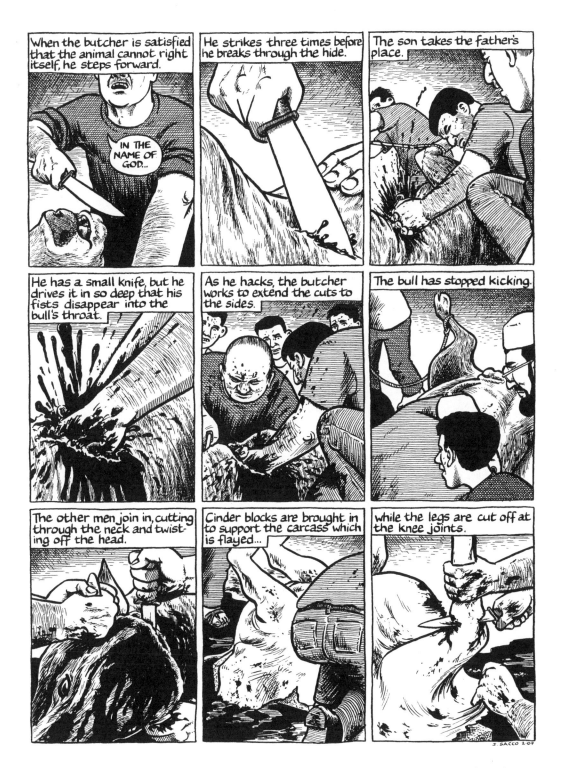

7.1. Joe Sacco, *Footnotes in Gaza*, in the section
"Feast" (New York: Metropolitan, 2009), 141. Used by
permission of Joe Sacco.

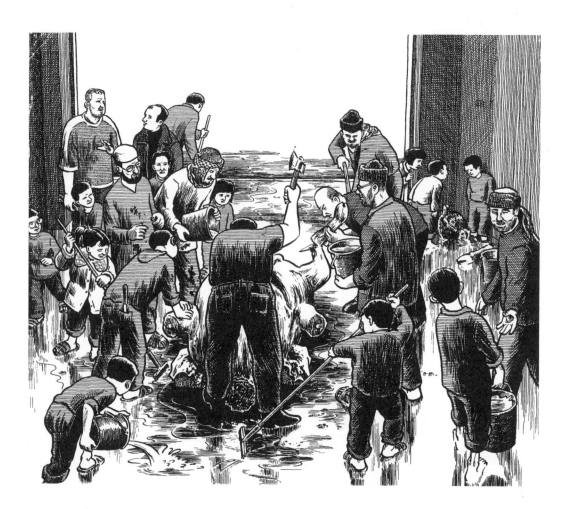

7.2. Joe Sacco, a large panel from *Footnotes in Gaza*, in the section "Feast" (New York: Metropolitan, 2009), 142. Used by permission of Joe Sacco.

being part of a tradition. I was showing how people are still hanging on to things despite what's going on. It matters to them to keep that tradition going, and to do it in the right way.

HC. I thought it was a really interesting look into how a community structure functions.

JS. Right. It started to make me think about doing anthropological comics.

HC. I was about to use the word *anthropological,* and then I somehow felt like it would sound awkward, but then you used it. [*Laughs.*]

JS. You know, drawing that was the most fun I had. Even though it was very difficult to watch it, and to look at all the photographs, it was the most fun because I think it said something about the Palestinian culture.

HC. For a couple of pages there's this superdetailed focus on the actual butchering. The book really slows down in that part.

JS. People are making jokes: "We slaughter the bull, Sharon slaughters us." Or "One day, you'll come and talk to the bulls about their slaughter, and

you'll have a bull as a translator." I show the whole process from beginning to end, and that's kind of what the book is doing. It's showing everything. I don't stop the book with the people dying. To me, it's important to show: so now what happens to the dead? I want the reader to get a sense of the breadth of it, what it means in its entirety, and not leave out any steps, as difficult as it is to read, and—believe me—as difficult as it was to draw.

HC. That scene transitions right into a Palestinian man saying, "I can't do it."

JS. He has this soft thing for the animal. He couldn't bring himself to eat from it. However, he isn't averse to the idea of suicide bombing and killing Israeli civilians. So I'm trying to show the different facets of a personality, too.

"WHAT AM I GOING TO DO AFTER THIS? KEEP DETAILING MASSACRES?"

HC. The notion of what history is, or how history moves, was implicit in your other books, but it's explicit here. You talk about capital-H "History."

JS. I reflected on it somewhat. And the truth is I've reflected on it even more since the book.

HC. Will you tell me about it?

JS. History is a combination of a lot of things. You can't isolate events today and say, "Oh, well, this happened—those awful people." The acts might be brutal, but there must be a context to it. I certainly didn't want to drop the reader into those incidents without telling the story of, well, Why are there refugees? Why were the Israelis and the Palestinians battling along the border? Who were the *fedayeen*? What was the Israeli response to that? But more than that, I think, for me, the book ends up being—this is going to sound strange—a dead end. Because I don't know where to go from here, except to delve into human psychology. I think I understand how history works. I understand why one people are battling another people. I understand that they both want land. But ultimately there's a level that I haven't really got to yet. I'm touching on motive in places, like what makes someone pull a trigger? What makes one person beat another one to death? I know we can dehumanize people. Obviously, that's the main thing. And I know we can fear them enough that we'd kill them before we think they're going to kill us. There's all that going on. But I think I need to go in another direction after this book. What am I going to do after this? Keep detailing massacres? For me, personally, I think I'm not going to get anything out of it anymore. I've come to the end of that.

HC. You mean in the arc of your career?

JS. In the arc of my understanding of why people do things and how

things develop the way they do. It's not that there aren't other incidents I could detail and make a great book about—an interesting book. It's just that for me, personally, it won't lead me anywhere new, and it's kind of about me on some level. If you're a creative person, it has to be, I think.

"ONE BIT OF HISTORY BLEEDS INTO ANOTHER."

HC. One thing I liked about Patrick Cockburn's review in the *New York Times Book Review* was that he was saying there's a real contribution here in terms of journalism and unearthing these events. The documents the Israeli researchers helped you work with—were they previously closed and classified, or was it just that no one had dealt with them?

JS. Perhaps no one had dealt with them. I had read bits of Ben-Gurion's testimony, but one of my Israeli researchers found a newspaper that reprinted his entire response to the incident at Rafah. My editor is Israeli. In a Chomsky book, I read a snippet of the story of Mark Gefen, the eyewitness soldier who talks about a "human slaughterhouse." It was footnoted to a magazine back in the eighties. Someone found it, and then my editor translated the whole document for me.

There is some new stuff in this book, definitely. I wish there was more. As far as I know, [then army chief of staff Moshe] Dayan's comments to members of the Knesset who were asking relatively probing questions about Rafah were in a classified document that must have been unclassified. One of my researchers found it, and it had never appeared before.

HC. How did you find the people you interviewed?

JS. I went and I spoke to Israeli historians in Israel. I spoke to them on the phone or else I met them. I asked, "How can I go about doing this?" One researcher I found was going and looking at the Knesset archives, the Israeli Defense Force archives, things like that. You can go and look at the IDF archives, but it's all in Hebrew. I did talk to military men, brigade commanders. One of my research assistants looked up people who are mentioned in different press accounts who were there, who died, and talked to their families. I mean, there was an effort to try to find something. But definitely I think an Israeli historian needs to really step in and take another look at this. One person alone cannot write a history of this sort of thing. I think you need many angles. This is just the beginning as far as I'm concerned.

HC. Have you had any response from Israeli historians?

JS. There is a historian, once a military man, named Meir Pail, who was asked about these incidents. And he said, "Not that many people were killed, no one was murdered, I was there, didn't happen." I was looking at my notes, and I realized, "Oh, god, I've actually talked to this guy." I had

forgotten. I have actually a whole list of notes about our conversation, which perhaps took place on the phone, definitely when I was over there. And what he told me was that, for example, he hadn't heard of any of these incidents. He didn't say nothing like that had happened. That's the only response that I've gotten in the course of this. It's sort of new, I think, yet.

HC. But it does seem like a beginning point in a potential ongoing conversation.

JS. Maybe. We're talking about two peoples who have been fighting each other and are locked in this sort of violent embrace, and have been for a while, and this is just—this is part of that puzzle. That's the contribution. Some of these people are still alive. My goal was, "If they're still alive, I want to talk to them."

HC. It seemed like what you're emphasizing in terms of the movement of history is the continuousness of the past and the present. That's something that's always fascinated me.

JS. You're talking to people who remember it but get it confused with other incidents. It's almost as if history bleeds. In people's minds, one bit of history bleeds into another bit of history. Some people have a very hard time keeping straight what happened in '67, what happened in '56. And it gives you this idea, especially in the particular case of the Palestinians, that history hasn't really stopped. They've never had the luxury of looking back and isolating things, and thinking about it and coming to terms with it. Whether it's pure anger, or a feeling that they want justice . . . I mean, there are Palestinians who even said, "You're wasting your time doing this. You're wasting *our* time doing this, because the Israelis are bulldozing homes a few hundred meters away."

HC. We seem to have a really clear sense, in those moments in the text, that what you are interested in is the fifties.

JS. I took some chapters out of the book that talk about how everything was getting very depressive because the war in Iraq was about to break out. It was also depressing me. [American peace activist] Rachel Corrie's death depressed me. All that stuff was depressing. And I began to realize that '56 was my solace, in some ways.

I think it's important to isolate things, because then you can understand how one generation, if not subsequent ones, were brutalized. You've got to stop it sometime and have a look at it. What happened in '56 is not like the Battle of Britain, where the British can almost look back with romantic nostalgia to that time.

HC. Palestinians don't have the luxury of reflection?

JS. They don't. Every generation is somehow brutalized, and their parents are transmitting bitterness and frustration. Even if you don't tell the specific stories clearly, you transmit things to your children.

CAN YOU DRAW WHAT YOU DON'T UNDERSTAND?

HC. There's one scene toward the end with teenagers who don't want a photographer to take their pictures . . .

JS. Oh, yeah, Asim.

HC. But we get your drawings of them in the book. Moments like those call into question: what does it mean to take a picture of something versus what does it mean to be drawing something?

JS. I began to understand that there's a difference as far as capturing an event. There are very few photographs—and we know them very well—that capture an exact moment, and that image is always with us. The guy getting killed in the Spanish Civil War [by Robert Capa], the Vietcong suspect getting shot by the Saigon police chief [by Eddie Adams]. . . . Now, when you draw, you can always capture that moment. You can always have that exact, precise moment when someone's got the club raised, when someone's going down. I realize now there's a lot of power in that. It's a bit scary in a way, because you're capturing moments like that constantly from panel to panel.

HC. I'm interested in this whole idea of visual witnessing and reporting before film, and before the camera.

JS. I can't answer for photojournalists. To me they're kind of a bit crazy, and they really get in there, and they risk their lives to get these shots. I can't talk about what they feel and what they experience. But in this case, it was kind of day in and day out for months. I mean, some of those chapters about burying people just took a long time. You have to put yourself in everyone's shoes that you draw, whether it's a soldier or a civilian. You have to think about what it's like: What are they thinking? What are they feeling? The truth be told, that's part of the reason I don't show Israeli soldiers' faces. I couldn't understand it.

When I show faces very explicitly, like at the school gate [in Rafah], I just assumed that the people who would be doing that kind of thing probably wouldn't be ordered to do it so much as—you could probably drop out of that kind of duty. I imagined they're probably more like sadists [than regular soldiers]. I couldn't always put myself in their psychology properly, so in a lot of cases, I refrained from drawing their faces.

HC. In some images a gun or some other implement is actually obscuring some part of the face of some of the soldiers

JS. —or their caps are obscuring their faces. Yeah. That's why it's human psychology I've become sort of interested in now.

HC. You've mentioned "Joe Sacco Trauma Syndrome." Was it depressing to be drawing, or were you upset when you were drawing . . . ?

JS. I like to draw, generally, but it was not a pleasure. I did not want

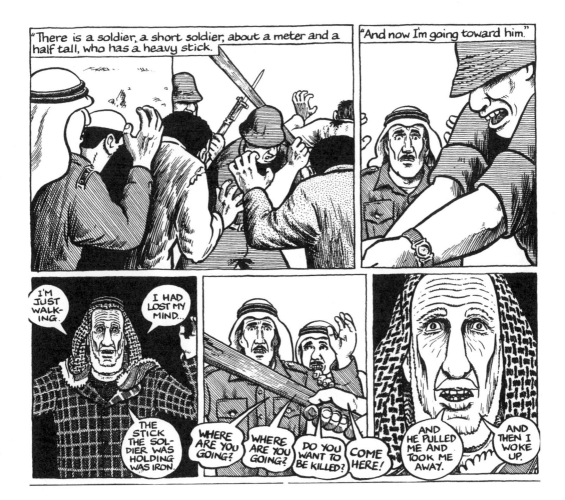

to go to the drawing table. But I knew, OK, just keep going, just keep doing it. It felt like an incredible chore. After I finished the book, I think it caught up with me. When you're in the middle of it, you don't like doing it, but it's your job. You know you have to get through it, you have to show this. You made that decision to show it. But afterward I was a little repulsed by the whole thing.

7.3. Joe Sacco, panels from *Footnotes in Gaza*, in the section "Rafah" (New York: Metropolitan, 2009), 242. Used by permission of Joe Sacco.

THE ASHTRAY IS FULL OF BALLOONS

HC. The address to the audience is amplified a few notches from your other books, like "Dear reader." Or using the plural, like "Our story," or "we," "we get to this point." I'm wondering if that kind of address helps readers of the book get through some of the really difficult aspects of it, through it being filtered through you.

JS. In some ways I wanted to include [my Palestinian fixer] Abed as part of the collective team—that it wasn't just me, that we were doing it.

But yes, there is a sort of collective view: I'm trying to understand this, like I imagine the reader's trying to understand it.

HC. I see the book as literary not just at the level of prose, but in the way that pages move. It's the rhythm of the narrative—that's what codes as literary to me.

JS. When I'm laying out a page, it usually takes me seconds to figure out where the panel's going to go. I sketch it on the board—

HC. Wait. That's crazy. Seconds?

JS. The initial thing has to be impulsive, because storyboarding will kill future creativity. I want something I'm going to work with on a day-to-day level, where I can be sort of spontaneous. So the basic layout of the page takes seconds. Where the individual figures go, the composition of each panel—that takes an enormous amount of time.

HC. So in a matter of seconds, you say, "Unbordered top tier, three boxes here . . ."

JS. Yes. I have a script. I'll say, "OK, this page probably starts here and ends there. This will be a panel." I'll make that decision very quickly. Then I'll write out the captions on a piece of scrap paper. I cut out a balloon about that size, and I place it. I think, How much room do I have? Where can elements go? I don't draw something and then lay things on it. I get the text and lay it down first. My ashtray's always full of these little word balloons that I've drawn . . .

HC. This is the stuff that blows my mind about cartoonists. They have to be good at so many things, including having a rigorous, special design sense, right?

JS. That's like walking, if you're a cartoonist.

HC. The page-dating is something that I don't see in a lot of other cartoonists' work.

JS. I've done that since I've been cartooning. It's one of those habits that I just kept going with. It's sort of a weird, anal thing, but I want to know that I'm producing. It's sort of a spur to produce, and it reminds me sometimes that I left a certain page for a while. For example, there's a page early on that was penciled for a long time, but I didn't have an Egyptian uniform. I finally found a book for that. It took a year. I didn't actually date the page until I was finished with that panel.

I'm always trying to demystify the whole thing, and that's part of it, letting people know your pace and your rate. Some people say, "It must have taken you a long time to draw that page, because you didn't draw the next one for a month." Well, maybe I was in some other country doing another assignment. Maybe I was on vacation.

HC. But surely you drew some of the pages out of order, right?

JS. It seems like no matter how finalized my script is, at the beginning

I mess up a bit. Some were drawn out of order, but mostly they weren't. Mostly I try to be consecutive, to understand it a bit more.

HC. There are footnotes in your other books, but there seem to be more here.

JS. At one point one of the characters talks about Israelis becoming soldiers at age sixteen or something. Well, that's incorrect. But I didn't want to sort of trip up what he's saying by correcting him in the body of the work. I thought I'd just put in a footnote to indicate, well, actually, it's *this*. In many ways, the book is based on eyewitness testimony.

HC. So that would explain why there are more footnotes?

JS. Perhaps, because there are things that need to be explained that people pass over, and sometimes I don't want to interrupt the actual flow by stopping them. But I realize the reader might not understand the subcontext or context.

HC. I also noticed that in this book more than others, in the testimonies you cite, you use brackets to show where you alter a sentence even slightly.

JS. Someone else said that to me. If you read *Safe Area Goražde* and *Palestine*, I think there's more of an awkwardness. I think the reader can follow it, but some of the sentences are a bit rougher. In this book I wanted them to be a bit smoother, but I wanted to show that I'm sort of trying to smooth it out.

HC. That seems very responsible to me. [*Laughs.*] It seems like a measure of your meticulousness or something . . .

JS. Yeah, well, it's funny, because I talked to Art [Spiegelman] about this, and he doesn't like the brackets. I understand his point of view. I do agree that this is not what I want to see if I'm reading a comic book, for god's sake, but on the other hand, the journalistic imperative means more to me when you're quoting someone than the "nice comics balloon" imperative. This is a very loaded context.

HC. I appreciated the brackets, actually.

JS. I'm glad.

HC. I'll be on the brackets side of the ledger.

JS. You're the only one who's voted for the brackets.

"ONLY PULL THE RABBIT OUT OF YOUR HAT WHEN YOU NEED TO."

HC. Would you say that you were working with a lot of comic-book conventions in *Footnotes in Gaza*?

JS. I see myself as a traditionalist in a way, like an old-school cartoonist. I'm influenced by people like Crumb and by basic storytelling techniques. To me, the important thing is to get the story across.

HC. I see what you mean about Crumb and straightforward storytelling, but the way you tell it on each page—your pages are so dense, there's so much going on—

JS. Yeah, maybe sometimes too much—

HC. But also on a formal level.

JS. I feel like I know what I'm doing, but I have intuition about things. Every now and then, I'm pulling a rabbit out of a hat in my own mind. My feeling is, only pull the rabbit out of your hat when you need to. When you look at *Palestine,* I'm pulling rabbits out of hats that shouldn't be there.

HC. Really? What do you mean?

JS. I just think it's overdone. A lot of the drawings I was doing were to amuse myself at the drawing table, so I wouldn't get bored. Over time, starting with *Safe Area Goražde,* I realized you can only use these techniques when it's going to advance the story or heighten it. You squander that sort of thing when you do it all the time.

HC. In *Palestine,* there's an instance where you're talking about yourself as a cartoonist. This comes up in various places in your work—your status as a cartoonist and reporter. You wrote the introduction to the book *A Child in Palestine,* by Naji al-Ali. Is there a history of respect for cartooning in Palestine?

JS. Well, there's a history of respect for Naji al-Ali, who was a Palestinian cartoonist assassinated in London in the late eighties. On my first trip to Palestine, whenever I was not so self-conscious that I couldn't bring up the fact that I was drawing their stories—because in those days I was a little more reticent—they would say, "Oh, well, we have this cartoonist, he's a big hero. . . ." People had pendants of his main figure, and even pictures of the cartoonist himself on the wall. He was revered.

HC. What was the deal?

JS. He basically did comics, or spot cartoons, in Arab newspapers hitting out at everyone who . . . everyone, basically: the Israelis, the PLO, Palestinian factions, corrupt Arab regimes—everyone who he felt was putting the boot down or exploiting poor people, refugees, and the poor Arab person, who is always represented by this same child. He was just really well loved for that. And the child was always looking at some scene, like the cartoon is just sort of recording what's going on.

HC. Do you like the comics?

JS. Technically, they're not beautiful drawings. They're very rough drawings. But they're very powerful. And Arabs certainly are drawn to his work. Mainly because he's really speaking truth to power.

HC. What's the sense of why he was assassinated?

JS. It's not quite known. I mean, some people say it was the Mossad,

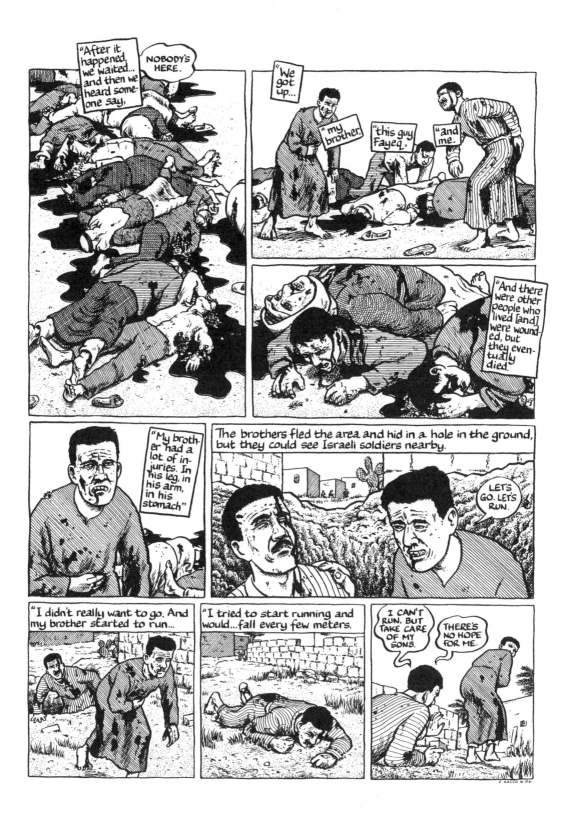

the Israeli intelligence organization. It could just as well have been a Palestinian faction he rubbed the wrong way. I've heard that also.

HC. Have you sent *Footnotes* to people you talked to?

JS. In Gaza, they're not even getting bread, so they're not going to get books. There's an incredible blockade. That's something I'd like to figure out. A lot of the men I talked to have died since, which is a shame. So I'd like to get it in the hands of at least some of the people I talked to.

HC. Do you ever worry about that?

JS. That they won't get to see it? Yeah, I do. I knew I couldn't rush the book. I worked very hard on it to get it done as soon as I could. But there was definitely that feeling. Man, seven years . . . it took a long time. And you know what's happening in seven years. People are getting older and older and dying.

HC. And a lot of these people were old to begin with.

JS. It was one of the things that motivated me to keep going, especially in the last few years of the book.

HC. I want to ask you about the ending of *Footnotes in Gaza*. Your text boxes make language so physical. In some pages they are layered on each other. I mean, the words have a weight here, and the sentences have a weight. But then, for me as a reader, in part because you're so good at this, when I get to the end, and the last four pages are silent—it's really striking.

JS. In finding out a story, you become so involved in dissecting it and pulling out its component parts and concentrating so much on specific things that the bigger picture loses its impact. There's this part at the end when a guy mentions that *fear* is the thing he remembers the most. It sort of brought it all back to me. I'm trying to talk about my role in a way, my role as a sort of quasi historian. In the end, it was a realization: Had I sterilized this whole event by the process of looking at it? Sterilized the component parts for myself? In a way, I just kind of wanted to give the whole story back to the people who suffered, and that's why I have that last scene.

It's easy for me to say, "I know more than they do." In some ways I did, because I heard many different stories, and I kind of knew the grander picture. But those individuals are the ones who went through it.

HC. So by taking your narrative voice out of it, yet drawing their experiences . . .

JS. It gives it back to them. And I want the reader to feel it, too—you know, the fear of it, the randomness. You worry because you realize it's a responsibility. You're trying to convey something that you weren't there for, and other people's emotions. But that's—

HC. —the whole point?

JS. Well, that's the advantage of comics. When does journalism start, and when does art start? There's a blending.

HC. Is New Journalism a rubric that has been meaningful to your work?

JS. It definitely has been. The passion behind something like Hunter S. Thompson's *Fear and Loathing on the Campaign Trail*. You got the sense that he really cares about America. He cares about the election. He's totally invested in what's going on. And it's almost like you see him collapsing in a way. I've never learned as much about American politics as I did when I read that book.

I took classes in elections. And I used to read these writers, who'd write, you know, "Campaign '76"—for every single election they'd write a whole book about the election as if it was a horse race, basically. But there was something else about that. You know, stuff like that impressed me. On the literary level it impressed me. They're *writing*. They were *writers*.

Journalists will read a book by a journalist who writes a book as opposed to a story, and they're usually really clunkers. They don't know how to write. They know how to write sort of flashes of stuff, but they don't know how to turn a phrase very well. Hunter S. Thompson and Michael Herr know how to turn a phrase. So that inspired me.

Dispatches, by Michael Herr, which is considered New Journalism— the strength of that book is in the atmosphere it creates. It gives you a taste of Vietnam in your mouth. It's not about "On April 12, 1965, the Americans landed and I drank..." or something like that. It's about mood, in a way. I've read many books about the Vietnam War, because once I was doing a comic about it, which I scuttled.

HC. Which is still unpublished, right? I feel like I've read about it.

JS. You did. Probably in some old interview. I was doing that around college. I was in my early twenties...

HC. Isn't it about fifty pages long?

JS. Fifty pages, then I gave it up, and then I did another fifty pages.

HC. Time to bring it out!

JS. Oh, brother. You should see that stuff. No one wants to read the complete Joe Sacco, believe me.

8

Alison Bechdel

Alison Bechdel brought graphic memoir to the forefront of twenty-first-century literature with two acclaimed works about her parents: *Fun Home: A Family Tragicomic* (2006) and *Are You My Mother? A Comic Drama* (2012). *Fun Home* takes place in the tiny, rural town of Beech Creek, Pennsylvania, and meditates on her closeted father's suicide in 1980 (a few months after Bechdel herself came out as lesbian). The book, now translated into twelve languages, received the kind of public admiration that few literary graphic narratives since *Maus* have garnered: a spot on the *New York Times* best-seller list, a National Book Critics Circle Award nomination, and selection as the best book of the year by *Time* magazine. Introducing my interview with Bechdel in *Modern Fiction Studies* in 2006, I suggested that *Fun Home* "is sure to soon become an important reference point in academic discourse on graphic narrative." That has happened—and to an even greater degree than I expected. *Fun Home* seized the popular and critical imagination profoundly. (As I write, a musical adaptation is currently enjoying a sold-out run at New York's Public Theater.)

Are You My Mother? carries forward the concerns of *Fun Home* about filial intimacy and the shaping effect of family relationships—as both a negative proposition and a positive one. Both books pivot on the drama of archival discovery; both books, as well, blur the private and public by comprehending family history through the lens of other published writers, whether James Joyce or psychoanalyst Donald Winnicott.

And like *Fun Home*, *Are You My Mother?* also was generated, in part, by Bechdel's fascination with a photograph—in this case of her mother and baby self staring at each other. But while *Fun Home* examines a deceased father, *Are You My Mother?* is about a very much alive mother, as well as about the other intimate adult relationships—with girlfriends and with therapists—that affect and are affected by the maternal one.

Also the creator of the popular *Dykes to Watch Out For* comic strip, Bechdel recently cotaught the course "Lines of Transmission: Comics and Autobiography" with me at the University of Chicago, and we co-curated the exhibit *Fevered Archives: 30 Years of Comics from the Not-So-Mixed-Up Files of Alison Bechdel*. In an interview that took place in New York City the month *Fun Home* was published, Bechdel and I discuss her research, influences, and production practices. In an interview for the *Chicago Tribune* that took place in Chicago the week *Are You My Mother?* was released, we explore the book's graphic techniques and focus on the haptic: not only how the work of hands writing and reading is a theme of *Are You My Mother?*, but also, crucially, part of the philosophy of comics.

JUNE 2006: *FUN HOME*

HILLARY CHUTE. What did you think of the *Times* review by Sean Wilsey ["The Things They Buried," June 18, 2006]? He actually drove to Beech Creek, visiting places you drew, and he reports on how accurate your drawings are.

ALISON BECHDEL. The really weird thing is I've heard from two other people who have gone [to Beech Creek] since the book came out. So it wasn't just that *Times* reviewer. I think that's partly the result of the fact that I put maps in the book—you really *can* go see it. One thing Sean Wilsey said that I really liked was that if this book had been fiction—if I had made this story up—it really would be meaningless. The whole allure of the book, the reason it's interesting, is because these things really happened. So to have maps, and an actual place you can verify, is kind of cool. And *Fun Home* is very much about place: this particular part of rural central Pennsylvania, on the edge of the Allegheny Front, where Route 80 got blasted through the isolated valleys in the sixties and seventies. The construction of the interstate during my childhood felt kind of mythic. It was just over the ridge from us, and it ran from New York to San Francisco. Of course I didn't think then of New York and San Francisco as gay poles, but now I see that was part of it.

HC. Can you tell me about the research you did for the book?

AB. I did all kinds of research. A lot of reading in particular. I haven't talked so much about that; people are interested more, I think, in the image research. One whole strand of the book is my father's love of literature, and the particular novels and authors that he liked. As I worked on the book I found this material creeping more and more into what I

IN A SIMILAR KIND OF LANGUAGE FAILURE, IN THE LOCAL DIALECT THE BULLPEN WAS SAID TO BE SITUATED SIMPLY "OUT ON THE MOUNTAIN," THAT IS, ON THE PLATEAU. IN THE PRIMEVAL WILDERNESS BEYOND THE FRONT, SPECIFICITY IS ABANDONED.

AND HURTLING TOWARD NEW YORK CITY ON ROUTE 80, SPEED AND PAVEMENT ERASED NOT JUST THE NAMES OF THINGS, BUT THE PARTICULAR, INTIMATE CONTOURS OF THE LANDSCAPE ITSELF.

IN THE END, ALTHOUGH THE ANONYMITY OF A CITY MIGHT HAVE SAVED MY FATHER'S LIFE, I CAN'T REALLY IMAGINE HIM ANYWHERE BUT BEECH CREEK.

LISTENING TO THE MUSEUM-TOUR TAPE, I'M SURPRISED BY HIS THICK PENNSYLVANIA ACCENT. DESPITE THE REFINED SUBJECT MATTER, HE SOUNDS BUMPKINISH.

IN THE BACK DISPLAY ROOM IS A FINE, CHERRY HEPPLEWHITE CORNER CUPBOARD OF ABOUT 1790. THIS WAS DONATED BY THE KLECKNER FAMILY OF SUGAR VALLEY. ON THE WALL ARE KITCHEN TOOLS USED BY EARLY FARM FAMILIES IN THE NINETEENTH CENTURY.

was writing. I was quoting Camus and Fitzgerald and eventually I realized that the book was sort of organizing itself around different books or authors; each of the chapters has a different literary focus.

That meant doing a lot of reading. Rereading things I had read before, like *Portrait of the Artist* or *Ulysses*; those are big sources for *Fun Home*. The first and last chapters reference Joyce, like bookends. I read a lot of biographies of the people my dad admired: Camus, both Zelda and Scott Fitzgerald, Oscar Wilde—a great biography of Oscar Wilde by Richard Ellmann—and a great biography of Proust. I never actually read all of Proust; I just skimmed and took bits that I needed. I really liked doing all this wandering about in books. My dad pressured me a lot to read certain things when I was growing up and I had always resisted it. In some ways I felt like he ruined literature for me, so this was sort of a way of coming back and reclaiming it for myself.

My research also involved a lot of archival stuff—diaries, photographs. Photographs were a huge resource for me. In many ways photographs really generated the book. In fact the whole story was spawned by a snapshot I found of our old babysitter lying on a hotel bed in his Jockey shorts. This photo was from a vacation when I was eight, when Dad took my brothers and me to the beach with our male babysitter in tow. About a year after Dad died, right after I got out of college, I was at home, sort of organizing all my stuff. That's when I ran across this photograph. It was a stunning glimpse into my father's hidden life, this life that was apparently running parallel to our regular everyday existence. And it was particularly compelling to me at the time because I was just coming out myself. I felt this sort of posthumous bond with my father, like I shared this thing with him, like we were comrades. I didn't start working on the book then, but over the years that picture persisted in my memory. It's literally the core of the book, the centerfold.

HC. It's the only double spread in the book, right?

AB. Yes.

HC. How else did you prepare for writing the book?

AB. I did some standard detective work, like I went out and looked up Dad's police record and his college transcript. Finding the police report was a pretty exciting moment. I knew he'd been arrested at one point for buying a kid beer. I had the precise date in my diary from when I was thirteen, which came in handy when I went to the courthouse to look up the record. The moment when I actually found the documents on Dad, there on the microfiche, was pretty strange. I felt triumphant as a writer, as a researcher—but kind of embarrassed as his daughter.

The college transcript was interesting—to see the classes he'd taken and his grades. He got a lot of Cs, which didn't really surprise me because

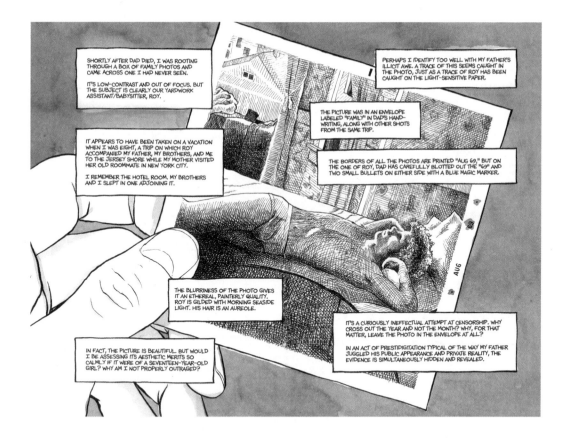

8.2. Double page spread from Alison Bechdel, *Fun Home: A Family Tragicomic* (Boston: Houghton Mifflin, 2006), unpaginated [100–101]. © 2006 by Alison Bechdel. Reprinted by permission of Houghton Mifflin Harcourt Publishing Company. All rights reserved.

even though he was smart, he was lazy. But who knows—a C probably really meant a C in 1957, whereas now it's like an F.

HC. What about the letters between your parents that you so fascinatingly reproduce in *Fun Home*?

AB. I didn't tell my mother I was writing this book until I had worked on it for a year. I wanted to get a purchase on the material before I had to grapple with her feelings about it. I felt like I could very easily be dissuaded from the whole project. Her initial reaction, I think, was to laugh. She just thought it was absurd. She didn't ask me not to do it, which I was really grateful for. At some point, though, she told me she was going to have to cut me off from any further information about my father. She felt betrayed—quite justifiably so—that I was using things she'd told me in confidence about my father. So she wasn't going to tell me anything else.

But then a year or so later, she gave me a box of letters that Dad had written her before they were married. My mom's a bit of a mixed-message kind of person—but maybe she gave me the letters because she thought they'd act as a counterweight to other things she'd shared with me. At any rate, the letters were a rich treasure trove, very helpful in fleshing out my father's character.

MY NUMBNESS, ALONG WITH ALL THE MEALY-MOUTHED MOURNING, WAS MAKING ME IRRITABLE. WHAT WOULD HAPPEN IF WE SPOKE THE TRUTH?

I DIDN'T FIND OUT.

WHEN I THINK ABOUT HOW MY FATHER'S STORY MIGHT HAVE TURNED OUT DIFFERENTLY, A GEOGRAPHICAL RELOCATION IS USUALLY INVOLVED.

BEECH CREEK — Bruce Bechdel, 44, of Maple Avenue, Beech Creek, well-known funeral director and high school teacher, died of multiple injuries suffered when he was struck by a tractor-trailer along Route 150, about two miles north of Beech Creek at 11:10 a.m. Wednesday.

He was pronounced dead on arrival at Lock Haven Hospital while standing on the berm, police said.

Bechdel was born in Beech Creek on April 8, 1936 and was the son of Dorothy Bechdel Bechdel, who survives and lives in Beech Creek, and the late Claude H. Bechdel.

He operated the Bruce A. Bechdel Funeral Home in Beech Creek and was also an English teacher at Bald Eagle-Nittany

Institute of Mortuary Science.

He served in the U. S. Army in Germany.

Bechdel was president of the Clinton County Historical Society and was instrumental in the restoration of the Heisey Museum after the 1972 flood and in 1978 he and his wife, the former Helen Fontana, received the annual Clinton County Historical Society preservation for the work at their 10-torian house in Beech

IF ONLY HE'D BEEN ABLE TO ESCAPE THE GRAVITATIONAL TUG OF BEECH CREEK, I TELL MYSELF, HIS PARTICULAR SUN MIGHT NOT HAVE SET IN SO PRECIPITATE A MANNER.

gardening and stepped onto the roadway. He was struck by the right front portion of the truck

degree from The Pennsylvania State University. He was also a graduate of the Pittsburgh

a member of the Society of America, d of directors of the Playhouse, National Council of Teachers of English, Phi Kappa Psi fraternity and was a deacon at the Blanchard

HC. How much did you already have, and how much did you have to dig up?

AB. I kind of commandeered all of the family photos over the years. Every time I'd go home to visit my mom, I'd bring more stuff back: some more books of my dad's, some more photo albums. I gradually amassed stuff over time. But a lot of it, I already had: my huge crate of diaries, Dad's letters to me.

HC. And you had saved all of your childhood diaries, and the letters that your father wrote you?

AB. Yes. And I have all my drawings. Even as a child I saved those. My mom didn't save them; I did it myself. I've always had this archiving impulse. I started a diary when I was ten. I'm the most anal-retentive person I've ever met.

HC. How did you reproduce this material for the book?

AB. Very painstakingly. That was one of the crazier rabbit holes I went down into on this project—reproducing my childhood diary entries and my dad's handwritten letters. It's all very carefully traced and redrawn. Except for one very small bit of actual childhood handwriting that I just scanned in a moment of laziness [p. 143].

HC. So you had to mimic your old handwriting.

AB. Well, yes. In a way, I was just copying it. But it's very difficult to capture the quick flow of handwriting when you're copying. I have a new-found respect for forgers. But trying to capture my father's handwriting was the really tough part. I don't even want to know how much time I spent on that little exercise.

HC. The narrative of *Fun Home* is so intricate.

AB. I worked really hard on it. I went over and over and over it, constantly tweaking the connections between what had happened already and what was still coming. I know everyone thinks this about their writing, but everything in the book is so carefully linked to everything else, that removing one word would be like pulling on a thread that unravels the whole sweater. There's really not much dramatic action. If you don't count the subplot of my own coming-out story, the sole dramatic incident in the book is that my dad dies. Everything else is this extremely involuted introspection about it all.

HC. In between when your father died and when you started working on this book, had you been thinking of him in relation to these books that he loved?

AB. No. That really happened once I got immersed in writing the book. It surprised me. At a certain point, it just became clear that these other books and authors were part of the story on a structural level.

Part of why it took me seven years to complete the book was because I

had to learn how to write. I had no faith in myself at the beginning. I was constantly deleting everything I'd written—well, no, not actually deleting, since I'm so anal-retentive. Instead, I created a massive scrap heap of discarded, disorganized text which eventually threatened to suffocate me. It was a real struggle to get to a point where I trusted myself enough to commit things to the page.

I think that was the inhibiting influence of my father. I really felt him looking over my shoulder. My mother too. They were both very critical people. Not necessarily in a bad way, just very discerning people. Especially about literature. They were both English teachers, after all.

HC. Is the book configured like a home, with the exterior drawn on the cover and the wallpaper on the inside as endpapers?

AB. Wow! I hadn't actually thought of that. The publisher came up with the cover design—I mean, I did the drawing, but it was their concept. Although the endpapers were my idea. God, recreating that wallpaper was insane. I felt like I was serving out some sort of penance. It's William Morris's "Chrysanthemums," a famous pattern, so I was able to find it online and print it out and slap it on my light box and basically trace it. For an entire weekend. One thing my mother did say about the book was that I didn't get the wallpaper pattern right. And she's right, I didn't get enough contrast in it. I've since learned that there are eleven shades of green in the original—and I was only using five different shades.

HC. Is that all she said?

AB. Yes. About the book itself? Yes.

HC. Positive or negative?

AB. Yes. No, no, no, I'm exaggerating. There was a point early on when she read one chapter and she said, "Wow, this is really good." That was pretty astonishing. But since the book came out, she hasn't said anything about the content of the book itself. But you know, how could she? This memoir is in many ways a huge violation of my family. I can't expect them to give me strokes on my style, you know?

HC. Each of the seven chapters starts with a drawing of a photograph; some even have drawn photo corners.

AB. All the chapter head images are actual family photos. That one with all of the photo corners missing is a mistake. There should be one there. You would not believe the number of details I had to keep track of throughout this project. My girlfriend actually got concerned that I was having some kind of memory loss, because I was constantly forgetting things in my real life. But it was just that my hard drive was so completely full of things like "put photo corners on page 203," that I couldn't retain the conversation I'd had the day before.

HC. Why the photographs at the beginning of each chapter?

AB. These are photos that feel particularly mythic to me, that carry a lot of meaning. They felt like a natural part of the story, somehow. At some point I just realized they'd work really nicely as chapter heads. I also like the way they anchor the story in real life—the book is drawn in my regular cartoony style, but the photos are drawn very realistically. It's a way to keep reminding readers, these are real people. This stuff really happened.

HC. I watched the promotional DVD that came with the book, which shows your method of setting up the poses.

AB. I can't even draw the simplest pose now without a reference shot.

HC. So you created a reference shot for every pose in every panel of the book?

AB. I hate to tell you this, but pretty much. It didn't take as long as you would think. In fact, it expedited matters, because I could draw more quickly, once I had these images.

HC. Would you feel weird drawing without setting up the pose?

AB. I just feel like I can't do it.

HC. Is it part of the "epistemological crisis" that you describe in *Fun Home* that you had with your early diaries [p. 141]?

AB. Maybe it is. There's some way that it's difficult for me to enter into the picture plane. I mean, everyone is daunted by a sheet of blank paper, but when you have to wrestle a three-dimensional image out of it. ... There are cartoonists who draw better than they write. I think I write better than I draw. I work very, very hard at the drawing. It doesn't come naturally. My hope is that one day it will come more naturally, that I'll get out of my own way and I'll trust myself more and I'll be able to draw stuff without so many references backing me up.

HC. Have you done your pose technique throughout *Dykes to Watch Out For*, since the early eighties?

AB. It has crept up on me. I would just do pencil sketches in the early days. And eventually I could afford a Polaroid. And I would use that, but only for very tricky poses, because it was so expensive. But I compiled quite a picture file of Polaroids.

HC. Do you still have it?

AB. Oh yes, I have different locations that I use in my comic strip—and I have cars, and trucks, and people holding teacups, and people going up stairs. But I don't really need them anymore because I can just quickly get exactly what I want with a digital camera.

HC. I was really fascinated to learn that you always did the script page first.

AB. It's true that I started with text; I was writing it just like in a

word-processing document. But at a certain point, I started hitting a dead end with that. I couldn't get where I needed to go just using text. So eventually I transferred everything into Adobe Illustrator. And then I started to actually write new stuff in Illustrator, which is a drawing program, so you can move things around on a single page. You can reshape your text boxes and make different sizes of panels, and it was a way for me to think visually.

HC. How did you know where the text would go? How did you decide how it would move? There's only one page at the end where the panels are really regular. How did you get the pacing and rhythms of the page?

AB. Writing in Illustrator really freed me up and allowed me to do all kinds of things. Even though I wasn't drawing, I could start thinking, What's the sequence here? What image will accompany this narration? Does this panel need to be larger? Vertical? Horizontal? Does it need to surprise the reader by appearing at the top of a left-hand page, so they don't see it coming? I tried to do as much of this as I could without actually drawing anything, so that if something didn't work, I didn't have to redraw it.

HC. You had the structure, the movement of the page, without the images.

AB. Even though I say I didn't have images, I knew in my head what they were going to be as I was mapping out the page. It took a while to get fluent with my own page design. I had to learn my own rules. I never wanted there to be more than four lines of text above the panels, so that the words didn't overwhelm the pictures. There's actually one page where I had five lines, but that's the only time I broke the rule. I liked the way my available space affected the language I could use. Even though I'm pretty wordy as cartoonists go, there's still a lot of concision going on. I was constantly having to throw words out, just to make things fit. One of my jobs before I became a full-time cartoonist was doing layout at a newspaper. That was a very useful skill, learning how information flows on a page, and how to manage the huge number of individual components that comprise a page.

I did have a grid. My standard page is three tiers, two panels across. But I could break that down in lots of different ways.

HC. How did you decide to do the book in a gray-green color?

AB. At first I was resistant to the idea to using color at all, because one whole theme of the book is how my dad was such a crazy color freak and how I became a cartoonist because it was a black-and-white world where I didn't ever have to think about color. I felt like theoretically there shouldn't be color, but then I had been looking at some other stuff—maybe [Daniel Clowes's] *Ghost World*, something that used two colors—and

it was so beautiful, so I thought, yes, I should do that, and I wouldn't let my father continue to control me by making me not use color. So I'm using color in spite of him. I think it works really well. It was a very fun color because it worked on a lot of different levels. It worked in a literal sense for foliage—there's a lot of foliage in this story—and it wasn't too odd of a color to use for skin tones, facially, and sometimes it would work in a symbolic way.

HC. In your thinking, do you have any obvious influences in terms of your style?

AB. R. Crumb is certainly a big influence. He's a graphic genius. I probably saw some of his underground stuff when I was a kid. Maybe some issues of *Zap*. I had a friend whose father would buy her underground comics. My mother would have been horrified if she knew I was reading these. Oh, I know where I first saw Crumb! It was that Janis Joplin album cover—*Cheap Thrills*. My dad had it, and I was mesmerized by the artwork—it was amazing. I got more into Crumb when I discovered Harvey Pekar's work, when I was in college. In the first copy of *American Splendor* I read, Crumb had illustrated some of the Pekar stories, and those collaborations remain for me the acme of autobiographical cartooning.

HC. When did you start drawing?

AB. Like all children, I started drawing immediately, and I just never stopped. I think most kids at a certain point get self-conscious or lose interest and I never did. I would read stuff when I was really little, like *Little Lulu*, and Disney comics, just in an idle sort of way. But when I got a little older I discovered *MAD* magazine and I read that quite religiously in the late sixties and early seventies. I also had a lot of old *Mad* stuff from the fifties, some compilations—the Harvey Kurtzman stuff. That stuff is such a big influence it's invisible to me. I grew up on his parodies.

HC. And then you read Crumb in college?

AB. Yes, and later, after I got out of college, I was reading a lot of his *Weirdo*, and *Hup*, and then stuff with Aline [Kominsky-Crumb]. They're very much an inspiration in terms of trying to be as honest as I can, especially about sexual stuff.

But I wouldn't be doing this if it weren't for Howard Cruse. I always loved to draw, and I thought maybe I'd be a cartoonist one day, but then I abandoned that—it seemed like a very impractical career choice. By the time I got out of college I thought, "Nobody gets to be cartoonist." But then I found a copy of *Gay Comix* #1 that he edited, at the Oscar Wilde bookshop, and it was like, "Oh, man! You can do cartoons about your own real life about being a gay person." And that was quite momentous for me. And it was right around then that I started doing my own comics.

So Howard was hugely formative in that sense. And also, I loved that he was *so good*—he was so technically good at what he did, but he still did queer stuff. That he would bring that talent into the subculture was very moving to me.

HC. What about any long-form comics works?

AB. I couldn't have done anything without *Maus* either, of course. No one had addressed anything serious in comics before then.

When I was trying to come up with the format for the book, I said, I'll just make it the same size as *Maus*—so it's exactly the same size as *Maus*. And I also loved Spiegelman's chapters' divisions. That inspired my own chapter structure.

HC. It also strikes me that both *Maus* and *Fun Home* are at once a biography of a father and an autobiography.

AB. Yes, they're both self-aware about the process of examining your relationship with your father. Again, that's something so fundamentally influential that I don't even see it.

APRIL 2012: *ARE YOU MY MOTHER?*

HC. *Are You My Mother?* is so much a book about touch—about physical touching, or the lack of it, in your childhood, as in the scene when your mom decides you're too old at age seven to be kissed goodnight. It's also about touch in your adult life, in your romantic relationships and also as a prospect of intimacy with your therapist. The book implies so much touching—like the hand on the page—because of all the scenes of writing in the book (diaries, letters, notes). Do you think that all the attention to hands and drawing and scenes of writing is about a kind of touch in the book? How is the process of making comics involved in literal or figurative touching?

AB. Huh! I have thought a lot about comics as form of touch, but oddly, I never connected it with the pivotal childhood experience I describe in this scene [p. 137] of being cut off from touch. I often feel, when I'm drawing, that the line I'm making on the paper is a way of touching the people and things I'm drawing. It's a figurative stroke, because obviously the only thing I'm really making contact with is the pen and the paper, but that contact—of the nib and ink on the paper—is very literal and sensual. The paper is like skin. And when you're drawing comics, you have to physically touch every square inch of every page you're working on. That feels really different from writing. It's possible for a novelist to write a whole book and never really touch the paper. But in comics you

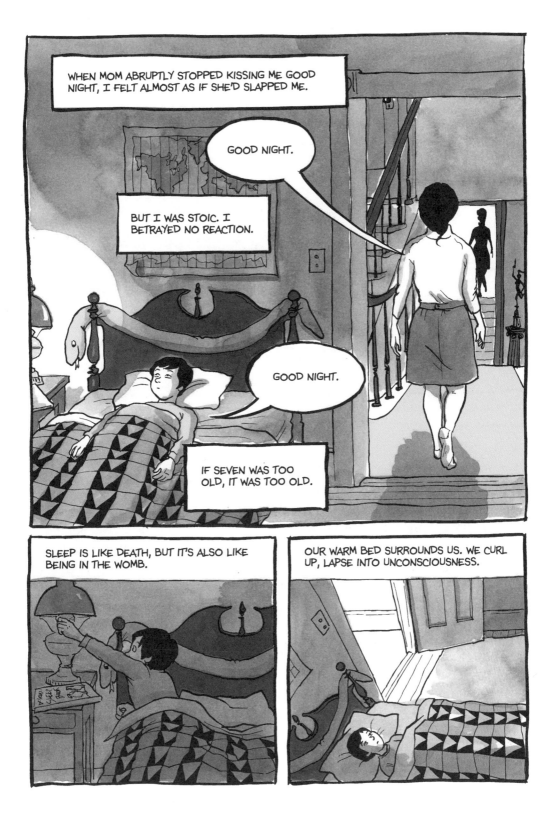

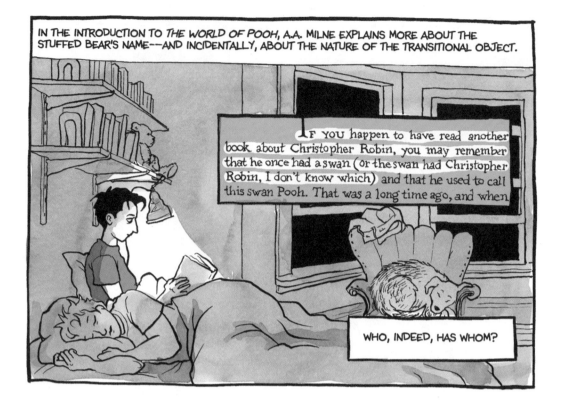

IN THE INTRODUCTION TO *THE WORLD OF POOH*, A.A. MILNE EXPLAINS MORE ABOUT THE STUFFED BEAR'S NAME——AND INCIDENTALLY, ABOUT THE NATURE OF THE TRANSITIONAL OBJECT.

IF YOU happen to have read another book about Christopher Robin, you may remember that he once had a swan (or the swan had Christopher Robin, I don't know which) and that he used to call this swan Pooh. That was a long time ago, and when

WHO, INDEED, HAS WHOM?

have to. Even if you're drawing on the computer (which I don't do) you're grappling with the two-dimensional field of the page in a way that prose writers don't.

I'm tempted to claim that yes, all the "scenes of writing" in the book are a commentary on touch. But I didn't set out to do that intentionally. In fact I worried that all the images of hands on a keyboard, or holding a pen, would get repetitious.

But I see now that the time when I was eleven, when my mother wrote my diary entries for me—taking dictation from me because I had this weird OCD spell which made it take forever for me to write my own entries—was a vital connection with her. All the stuff that most parents and children would convey through touch got channeled into that attenuated, cerebral connection between my words and her pen. And now I am doomed to a life of drawing cartoons!

Nerdy aside: I did realize after a while that my book is kind of a love letter to outmoded ways of writing. The letters my father wrote to my mother, the old Remington typewriter my mother wrote her poems on, the Selectric at my office job on which I composed some early writing experiments.

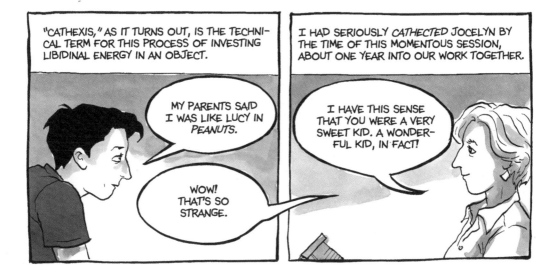

"CATHEXIS," AS IT TURNS OUT, IS THE TECHNICAL TERM FOR THIS PROCESS OF INVESTING LIBIDINAL ENERGY IN AN OBJECT.

MY PARENTS SAID I WAS LIKE LUCY IN PEANUTS.

WOW! THAT'S SO STRANGE.

I HAD SERIOUSLY CATHECTED JOCELYN BY THE TIME OF THIS MOMENTOUS SESSION, ABOUT ONE YEAR INTO OUR WORK TOGETHER.

I HAVE THIS SENSE THAT YOU WERE A VERY SWEET KID. A WONDERFUL KID, IN FACT!

HC. There are many scenes in the book that show you in bed reading next to a sleeping partner (this is a visual leitmotif in the book across multiple girlfriends). Is this structure significant to the themes you explore in the book that relate to your mother?

AB. I do show myself reading in bed a lot, but I think it's only with two different girlfriends. I didn't intend it as a significant structure. But now that you mention it, and this is a total digression but I will just go with it and free associate—I do always seem to get involved with people who fall asleep earlier than I do.

And I have consequently spent a lot of time reading in bed with various kinds of flashlights or headlamps, and now my iPhone, so as not to disturb them. I guess it's kind of hard for me to fall asleep. Honestly, I'm only putting this together right now for the first time, but maybe this has to do with the "goodnight kiss" scene that you just asked about. (I think I'm going to have to get used to the feeling of other people having profound psychoanalytic insights into my life since I've essentially turned myself over to readers as a patient.)

But I always resist going to sleep at night, putting it off as long as possible. And when my girlfriend inevitably gets tired and falls asleep first I can't help feeling a sense of abandonment. You would think I'd get used to this, but it happens every night.

Anyhow, the scenes of reading in bed in the book were mostly used as links to dreams that I had immediately following those reading sessions. I think all the books I'm reading in bed are psychoanalytic texts—Jung, Freud, Alice Miller, Adam Phillips. It was just interesting to me how these

8.6. From Alison Bechdel, *Are You My Mother? A Comic Drama* (Boston: Houghton Mifflin, 2012), 216. © 2012 by Alison Bechdel. Reprinted by permission of Houghton Mifflin Harcourt Publishing Company. All rights reserved.

books informed my dreams in a funny, meta way. Like, my Freud dream was clearly a dream *about* the unconscious.

HC. At least visually, it suggests an active/passive divide in your relationships, actually kind of the opposite of what you say above about abandonment: more like, the other person wants go to sleep together, like [your girlfriend] Eloise does on page 55, but you stay up doing the solitary activity of intellectual mining!

AB. Oh, God, you're right. With my miner's helmet and everything. I might feel abandoned when the other person goes to sleep, but really I'm the one leaving the space of the relationship by refusing to join them. Even just relaxing or being still together as a couple is hard for me. I feel like I always have to keep slogging on alone. I think I'm getting a little better about this as I age, but it's still a challenge.

HC. In some ways, I feel like this book isn't centrally about your mother, but rather about therapy. I was struck, too, by the visual way you represent therapy, such as when a speech balloon from a session covers over the gutter separating you and your therapist Jocelyn—suggesting a literal connection across a gap. In some ways this is a "therapy book" as much or more than it is a "mother book." How did you approach drawing the scenes of talking in therapy?

AB. There are a *lot* of therapy sessions in this book, it's true. I have no idea how many scenes or panels there are—I didn't actually count. But there are a lot, and I felt stumped about how to make these visually interesting. There's only so much you can do with two people sitting in chairs. I do play around a bit with some high-angle views, and some exterior shots looking through the window, but mostly it's me and my therapist just sitting there. At one point I watched all the existing seasons of the HBO series *In Treatment* in a big binge to see how they managed it on television. There, too, it's just two people in a room together, but it's dramatic because the acting and writing are so good. In the end I just did what I always do—posed for each of the figures, alternately as myself and my therapist—and I just tried hard to make the drawings of myself, my pose and gestures and expression, as emotionally accurate as I could. I wouldn't say these are necessarily spectacular drawings, but I do think something "true" comes through.

HC. Do you think about *Are You My Mother?* as a book about therapy and psychoanalysis? On a thematic and formal and visual level, the analytic situation is a big focus.

AB. If I hadn't had such productive and liberating experiences in my personal psychotherapeutic journey, I would have remained frozen or stuck on some deep level, and I would not have been able to write these

A REPLY FROM THE MORE PRESTIGIOUS ONE ARRIVED WITH SURPRISING RAPIDITY.

I WAS ASTONISHED BY THE SIGNATURE ON THE REJECTION LETTER.

at a rather superficial level. Even for yourself, I think it would be useful to go back and ask yourself some real questions as to the meaning of each incident, and its context.

I hope this is helpful. Don't be put off, or discouraged. Writing is a very long, demanding training, more hard work than luck. Strength to you.

In sisterhood,

Adrienne Rich

I MUST HAVE KNOWN SHE WAS ONE OF THE EDITORS, BUT SOMEHOW I HADN'T IMAGINED HER ACTUALLY READING MY SUBMISSION, LET ALONE RESPONDING PERSONALLY TO IT.

I cringe at my arrogance. Actually, cringing at my arrogance is just another, more rarified, level, of arrogance.

SHE WAS RIGHT. I HAD NOT DONE THE HARD WORK.

I FELT ANOTHER WAVE OF SHAME SIX MONTHS LATER, WHEN MY UNREVISED STORY WAS PUBLISHED BY THE LESSER JOURNAL.

COMMON LIVES LESBIAN LIVES

I HAD SET WRITING ASIDE BY THEN AND TURNED MY EFFORTS TO DRAWING A SERIES OF CARTOONS TO ENTERTAIN MY FRIENDS.

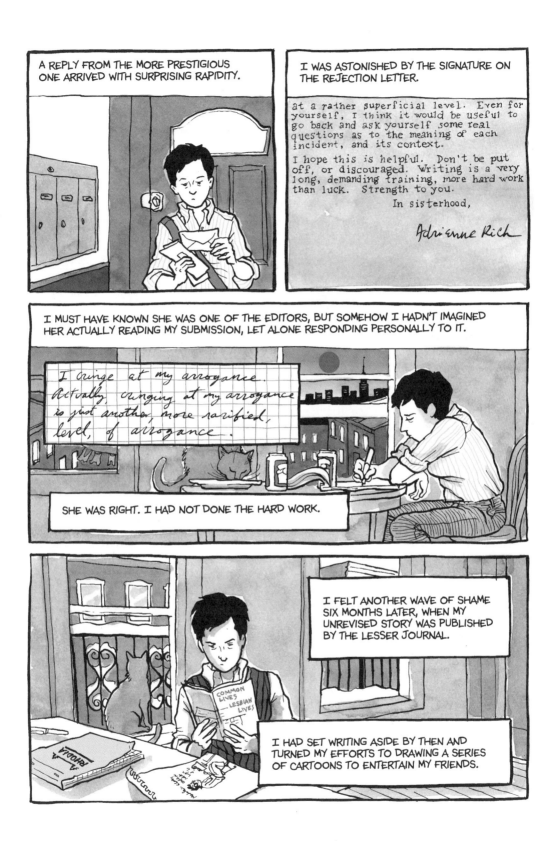

books about my parents. It's a kind of circular logic: If I'd had different parents, I would probably not have needed to write these books about my parents. But I'm glad I had the parents I did, I'm grateful for all the ways that they both oppressed me and nurtured me as an artist, and I'm glad I have been able to climb out from underneath their thumbs. I couldn't have done that without outside help. *Are You My Mother?* is my attempt to figure out why and how therapy helped me.

HC. I am very struck by the presence of poet and essayist Adrienne Rich, who died last month, in your book. I am especially struck by the excerpt of the rejection letter she wrote you that you reproduce [p. 180]. How do you feel about her, in retrospect, as an influence, and did it feel hard to highlight this rejection? You write about her "going for broke" once she breaks free from the formalism of her youth. Are you doing the same thing? Did you do all the hard work she recommended in her letter?

AB. I felt really sad about Adrienne Rich's death, in the usual way one feels sad about the death of someone who has been very influential. But it was also odd timing. She plays a very pivotal role in the book, in the chapter that is most directly about writing. And she died two days before I received the first copy of *Are You My Mother?* in the mail.

In the Adrienne Rich chapter I go to great lengths to trace a connection between Rich, my mother, my father, and me. In a letter my father sent my mother from grad school, he asks her to help him find a copy of Anne Bradstreet's poetry for a paper he has to write. It's kind of a bossy and condescending letter, treating Mom as his amanuensis. When really it was my mother who should have been in grad school. As I was doing my research for this part of the book, I went out to find a copy of Anne Bradstreet's poetry myself, and Rich happened to have written the forward to it in 1967.

In another complicated involution, Rich herself wrote an introductory note to her Bradstreet essay in a book that was published ten years later, after Rich had come out as a lesbian and had become much more radical in her writing. She was sort of calling herself to task for having been so detached about Bradstreet in 1967, for not talking about the powerful personal connection she felt to this early poet's work.

I write about that in my book because her example of self-revision was so impressive. And Rich's powerful demonstration in her work and her life that "the personal is political" was hugely influential to me as a young person. And a middle-aged person. For better or for worse, I can't seem to stop making my private life public.

Getting Rich's rejection letter when I was twenty-four was mortifying, but I was also very conscious even at the time that it was a great gift. It

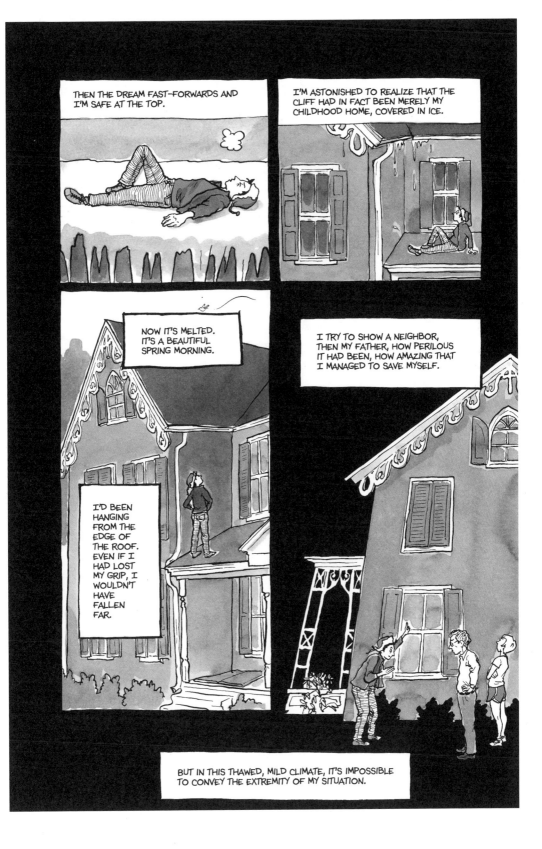

has taken me many years, but I do feel like at last I have done some of the "hard work" she talks about in her letter. But of course it's an ongoing process, and there's always something harder lying in wait.

HC. Each chapter of *Are You My Mother?* starts with a dream sequence. How did you decide to structure the book this way? Some dreams come into *Fun Home*, but not as many. Why so? I also love that you first depict, and then interpret your dreams for the reader—it's like you're briefly taking on the analyst's role for us, explaining the psychic motivations of the narrative we've just encountered.

AB. The dream structure came about very late in my process, about four years in, when I jettisoned an earlier version of the book and started over. The chronology of the story is so confusing—I'm jumping around from childhood to the present to before I was even born. Plus I have all these other layers of things I'm writing about like Donald Winnicott's theories and Virginia Woolf's memoir writing. It had all just gotten really confusing and wasn't making sense.

Then I realized that there really was a very simple, straightforward chronology to the book, and it was this powerful sequence of dreams that I had many years earlier, when I was just starting to write *Fun Home*. I had the first dream right before I told my mother I was going to be writing a memoir about my father. The rest came a couple years later when I was preparing to send Mom my first draft of the book, anticipating her reaction, then dealing with her reaction when it finally came.

I could see that these dreams created a chronological spine for the book, and gave the story a shape and narrative propulsion that it had been sadly lacking. At the same time, I realized that it's problematic to write about dreams. Listening to someone else's dream is usually unbearably boring. So I worked hard to keep them very short and to the point.

I do try to analyze the dreams, to make sense of them for the reader. But I feel very conscious that I don't do a very exhaustive job, that there is a lot of raw material left for the reader to interpret. To go back to your touch question, I feel like the book is in a way me, my self, my body. And I'm asking the reader to hold me not just figuratively, in the sense of an analytic "holding environment," but literally. "Hold me!" It is so pathetic! What was I thinking?

HC. I really love this response. You and I are teaching a course together on autobiography, and one of the books we're teaching is *Roland Barthes by Roland Barthes*. He discusses his idea that "one writes in order to be loved"—and then he says this idea is endurable only if you first find it touching, then imbecilic. Then you are finally free to find it accurate. But I love the idea of writing in order to be held.

AB. Yeah, the Barthes book is wonderful. When I first read it in my twenties I was simultaneously baffled and entranced by it. It made no sense to me, but it also made complete sense. Another line in there that I love is, "To write on oneself may seem a pretentious idea, but it is also a simple idea. As simple as the idea of suicide." I guess I love that so much because for me, autobiography is also the opposite of suicide. My father killed himself, but I became a memoirist.

Françoise Mouly

The Paris-born Françoise Mouly is one of the most important comics and art editors and publishers of the past thirty years. Arriving in New York City in 1974 at age nineteen, Mouly has since shaped American comics—and contemporary print culture—profoundly. She worked as an electrician, plumber, cigarette girl, babysitter, and architectural model maker, among other jobs, before she started printing her successful *Streets of Soho and Tribeca Map and Guide* in 1977. Mouly, it should be noted, still lives (along with her husband Art Spiegelman) in the cozy SoHo loft that she bought in the 1970s—and in which she installed a thousand-pound printing press (pictured in this interview). In the 1970s Mouly was also a freelance colorist for Marvel Comics.

Along with Spiegelman, Mouly founded, edited, and published the influential avant-garde "comix and graphix" magazine *RAW* (1980–1991). *RAW* provided a venue for numerous groundbreaking alternative and international comics artists—including many interviewed here—and Mouly, passionate about production values, became famous for her rigorous editing and design. Spiegelman's *Maus* first appeared serially in *RAW*, starting with its second issue. Mouly has been art editor of the *New Yorker* since 1993, and has been responsible for nearly one thousand covers in her time there—including such controversial images as the famous Michelle and Barack Obama "fist bump" cover from 2008. She recently published *Blown Covers: New Yorker Covers You Were Never Meant to See* (2012).

Mouly's interest in images and the literacy comics demands extends to its youngest readers. In 2000, she created a Raw Junior division; her *Little Lit* books have been *New York Times* best sellers, and an anthology, *Big Fat Little Lit*, was published in 2006. Mouly is the publisher and editorial director of TOON Books, a series of learn-to-read comics for children, which she launched in 2008 (as if her *New Yorker* day job wasn't keeping her busy enough). In 2012, she edited Houghton Mifflin's *The Best American*

Comics. This interview is adapted from two interviews I conducted with Mouly—one in said loft, in 2008, about her early life in New York, and one in 2010, at the Philoctetes Center in New York, for which we were joined by Ben Katchor, Lynda Barry, Tracy White, and N. C. Christopher Couch.

HILLARY CHUTE. Tell me about when you first came to the US.

FRANÇOISE MOULY. When I first came here, I knew no one. But I had been given the phone number of somebody who was an architect, Bernhard Leitner. So I looked him up. He was an Austrian, older person, he was thirty, thirty-five, something like this . . .

HC. And how old were you?

FM. I was eighteen, then turned nineteen. Leitner spoke French fluently, so he enjoyed speaking French with me, and I couldn't speak English to save my life, so . . .

HC. Were you terrified coming to New York and not speaking English?

FM. Yes, yes, yes. [*Laughs.*] He thought I was really amusing. Because I felt my life was over at the age of nineteen.

HC. Why did you leave France?

FM. Because my life was over, the future was predictable, and my boyfriend had dumped me! I had been studying architecture for two years already because I finished high school at fifteen or sixteen. I lived with my boyfriend, so when he decided that we should take a break from each other, it left me homeless. Paris real estate at the time was really difficult. I was not getting any money from my parents—I wasn't really in touch with them. And I didn't have a job. So I felt really stuck.

I was studying architecture, an eight-year course of study at the Beaux-Arts. I liked the Beaux-Arts a lot, but I wasn't looking forward to being an architect, because then you just work for somebody; you do drafting, and you never get to do all the fun stuff that you do in school, where you're asked to design a school or a city, or God knows what. So I thought I would take a year off on my own. I had already been pretty much everywhere in Europe where you could drive. I just wanted to go far away and the US was far away so I took a plane ticket. I didn't have any special love of the US, but I thought, "I'll just spend a year, I'll land in New York. I'll need to make money so I'll find a job, I'll make some money, then I'll go to Chicago, then I'll go to San Francisco, then I'll go to Texas . . ." I thought I would just spend three months here, three months there, but I arrived in New York and a year later I was still there. I just completely fell in love with being in New York. Within a few months I went from being at the YMCA to being at the Salvation Army to being with a roommate on 13th Street to taking the loft.

HC. This loft?

FM. This loft, yes. I found it back in 1974. Leitner was teaching urban planning over at NYU. I would go meet with him in a café once or twice a week. At that time he was looking for a new place to live—looking at lofts. I said, "Can I come with you?" I needed a place on my own after leaving the Salvation Army. I was in an apartment on 13th street, but couldn't stand staying with my roommate. I was earning rent money; I had three jobs. Debby, my Salvation Army roommate, had said, "Oh, you need a job." She had introduced me to her Greek boss, owner of a few newsstands, and I sold cigarettes.

HC. Where?

FM. Both on 23rd Street and at Grand Central. The boss also had an outdoor booth at Grand Central and I worked one of those. A large counter with newspapers, candy bars, and cigarettes. I worked from 6:00 a.m. until 1:00 p.m. selling cigarettes, which was a great job—I just loved it. I had gotten another job, maybe also through Leitner, actually, that was architecture related. I worked for a Japanese construction company, Kajima International, which had an architectural bureau here in New York, all staffed by Japanese. But they had hired a model maker who was American, and at first I worked freelance for him, making models, which is something I had learned how to do at Beaux-Arts and which I enjoyed. And my American boss got fired by the Japanese—I think for lack of productivity–but they hired me to replace the whole department. My work ethic was like the Japanese's: you go in there, you work, then you leave. No coffee break, no talking on the phone, no hanging around and chewing the fat. So I worked for the architectural firm from 1:00 p.m. until about 7:00 or 8:00 p.m.

HC. How did you meet Art Spiegelman?

FM. I had seen flyers for the Ontological-Hysteric Theater of [Richard] Foreman, and I had gone. And at the end of the play, Kate Manheim, Richard's girlfriend, made an announcement, "If you're interested in seeing more, we have an open house every Saturday." She gave the address. At that open house on Saturdays, I met a number of independent filmmakers whose work I knew, because I had been going to the Anthology Film Archives.

At the time, the Anthology was at 84 Wooster Street, around the corner from where I lived. It was a tiny little thing, a screening room. I had seen a fair amount of great films at the Anthology, such as [Ken Jacobs's 1969 film] *Tom, Tom, the Piper's Son*. I liked hanging out there. Then I met Ken at Foreman's. And then Ken, who was teaching at [SUNY] Binghamton, had a coterie of people which overlapped with the people at the Anthology and some of the people in Foreman's plays. I became friends with Renée Shafransky, who later on was Spalding Gray's producer and wife. Then Renée and a couple others went on to create the Collective for Living Cinema. I was helping whichever way I could. I was in that milieu. Meanwhile, long

answer to your question, I would occasionally go out to dinner with Ken and his wife Flo. One evening, Art was there with another cartoonist, Jay Lynch. I wasn't really that aware of Art, except that I couldn't quite follow what he was saying because he spoke so fast. It may have been in 1975 or in 1976.

I didn't pay attention to him that much. Afterwards, I saw him at Ken and Flo's, and that time—I thought of him as a jerk. I vaguely remembered having met him before, and he was with a girl named Cheryl or whatever, who was spooked by being in Ken and Flo's loft, because it's this messy, intensely crowded place. She's so wary about being in that space, whereas to me the only acceptable reaction was: "Wow, this is fantastic! This is great!" Instead Cheryl goes: "Uh, hmm, there's . . . dirt here . . ."

HC. I can't imagine Art hanging out with anyone like that.

FM. No! That is probably the only time I've seen Art being attentive to anybody . . . [*Laughs.*] But he was so solicitous. "Oh, Cheryl, oh, sit here," and getting a chair, you know, finding a chair that he can clear out for her. I thought, "Why is he paying attention to this girl, who's simply not worth the bother? If she doesn't like it, let her go . . . this is never going to work." I formed a rather unfavorable opinion of him that day.

But later, I was working on *Idealect,* a little magazine put out by the Collective if I'm not mistaken. I think I was writing a piece about Louis Feuillade and the French silent films. Ken and Flo said to me that they wanted their eleven- or twelve-year-old daughter Nisi to be a cartoonist, and they asked me to take Nisi to Brooklyn to Art's studio—she was too young to travel by herself. That was the first time I crossed the bridge and went to Brooklyn. Art was living across the street from the St. George Hotel. That time, I thought he was really nice, because he managed to offer the young girl something that wasn't that obvious, criticism about what she could do better, without hurting her and without being condescending, without saying, "Oh, you're so cute." I was very impressed with his response to Nisi. He was neither overly critical nor unduly praising and I thought, "Oh, that's pretty good." I was also impressed with how tiny his apartment was. His bedroom was barely the size of a bed—he had had a hard time wedging the mattress inside. [*Laughs.*]

HC. How did you come to the world of comics—whether professionally, or on your own as a cartoonist or as an editor and a publisher?

FM. Well, I have an easy answer: I fell in love. I fell in love with a man and an idea and the two were very much wedded together. And I ended up wedding him. . . . I had seen and loved *Arcade,* was thrilled by Justin Green and George Kuchar's work, had seen Art's "Don't Get Around Much Anymore," but I fell in love with Art and his work because of a strip that he had done in 1972 called "Prisoner on the Hell Planet."

In four pages he talked about his mother's suicide, and its impact

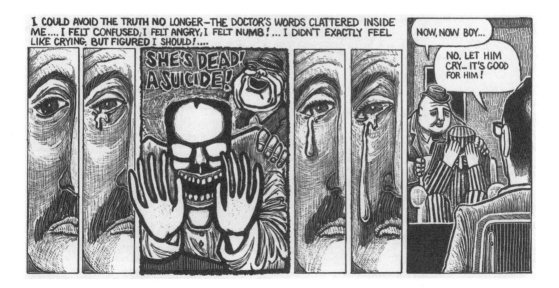

9.1. Art Spiegelman, panels from "Prisoner on the Hell Planet," *Short Order Comix* #1 (1973). From *Breakdowns: Portrait of the Artist as a Young %@&*!* (New York: Random House, 2008). © 1972, 1973, 1974, 1975, 1976, 1977, 2005, 2006, 2007, and 2008 by Art Spiegelman. Used by permission of Pantheon Books, a division of Random House, Inc., and used by permission of The Wylie Agency LLC.

on him. And I found the work so provocative, it led me to call him up (I had met him socially, as I explained) and ask him questions. When I could hardly put two sentences together in English, I ended up spending something like eight hours on the phone.

I just couldn't let go. I needed to know more—more than what was incipient in that strip. And then I realized firsthand the depths of possibilities in the medium. I spent more time with Art: he was an incredibly articulate and generous advocate for the medium that he loved. He courted me by reading George Herriman, Lyonel Feininger, and Winsor McCay, and all of the old comics that he was inspired by. He pointed out so many different, rich interpretations and readings, it was irresistible. And it was completely unique.

It wasn't like Art was [just] one of the members of a generation of people who were interested in comics and graphic novels, the way there was a community of independent filmmakers. Even among his peers—he was part of a group of underground cartoonists—I didn't see the same passion for the medium. I met a number of other underground cartoonists through Art—some of them had found themselves precursors. But Art was singular in the clarity of his vision and the intensity of his scholarship. When we went to Paris, he found Rodolphe Töpffer, who had actually started the medium in the 1820s; he spent time with old newspapers, with whatever he could find; he had spent a lot of hours with Woody Gelman's collection. He gave a series of lectures at the Collective in late 1977, where he talked about his idiosyncratic history and aesthetics of comics. It was such a rich field that no one else was mining. I couldn't help it—I wanted to know more, wanted to immerse myself in it, so I just dropped everything else, which for me at the time was architecture school and Paris.

FRANÇOISE MOULY 181

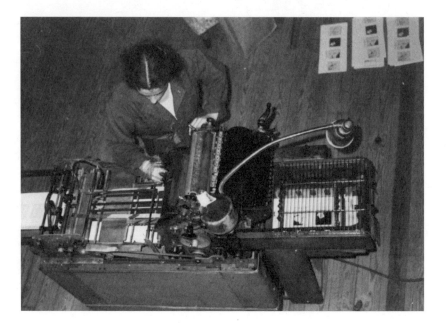

9.2. Françoise Mouly
at her printing press
in SoHo, c. 1980.
Photograph courtesy of
Françoise Mouly.

HC. What was the cultural context that you were coming from in France?

FM. When I left France, I had left behind something I wasn't interested in pursuing intellectually. I felt lost in studies that revolved around the kind of abstract discourse architects favored then: postmodernism was hot. I wasn't thriving in that kind of theoretical debate. Like everybody else, I was reading Deleuze—though I was reading this stuff for pleasure, not studying it in school. The discussions we were having felt so pretentious— we talked about getting rid of corridors, declared death on closets, we set out to design new cities. It just made me miserable, because I felt we were insanely presumptuous: who were we to tell people where and how they should live? It was refreshing for me every time I came back to New York (I went back and forth for a few years). In New York, I could actually do something. I was a plumber here, I was an electrician, I made things happen.

I had had to rebel in order not to be a doctor or a surgeon—that's what had been scripted for me. There was a lot to prove, as far as I was concerned. I never impressed my father [a plastic surgeon] as much as when he saw I could draw. Calculus or writing, that didn't impress him or my mother. When I was nineteen or twenty, my father was still saying to me, "It's not too late for you to change your mind" to be a surgeon. Or short of that, marry one.

HC. Was France in some ways more open in terms of having a comics culture?

FM. Well, France had a lot of comics going on, and also the comics makers or lovers there didn't have to overcome the prejudices that Americans had to contend with. It was easier to see, coming from a country not

tainted by it, that Americans have layers of prejudice against any kind of popular culture. Here, if something sells well, if it's commercial, then it simply can't have any artistic or literary value. There's an either/or, which is not true in France—where something can actually be attended to critically and be popular. Popularity doesn't necessarily mean that it's schlock. Sometimes it is, but it's not a logical connection.

When I was growing up, comics were ubiquitous. They were called the seventh art, in line with the Greek conception of the muses and of all of the arts. The categories weren't as narrowed down as what it had become in America, where, in the seventies, art was only what was in the galleries or museums, and literature was only what was published by Knopf. Take a French, actually a Belgian, writer like Georges Simenon—the French don't worry about whether his work is a popular novel or whether it's literature. It's well written, so it's under the heading of literature, even if it enjoys a measure of success. Similarly with comics, everybody in my generation grew up with *Tintin* or *Asterix*. *Asterix* is an extremely literate comic—the jokes only make sense if you've had the requisite six or eight years of Latin in school. Up to my generation, everybody grew up with Latin, and *Asterix* was the most popular comic strip in France. It wasn't ghettoized, and reading comics didn't label you as slow-witted.

So I was surprised to discover both the wealth of possibility in comics and how deprecated they were in America. I was shocked to hear that the US had had Senate hearings [about comics], actual senators holding hearings on how comics pervert the minds of children, and how they should be banned. These prejudices are specific to American popular culture. First, Hollywood's rating systems, then a code and ratings for comics. There's not the same kind of insecurity in France in terms of protecting children from the adult world. If you walk down a Paris street, you'll see billboards advertising lingerie with naked women. France doesn't have the same kind of puritanical impulses in restraining its media. In [the children's comic] *Le Petit Spirou*, the main plot line seems to be about little boys, nine or ten years old, lusting for their buxom and pretty teacher.

Here in the US, there were lots of barriers, so many ways that comics couldn't be published, couldn't be appreciated by intelligent people. Comics were deemed only fit for children. I think that's what drew me so strongly to the field: all of the challenges of exploding the "you can't do this, you can't do that."

HC. So what was it in Art's piece, "Prisoner on the Hell Planet," which seemed different to you?

FM. The core of it was the honesty with which he addressed the reader. There is a difference between comics and museum art, which is that the cartoonist posits a reader, while a painter is presumed to make a piece

for him or herself, and worry less about how it will be looked at. The painter is in dialogue with his paint, but a cartoonist is in dialogue with a reader, so it's more akin to literature that way. Still, all the comics I had read as a kid and as an adult until then kept a fairly opaque surface between the story and how it was told. In "Prisoner on the Hell Planet," you see the hand, you feel the contradictory, unvarnished nuances of a real voice—it's as if you were talking to someone, I mean really face-to-face. And Art in his work disregards any kind of polite niceness. He doesn't limit himself to what you *should* say, nor does he shy away from what you *can't* say. His work feels uncannily personal and intimate in a way that still resonates, I think, when now, decades later, you have so many other comics. If people are new to graphic novels, they can discover, as I did then, a really rich world. Works of art and of literature that have the unique power of giving you a window onto how somebody else thinks.

HC. Do you think that the prejudices separating artists with a capital A from cartoonists are now a thing of the past?

FM. Actually, even at *The New Yorker*, I've had to contend with artists who would not do *New Yorker* covers because they were afraid that it would devalue their work in galleries and museums. They said they, or their gallery, didn't want work published in a commercial venue. I'm like, "It's the *New Yorker*! What do you mean 'a commercial venue'?" But no, they're just afraid and insecure that somehow doing art for reproduction would take them down a peg from the pedestal. That's such an American set of arbitrary divides. One of my privileges as art editor of the *New Yorker* has been to be Saul Steinberg's editor. Steinberg grew up in Romania, where his dad and uncle were in the commercial printing trade, making boxes. He loved being at the factories, seeing the papers and the ribbons. He escaped from Romania during World War II and studied architecture in Italy. By the time he got his degree, he was about to be deported as a Jew, so he escaped on a boat, tried to get into America, but was denied and spent a year in the Dominican Republic waiting for a visa. He finally got it thanks to William Shawn, to whom he remained eternally grateful for saving his life, literally. He was twenty-two or twenty-three years old and had published a few drawings in Italy, so there wasn't that much for Shawn to go on.

Steinberg devoted his entire life to doing drawings for the magazine. His wife Hedda Sterne was an abstract painter. Jackson Pollock, Willem de Kooning, Calder, Henri Cartier-Bresson were his friends—artists whose entire life was aiming at getting work in private art collections and in museums. Saul talked to me about how he could have gone that route, but chose not to, because he had a genuine love for the power of art for reproduction. That's something that cartoonists treasure, value, and devote their life to. Many of them could be museum artists, but they would be isolated, basical-

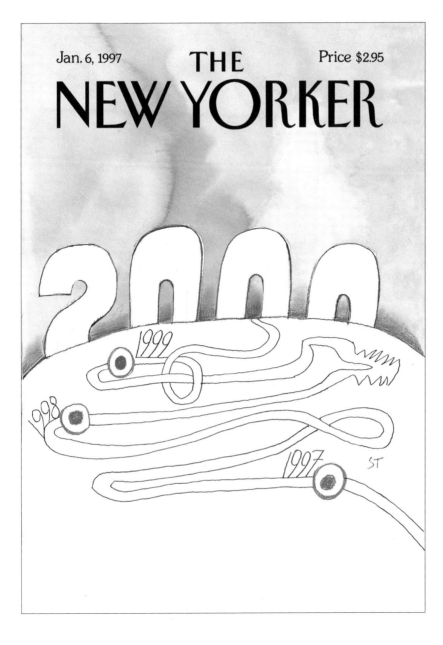

ly doing art for the very few who can own their paintings, or the very rarified museum-going [public] ... well, the separation is less true these days, but still! Comics are art for reproduction. Being a cartoonist implies a certain kind of humility about where you stand vis-à-vis the viewer or the reader.

Besides, in the past century, there's been another prejudice, one against narrative art in the fine-art world. One cartoonist put it very well. Chris Ware was saying that if you go to a museum to look at a painting and you don't understand it, you think you're an idiot. But if you're reading comics and don't understand them, then you think the cartoonist is an

9.3. Saul Steinberg, "2000," *New Yorker* cover (ed. Françoise Mouly) (January 6, 1997). Used by permission of Françoise Mouly.

FRANÇOISE MOULY

PRICE $3.99 — THE — MAY 29, 2006

NEW YORKER

idiot. The burden of communication is very different when the medium
is art for reproduction—it's a profound difference. Steinberg, specifically,
kept the burden on himself—when you do a magazine cover, you can't
aim at something that's opaque or incomprehensible, because a maga-
zine cover has to be read instantly. It's true that the impulse to become a
cartoonist comes from wanting to tell stories, to communicate.

HC. I had the pleasure of hearing you speak on a panel yesterday at

the Brooklyn Comics and Graphics Festival, and you were saying comics is one area where we can see that print is actually not dying.

FM. It's thriving. Anything that is drawn, like comics—and this goes back to what Lynda Barry has pointed out, which is that comics show the hand of the artist—are manuscripts by definition, made by hand. Even when an artist colors their work on the computer, they first draw, then scan it. Sure, some artists draw right on the tablet, but that's not the root of the impulse. And because comics are a window into the thinking process of the artist, a revealing "automatic drawing" as well as a distillation in concise terms of the author's story, the object of the printed book integrates many crucial aspects. Lynda was pointing out that when you're a kid, first you make a book—and then you figure out how to fill it. When I publish comics, thirty years ago with *RAW* or now with the TOON books, my impulse comes from wanting to make a book object, an object that has permanence. I'm not thinking about how the book will be reviewed in six months, or what people will think in a year. I think about it existing for somebody a hundred years in, or even five hundred years in, why not? And frankly, something you put on a website doesn't last more than a few months. But a book will have the same image, in the same place on the page, and you'll turn the page, and the same magic will happen for the Martian that will come in from the future. A book, especially a picture book, is an artifact you make by hand, which has a way to anchor the soul. Everything that you do electronically—whether it's a facsimile version or an enhanced epub, it's interesting; I'm not against it; I actually do a fair amount of the promotion of my books on the web; it's a good tool for a number of things—is separate because it doesn't have that primal impulse of just making something permanent and by hand. There's plenty of text that's just as readable on an electronic device—it's liberating for transient type—but the avalanche of epub platforms only makes me value the book even more.

HC. Maybe this is a moment for you to talk about what you were thinking about when you decided to start *RAW*.

FM. Well, you know, there were lots of cartoonists who were against the ideas behind *RAW*. I mean, it wasn't just Ben [Katchor]. Ben was a pretty hard nut to crack, but Art was part of the underground comics, and there were plenty of underground cartoonists who were doing phenomenally interesting work who had a very different aesthetic and philosophy. Justin Green had done *Binky Brown Meets the Holy Virgin Mary*, Bill Griffith was doing *Zippy the Pinhead*, and Robert Crumb was at the center of the scene doing *Zap*. Crumb had done the covers for *Arcade*, but all of the underground comix prided themselves on being disposable

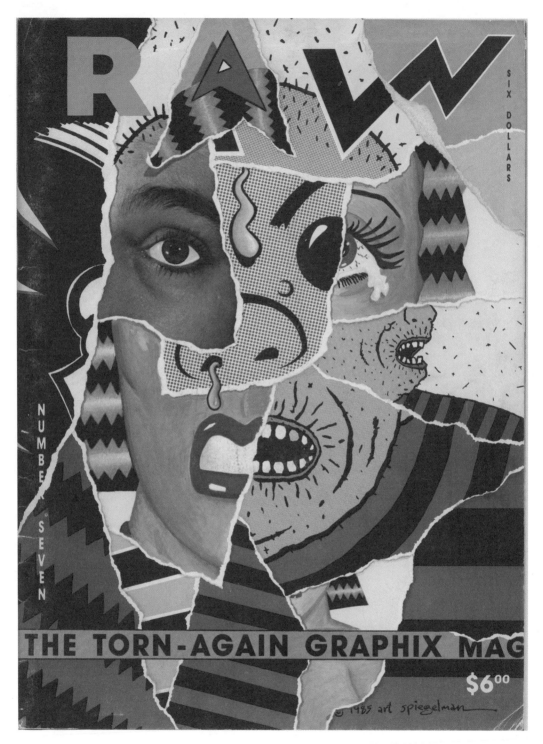

9.5. Art Spiegelman, Cover of *RAW* #7, *The Torn-Again Graphix Magazine* (May 1985). Used by permission of Françoise Mouly.

and throw-out-able. Literally to be read on the toilet when you're stoned, but certainly not to be taken seriously or archived in deluxe editions. I'm not saying that trash culture is not a perfectly valid place for comics. I think it's actually an incredibly healthy and generative attitude. But it also allowed me to say, "At the same time as it should be this disposable thing, it shouldn't just *only* be that, and if we want to make people realize the potential of the medium, we shouldn't feed their [impulse] 'Oh, it's just garbage, it's just trash, it's disposable newsprint'—"

HC. So what changed?

FM. Actually right now there's way too much stuff being published. I think it's rather indiscriminate. What changed? So thirty years passed, thirty-five years. *Maus* had an enormous influence. *Maus* is a book that reached outside of the comics fan audience. All of a sudden, it made it possible for people that weren't necessarily conversant with the form to have read a "graphic novel" and to look for more. What Ben said is true: publishers want to publish anything that anybody's willing to read, so once you expanded what's possible, then they put out. Why did it take a long time? Because it's a very slow medium, labor-intensive medium. A book that got published last year by David Mazzucchelli [*Asterios Polyp*] was ten years in the making; Charles Burns published a book, *Black Hole*, that was also ten years in the making.

It's not just any comics that can have an impact, though—no medium has the power to transform crap into art or literature. There are plenty, a great majority of tedious, banal, rote comics. But when I read *Binky Brown*, or the first three pages of *Maus*—I remember the experience—I was knocked out. I couldn't believe what I was seeing on the page. Same when I saw some of Crumb's better pieces. When we were putting together *RAW*, everywhere we went in the late seventies, the one common denominator that we would see in every artist's notebooks was their R. Crumb period. Whether it was Charles Burns or Gary Panter in the US, or when we traveled to France, Holland, Spain, or Italy, every cartoonist had gone through a period of being influenced by Crumb. That shows how the work of a great cartoonist can get into your mind and imprint. This said, on the "graphic novel" front, comics have gone further than I thought, and that's saying something.

HC. We've tried to give an account of how we got to the place we are now, in terms of even having a so-called graphic novel field that we can all identify. But where are comics going, and what sort of forms are they taking now? How is TOON Books, your imprint for emerging readers, related to your previous work?

FM. I do children's books because that's the last frontier. I wish somebody else would fill the void, would do good comics "readers" for that cru-

9.6. Rutu Modan, *Maya Makes a Mess* cover (New York: TOON Books, 2012). Used by permission of Françoise Mouly/TOON Books.

cial moment in elementary school, but so far everything else done for that age group is abysmal, stripped of life, humor, or pleasure. I do believe that that's what creates the future: kids falling in love with books the same way I fell in love with books at that age. I know it's not going to happen through a dreadfully boring illustrated primer, or a website, or *Sesame Street*.

It's a bit similar to what Lynda was talking about before, that the child is preliterate, so she hasn't yet subsumed everything into a verbal way of apprehending things. She mimes, she smells, she touches, she hears, she sees—all of this is a multimodal experience for her, when she's four, five years old. A book also comes with the one-on-one attention given to her by the teacher or the parent, and the tactile and visual pleasure of turning the page, which she can do herself. With a book, and especially with a comic, the young child is at the wheel, she gets to drive the narrative. That book, that physical object, is the madeleine around which she'll form her literacy. Literacy is a structure for understanding the chaos of information in the world. Books, especially visual books—picture books and comics—are uniquely suited for this, because of the way they distill, condense, juxtapose, and display multiple levels of information that the reader then unfurls and brings to life. Publishing comics for very young kids creates readers, creates an intelligent audience, and therefore creates a future for comics.

I've had to try to understand things that I have done more instinctively than intellectually, such as falling in love with comics. I talked with [TOON Books advisor] Dr. Barbara Tversky—a professor of psychology at Stanford and at Columbia. She pointed out that one of the powers of comics is the fact that it's multimodal, the preferred mode for a young child, up until the moment where he or she learns to read. Say you have a bunch of kids over, and say in French, as I did, "Hey, it's four o'clock, it's snack time!" And all the four- and five-year-olds would be there in a moment. But why, since they didn't understand what I said? Because there was my intonation, the smell of cookies in the air, the fact that their stomach is growling, and the context, all the other kids running to the kitchen, so they're not even noticing they don't understand the words, they're integrating the music of the language in an entire multisensory context in which all meaning is embedded. When we demand that a young child get the whole story only from reading the words, we're demanding a jump into such a level of abstraction that most kids stumble. Many who cannot create a rich experience from a poorly illustrated text whose images only repeat what's in the text become "reluctant readers," and will be hard to win back. Comics, on the other hand, give them a varied and textured narrative flow even before they make out the words.

HC. Is there a connection with editing work for adults?

FM. When I work with artists on editing comics, the size of the panel

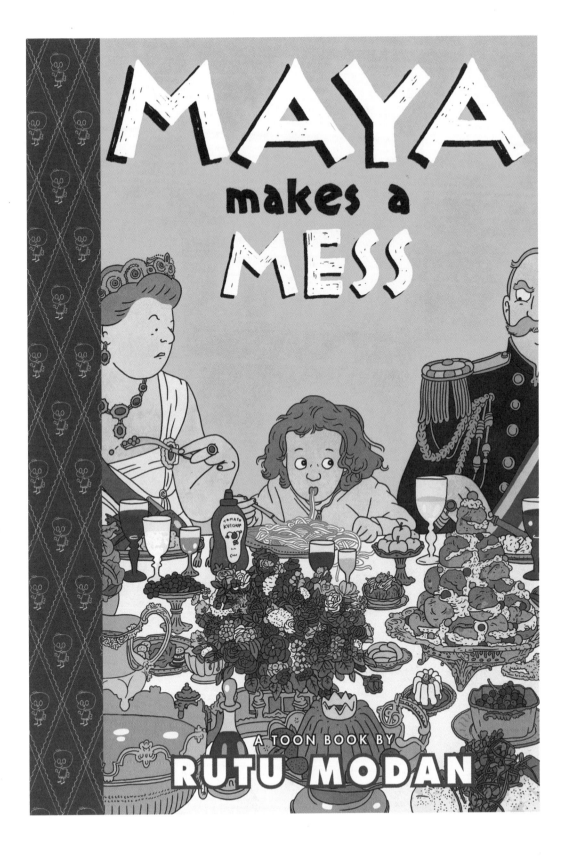

Play with me

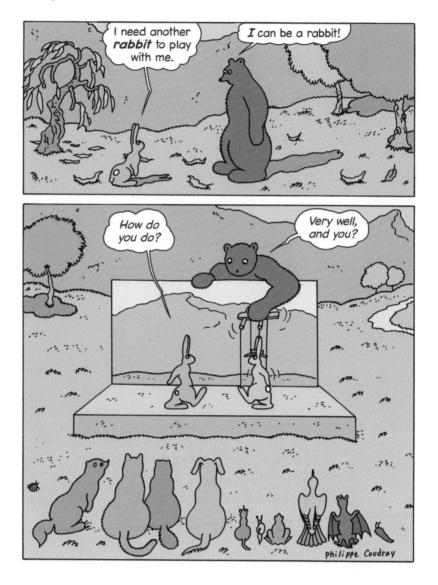

9.7. Philippe Coudray, a page from *Benjamin Bear in Fuzzy Thinking* (New York: TOON Books, 2011). Used by permission of Françoise Mouly/TOON Books.

matters; it carries meaning. So does the size of the type, the way the lettering and the shape of the balloon will tell you whether the character is talking, shouting, whispering. With facial expressions and body gestures, the information is given on at least four or five tracks. Reading a comic made for early readers rather than an illustrated primer is like comparing the notes of a musical instrument to a symphony. Good comics can have a visceral hold, such as in my first experience with Art's work. It was overwhelming in its impact because it wasn't just words and pictures—it was also the way they were arranged, and how they interacted with each other. That gave me a complexity of experience that is seldom obtainable in other media.

Each medium brings about its own way of reading. Socrates was decrying the invention of writing—he felt that people would stop being literate because literacy to him meant memorizing. Once plays were written, people would stop learning by heart all that they knew, and they have. So by Socrates' standard, we have been illiterate ever since. Now, actually, we're going back to a more ephemeral, disappearing-every-day culture on the web. We're going back closer to ancient Greece in terms of an oral culture—except that we don't remember anything because we can find it in two seconds on Google. So we're not developing our memories, but at least our kids are able to multitask. Socrates would have had a hard time with this new twist and I do too. Then again, it's generational. The issue of using your imagination is part of the prejudice against comics. Many people feel that a cartoon is not as worthy of attention as literature, art, whatever, because everything is spelled out. They think that because the cartoonist has drawn what the character looks like, the reader doesn't use his or her imagination. I believe it's a misunderstanding. The image of Tintin is as much of a cipher as the word "Tintin." You're not looking at a representation of the real person, Tintin; you're projecting.

HC. That's actually one of the things that fascinates me about comics as a form. To me there are two fundamental spaces for reader participation. One is the gutter space, so between each frame, the reader is filling in the causality in a way: what happens from A to B, and there is a white space between A and B. And it's very evocative, and it's really the work of the reader projecting the narrative, and creating the narrative. Also, since comics aren't illustrative, they're not redundant. It's not that the words and pictures match, and synthesize, so there's also that disjunct between word and image that the reader is always trying to figure out.

FM. I heard a teacher recently who was attending a conference about comics for kids use a metaphor I thought was very apt. She said, "Oh I get it, comics are like jigsaw puzzles." It's true—it's up to you, the reader, to make the whole picture. That's also what you're talking about: the gap between the panels, the work the reader has to do when building a sequential narrative. There's a shape given by the creator to each piece, but it waits for you, the reader, to put it together—that thought brings to mind another quote I heard recently, which is "Life is a jigsaw puzzle, and the answer's on the back."

10

Adrian Tomine

Now thirty-nine, Adrian Tomine entered the comics world as a wunder-kind. In 1991, while still in high school, he started self-publishing his stylish, broody comic book series *Optic Nerve* ("My teenage idea was it's a weird title that means 'whatever this artist is working on'"). Several years later, already acclaimed, it was picked up by the prestigious Montreal publisher Drawn & Quarterly. Tomine, who graduated with a degree in English from Berkeley, is the child of professors (his father is an emeritus professor of civil engineering at Cal State; his mother, currently a practicing psychotherapist, has produced two films for PBS about Japanese internment camps, where Tomine's relatives were incarcerated). Despite his reputation as a cover artist for the *New Yorker*, where many of his covers have become famous and already feel timeless, Tomine is still immersed in the format with which he began his career: at the time of this printing, *Optic Nerve* is heading into its twenty-third year. A print-culture loyalist and a defender of the inexpensive, accessible, circulating comic book, Tomine continues to work in a format his peers in literary comics have mostly abandoned.

Tomine's graphic novels include *Sleepwalk and Other Stories* (1998), *Summer Blonde* (2002), and *Shortcomings* (2007), which focuses on the fraught relationships protagonist Ben Tanaka sustains with his girlfriend Miko Hayashi (a Japanese American), his best friend Alice Kim (a lesbian Korean American graduate student), and several women who are objects of his desire (all younger and white). In its review, the *New York Times* named Tomine "a mild observer, an invisible reporter, a scientist of the heart." His most recent book of comics, *Scenes from an Impending Marriage: A Prenuptial Memoir*, fits that bill, balancing conflict and levity in a looser, more fluid style than his previous work.

New York Drawings, a collection of Tomine's illustration work, appeared in 2012. He is also the editor and designer of several translated

manga works by Yoshihiro Tatsumi, a Japanese cartoonist now also published by Drawn & Quarterly. Kind enough to invite me to his lovely, immaculate Park Slope, Brooklyn apartment, which he shares with his wife and four-year-old daughter, Tomine offered me a cup of coffee before sitting down next to me on the couch. Consummately polite, he began, "Should I sit over there? Is it weird to be looking sideways at each other?"

HILLARY CHUTE. I don't know the story of how you started publishing *Optic Nerve* [with Drawn & Quarterly]. Was that in 1994?

ADRIAN TOMINE. That sounds about right. And prior to that I was self-publishing minicomics back in high school.

HC. And they were being sold in comic shops?

AT. Yes.

HC. Were you selling them to your friends in high school?

AT. I didn't have any friends in high school to sell them to.

HC. How did you start drawing?

AT. They're both retired now, but my parents were both professors. My parents got divorced when I was two, and then I moved around with my mom as she got her PhD and then got teaching positions. Through third grade I was living in a town called Corvallis, Oregon, and then I moved to Fresno, California, and then I moved to Sacramento, California. The fact that the towns themselves were sort of small, and that I moved around so much that I didn't have a big lifelong group of friends to hang out with—those two factors worked in concert to get me drawing. But they also limited the sort of influence that was available to me, in, say Corvallis, Oregon. You know how kids who grow up in Manhattan are like, "I don't wanna go to the Met again, can't we go to the Frick?"

HC. Brats!

AT. There were two different stores that sold comic books, and they were on a spinner rack, and they were Marvel and DC. That's what I had access to. I found the kind of stuff that I like now on my own later on.

HC. How?

AT. That was when I was around twelve—which in hindsight I feel is the natural age that people should start to lose interest in the superhero stuff. I don't know how many weekends in a row I'd gone to the comic store and picked up the stack of the weekly comics from my little saver file, and brought them home and instantly put them in bags and filed them alphabetically without even reading them.

HC. So you were a hardcore collector as a kid?

AT. Oh yeah. I was subscribing to the *Comics Buyer's Guide*, and buying the price guide, and tallying up the value of my collection. It became

worthless! All the stuff I put all this care and effort into, it's like, anybody want "The Dark Knight"? No. . . . OK.

To me it was like this weird turning point when I realized: this is this joyless collector treadmill I'm on where I'm not even reading the stories or anything. So much of my life has been dictated by my upbringing of my parents divorcing and moving around a lot, so having a comic book that comes out once a month that I keep buying on schedule and putting it in order was a pretty clear way of trying to have some kind of order or control. So that was when I was around twelve, and fortunately, even though I was living in a town as small as Fresno, the store that I went to had a little nook in the back with, you know, basically pornography, but that's where I found *Love and Rockets*, and they had *RAW*, and I think they might have had *Neat Stuff*, and just enough crucial things that would open up that whole world to me.

HC. I had a similar experience with the comic book store Million Year Picnic in Cambridge. I remember being out in France and staying with Aline [Kominsky-Crumb] and with Robert [Crumb], and Aline said, "How did you find my work?" and I said, "I just found it on the shelf," and she just fell over. She was like, "You just saw it on the shelf? Where?"

AT. *Love and Rockets* was the big eye opener for me. There was that little period for me around thirteen when I was probably feeling particularly lonely, and I had just discovered *Love and Rockets*. I really felt that I had more of a personal connection and investment in the lives of these fictional characters than in the real people in my life.

HC. How did you start publishing your stuff?

AT. I transitioned from reading superhero stuff to reading underground and alternative work. That was second to discovering comic books as a medium—it totally just affected what I would try to do when I sat down to draw at my desk. I went from trying to copy Steve Ditko and John Romita to: "How does Jaime Hernandez make those lines?" When I was a kid, people would say "Oh, you have a talent for drawing," but with writing I always struggled: "How do I invent a superhero and a whole world of monsters that he has to fight?" It just didn't click for me. Then I started reading things like Robert Crumb's autobiographical strips or *American Splendor*, and even Chester Brown. It was like, "You can really do this?" You can write about like, your day, and people give you praise for that? And that really opened up the whole avenue of being able to write; suddenly I felt like, I can understand how this is done, and I can try and do that.

I was just working in sketchbooks and doing imitative work, like my version of a Harvey Pekar story. Then at a certain point when I was around sixteen, I felt like there were a few of those little stories that

weren't awful, so that's when I decided to put together the first little minicomic issue of *Optic Nerve*. I made it at a Kinko's in Sacramento and I made twenty-five copies of it just as an experiment, because I was getting interested in minicomics. I was ordering minicomics from other people around the country and getting excited—

HC. By mail?

AT. By mail, just to see. I had no idea how a full color *Spider-Man* comic could be made. . . . I thought it must be made in some factory overseas, I don't know. But just to look at a little small hand-trimmed thing from Julie Doucet, I could I see how she did it, and that was exciting for me. So that's how the first *Optic Nerve* came about. I think that one was mostly just given out to family members.

HC. Then what happened with the second one?

AT. There were a couple comic book stores in Sacramento that allowed me to put it on their shelf on consignment, and I'd go in every week and see if any copies had sold so they'd give me twenty-five cents or something like that . . . it was nice! It started to grow a little bit, and I started getting letters from other people who had picked it up.

FORM AND FORMAT

HC. I remember being so excited for the next issue of *Love and Rockets* to come out. Isn't it still so amazing—I guess it's a tiny bit more expensive now—that you can buy something for three dollars and fifty cents that is that awesome?

AT. I also am totally depressed about comic bookstores going out of business, and I know that a little three-dollar comic from me every two years isn't going to save any comic book store. But just in my conscience, there's this part of me that thinks: in the future, this material will be in a hardcover book available on Amazon, but until then, the only place you can get it is in little comic book shops; and you know, for the ten hardcore fans that that is important to, they will seek it out, and I still feel like that's nice. I wish that more people could still give that to the comic stores, because it obviously doesn't hinder the sales of the hardcover when it comes out.

HC. There's this amazing thing about browsing—a person going into a store and browsing the shelves. Because a comic book is not that expensive, I could browse and I could choose a couple. I would find things.

AT. I guess that whole experience is kind of gone, because it's very rare that you'll walk into a comic book store and not have already read about someone on the Internet. That was definitely how I discovered a lot of stuff.

The comic panels read:

EARLY 2010

SO WHAT'S THE PLAN FOR YOUR NEXT BOOK, ADRIAN?

YEAH, ARE YOU WORKING ON A "GRAPHIC NOVEL" FOR A BIG PUBLISHER LIKE THE REST OF US?

WELL...

IT'S A **GOLD RUSH** RIGHT NOW, MAN! DID YOU SEE MY "TWEET" ABOUT THE ADVANCE MY AGENT GOT ME?

YEAH!

UH... I'LL PROBABLY JUST DO MY USUAL THING OF PUTTING OUT A FEW ISSUES OF **OPTIC NERVE** WITH D+Q AND THEN RE-PUBLISHING THEM AS A BOOK LATER ON.

REALLY?

HUH!

AH... "THE LAST PAMPHLETEER"!

HA HA HA HA

HAHA HA AH HA HA HA HA HA

WHY IS EVERYONE LAUGHING SO MUCH?

A FEW MONTHS LATER...

GOD...EVEN **PALOOKA-VILLE** HAS TURNED INTO A HARDCOVER BOOK. I GUESS THE DAYS OF THE "ALTERNATIVE" COMIC BOOK ARE REALLY OVER.

10.1. Adrian Tomine, panels from *Optic Nerve* #12 (Montreal: Drawn & Quarterly, 2011). Used by permission of Adrian Tomine.

HC. Maybe because I'm change-aversive too, I love that you're still putting out the comic book.

AT. I don't think most of my other cartoonist friends have any sentimental nostalgia for that part of the process. Instead it is: "I want the best-looking printing and the fanciest book!"

One of the things that I always think about, now that everyone has pretty much abandoned the comic book format, was that with Peter Bagge and Chester Brown and the Hernandez brothers, in the comic book, say, in the inside cover, they would list: Here's ten comics that we really like, or here's some recommendations for some new up-and-comers. I really benefited from that. I got some plugs for my minicomics that really helped me out. There's really no place for that now in a hardcover book from Pantheon. And the Hernandez brothers did it with both comics and albums. I basically committed those lists to memory and thought, "I now will seek out each of these items and figure out what was great about it to them," and even when it was, say, Dolly Parton, I was like, "OK! I think I see it, I think I get it."

HC. I always loved that too, because I felt like I was learning about a certain part of the punk scene that I didn't know.

AT. Right! At that time I was really into skateboarding, and all my friends were into really hardcore punk skateboarding kind of music that for me was difficult to actually get into, even though I wanted to act like I was. So then to see these elder punks who seemed like unimpeachable

experts saying "But we also like Elvis Presley and Johnny Cash!"—all of these little things started connecting that I hadn't thought of before.

HC. [Holding most recent issue of *Optic Nerve* from 2011] So do people now really call these floppies?

AT. At this point it's common enough that it's said without air quotes around it.

HC. I love that there is a letters section here. I remember from earlier issues of *Optic Nerve* that there was always a letters section.

AT. Usually with pretty negative remarks in it. I love doing it. It's one of the only advantages of putting out a comic so slowly—that it gives me time to accumulate a lot of good letters. At the start there was so much more of a culture of exchange through the mail with other creators.

HC. Especially around zine culture in the nineties too.

AT. Right, so it was so fun for me to open the mailbox and get some guy's minicomic or some girl's music zine. I got cassette tapes ... all kinds of handmade stuff. Everyone was exchanging with each other through the mail. I was doing it more out of my greed to get fun stuff, and then it started to become more like a critique in the letters—people angrily critiquing my work. But it started out more like friendly, like-minded weirdos across the world, really just sharing their stuff with each other, which has totally been replaced by the Internet now.

HC. There's much more communication happening on the Internet, but much less material culture being exchanged.

AT. I've probably spent as much or more time in post offices and stationery stores as I have in bookstores in my life. I mean of course stationery stores are quickly disappearing too.

HC. I think this is why I like cartoonists. I'm not a cartoonist, but this is what I've always liked! Where do you find the other people who are really into this? They're all cartoonists!

AT. I had the really poignant experience of being back in California—it was after I moved out here but I went back to visit—and I was with Dan [Clowes], and with our friend Richard Sala, and we were just walking around in the little neighborhoods where we would get coffee, and the old stationery store where we'd always stopped to pick up our supplies was having their closing sale. We just walked in there on their last day and were loading our arms up.

HC. I remember Dan telling me about growing up in Hyde Park, that there was a stationery store, and when he was a kid that was closing, and he went into the stationery store and bought all this stuff—

AT. Ha, and started crying about the dying world ...

HC. —and he was like ten or something! There are people who are just like that, and a lot of them are cartoonists!

AT. I think there's almost now a cultural stereotype of the nostalgic cartoonist guy, and you don't want to play into it too much.

THE 1990s

HC. Tell me about the nineties.... Do you feel like your work was part of this nineties moment in an important way—do you think it shaped you?

AT. I definitely benefited from some sort of cultural shift that was happening at the time, and I definitely got to ride the coattails of a lot of other artists who had blazed the trail for me.

HC. But even just aesthetically, I remember picking up *Optic Nerve* and thinking, oh that's a girl in a cute miniskirt I would wear. You know, I felt like people you were drawing were people who looked like me and my friends and that was very appealing.

AT. There's definitely a possibility that my career could have ended with the nineties, and I would have been contained within that little time capsule of whatever bands had had a short career during that time. I was trying to be very trendy and cool, and some of those things are not by accident. I was like, "I hope there's a girl in Cambridge who will find my comics at Million Year Picnic and see this miniskirt that I drew . . ."

HC. It's great! There are so many people searching for images just even slightly like them! And you could find them in comics in a way you couldn't so much find them in other parts of culture.

AT. I think the last ten years of my life has been a bit of a struggle for me to try to climb out of that, to try and climb onto some next level.

HC. I feel like your subjects have gotten more timeless, too. In a more explicit way the stories are about things that never go away, about desire and sexuality and race and marriage.

AT. I certainly have no shortage of ideas I could do that would be based on some of that same material. Because it was the time in my life when I was going out most, and interacting with the widest range of people, and doing things for the first time rather than having a daily routine. There's a part of me that thinks maybe at some point in life it'll be interesting to revisit some of that stuff, but right now, there's a part of me that feels very self-conscious about doing youth-romance kind of stuff, which I think was sort of a corner that I was boxing myself into.

HC. Do you think your style has changed?

AT. I've been on this endless seesaw or winding path to find what my style is, to separate any little kernel of style that could be considered my own from all the influences that I've absorbed so heavily. I don't think that has hung over other artists that I know as much as for me.

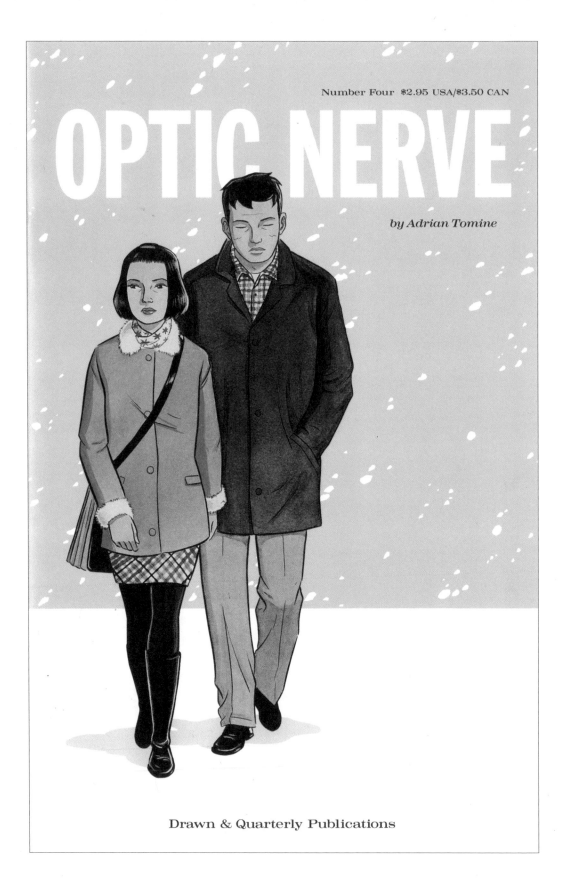

HC. Can you be more specific, in terms of graphic influences?

AT. The most prominent and long-lasting ones have been Jaime Hernandez and Dan Clowes. There are plenty of other people who I've ripped off shamelessly or been influenced by deeply but I think those are the two that jump out to people the most when they look at my work.

HC. In terms of the line?

AT. In terms of everything. I didn't go to any kind of art school and didn't really get to be immersed in college even as an English major, and I spent most of my life developing my interests and abilities in terms of comics kind of in a vacuum. When I started meeting these people who had this wealth of knowledge and experience with this stuff I kind of just soaked it up like a sponge.

I absorbed so much from both of those guys that it then became a challenge of trying to see my work clearly again. When I was first starting out, if I could make my artwork look exactly like a page out of Jaime's book, that would have felt like a success—that's what I was trying to do. And it's only when I starting getting a little older and putting myself out into the world that I realized, "Ooh, people really react negatively to that." People really say mean things if your artwork looks like people whose work you've studied. So that was a revelation to me.

HC. What was the thing you liked about it?

AT. About those two guys?

HC. Yes, how would you articulate it?

AT. That's a good question. . . . For better or for worse I've always had an attraction and an aspiration to kind of beautiful, clean artwork. The surface is important to me. Which is not to say that either of those guys are lightweight, superficial cartoonists, but I was definitely attracted to their work by some aesthetic quality more than the content at first. I feel like there does seem to be two different types of cartoonists; there are some who might even dismiss some of the guys that I love for being too pretty or too clean—they think it's got to be scratchy, like that's the real art, when someone's really vomiting on the page or whatever. I think there's something to the fact that, of all the cartoonists that I'm friends with, even twenty years later those are the two of the guys that are among the closest to me in terms of just attitude, world view, sense of humor, all that.

HC. So you do a lot of illustrations for the *New Yorker*, and Jaime has done a lot of interior illustrations, and Dan has done covers. So there is something about the style that makes it appropriate for illustration too—it's graphic, it's beautiful, there's something there . . .

AT. Even as a kid, I was often more interested in illustrators than fine artists. It's kind of embarrassing to admit, but going to Paris, I was sort

10.2. Adrian Tomine, cover of *Optic Nerve* #4 (Montreal: Drawn & Quarterly, 1997). Used by permission of Adrian Tomine.

of forcing myself to walk through the Louvre, and then I was so excited by some illustration on a subway billboard.

HC. Yes, I often feel the same way; something just pulls you in.

AT. I remember as a kid, doing a drawing, like a nice drawing, a comic book kind of drawing, and then I'd get out crayons or watercolors and try and color it and just ruin it. And I would wonder, "How come in the comic books it's these flat areas of color that look so cool? If only I could get that!" So there was something—I guess I always liked the commercial, or the illustrative. That quality has always appealed to me. And even as I started to become more exposed to different types of fine art, to this day I still love Edward Hopper, and he's kind of just one hair's breadth from being just a magazine illustrator. I love that kind of stuff.

THE *NEW YORKER*

HC. How did you start publishing illustrations in the *New Yorker*?

AT. I was living in Berkeley and I decided that it would be neat to be in the *New Yorker*, so I walked down to Cody's Books, which is now out of business, and I got an illustration annual down off the shelf and found the name of an art director at the *New Yorker*, which was Chris Curry. I guess out of ignorance and sexism, I wrote "Dear Mr. Curry"—it's a woman, of course. So I put together a little package of tear sheets—it was just totally amateurish. I went to the stationery store, which of course doesn't exist anymore, and I bought a folder. I got a little nametag label, and I wrote my name and fax number on it (again, which doesn't exist for me anymore), and I was going to visit a friend in New York anyway, so I got to New York, and either I called information or I looked in the phone book, and I found the address of the *New Yorker* offices, and I walked over there. There wasn't security; I just got in the elevator and went up, and the receptionist let me in. I said, "Can I leave a portfolio here?" And this guy actually still works there, but he was so intimidating to me at the time. He paused and he said, "You can"—like, you are physically able to.

HC. This sounds terrifying!

AT. So I just sort of dropped this little folder on the counter and shuffled out. And then a few months later I actually did get a phone call from Chris Curry, and she offered me a tiny little spot to do an illustration in the calendar section of the magazine, kind of like a trial run.

HC. It just worked out! You dropped off the little portfolio, the receptionist was snotty to you, and you got in the *New Yorker* on your first try! Nice going! How old were you then?

AT. Maybe twenty-five or something. I probably put a copy of *Optic Nerve* in there. I'd done a ton of other magazine illustration work, but

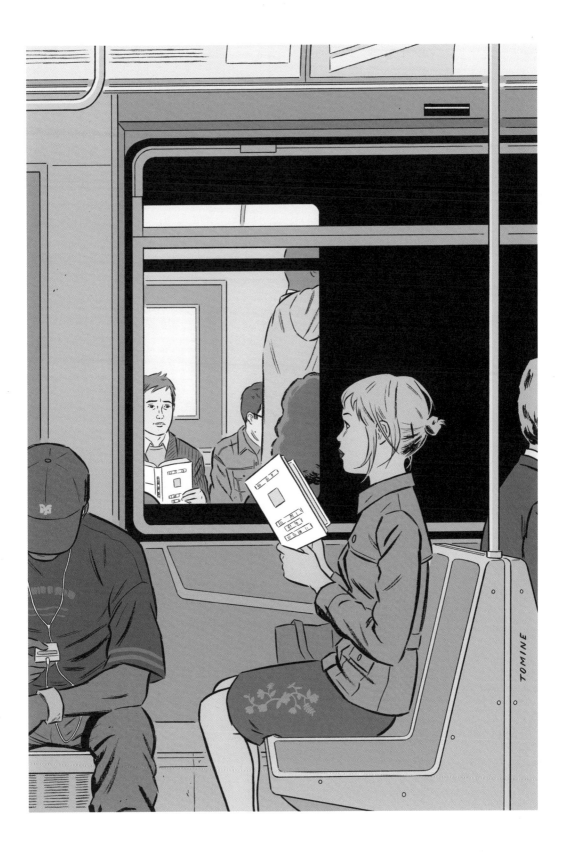

nothing like the *New Yorker*. It was a lucky break that they happened to give me a shot, and they were also nice enough to give me a few shots.

HC. Did you find it difficult to be working on illustration and comics? Or did you see it as two parts of a whole?

AT. Because I'd been so spoiled in the world of comics working with Drawn & Quarterly, to then have to step into the world of magazine illustration and be edited, and micromanaged, and the whip is being cracked to get it in earlier than seems humanly possible … I would bristle. Eventually I realized that they were just totally different endeavors and that there's something to be gained from the collaborative aspect of the illustration project. And money started to be a lot more important to me. When I was a single bachelor in a tiny little apartment in Berkeley where all I needed was to make sure I could buy my burrito that week, I felt like I could thumb my nose at some magazine editor who dared to suggest a change, like how dare he insult the great artist, or something. And then when I got more into the real world of needing to support a kid, I became more grateful for those kinds of opportunities, and understanding of the idea: "What's wrong with trying to make the person who's paying you happy?"

And the *New Yorker*'s not an example of one of those things where I'm gnashing my teeth—that's more when I'm doing advertising work.

HC. So many of your covers have become so iconic—like "Missed Connection." I ripped that off and tacked it on my bulletin board above my desk. And one thing I love about the covers is that so many of them are girls reading!

AT. That's true, that's true! When they started giving me covers, they sort of decided I was "the book person."

HC. I feel like there's a kind of a new/old sort of thematics, like the one of the screening of the bridge by the bridge ["Double Feature"], and the Amazon one ["Read-Handed"]. I see a new/old tension that also connects with an aesthetics of attention, like the one about tourism, where the girl is looking at the book instead at of Radio City Music Hall ["Bored of Tourism"].

AT. Yeah, that's a good point.

HC. Does that connect at all with your comics? Or with being a cartoonist?

AT. I mean it obviously connects to the whole issue of format. Obviously my personal bias is towards like the bookstore, not the delivery man. I'm nowhere on the level of someone like Chris Ware or Seth who have such a wealth of knowledge and dedication to the past, but I think there's some element of that personality that is deeply embedded in me. Even the idea of an old sign on a Brooklyn storefront replaced by a

horrible new one. . . . My wife always says, "Why do you care so much?"

HC. I agree, it's a travesty!

AT. I compose drafts of letters that I end up not sending, because who's going to pay heed to it, but I get worked up about things like that! I think with these *New Yorker* covers Françoise [Mouly] has always been very smart about guiding me. It doesn't have to be a gag, but there should be a bit of a story that you can sort of figure out by studying it a little bit. When I'm thinking of that, I think of contrast, or conflict, and then of course my personality guides me towards old vs. new or fake vs. real, and of course in a place that's changing so quickly like New York there's always source material for that.

MARRIAGE BOOK

HC. Tell me about your last book of comics, *Scenes from an Impending Marriage*, based on your wedding.

AT. Well, it's a horrible endeavor for someone who's picky about aesthetic kinds of things. I think it would be fine if there's a couple who just want to have a fun time and whatever makes people happy is good with them. But every little thing for me was this annoyance, and the default option for everything about planning a wedding was something offensive. So every step I had to go against the tide and sort of fight for what I thought was the "right way."

HC. The aesthetic integrity?

AT. Yeah, I can't think of any other thing that I've been involved with where at literally every juncture all forces were pushing me towards the uglier or the dumber option. And then all the stuff that I fuss about and care about and worry about, like no one else cares. No one says to me, "I'm so glad you didn't do offset printing for your invitations."

HC. One thing that comes up in that book that I thought was funny was the cultural sensitivity issue, like your different ethnic backgrounds . . .

AT. Well, I had to certainly streamline some of that subject matter for the book. Because the book was originally given out as a favor at the wedding. Even when we published it later as a book I still thought, "Eh, I don't want to turn this into some heavy kind of controversial thing. It's still supposed to be a fun thing . . ."

HC. It wasn't heavy at all.

AT. No, it wasn't, because I consciously made that choice. Maybe you'll have to deal with it someday: cultural things that seem so insignificant on a day-to-day basis suddenly start becoming meaningful when you have parents and grandparents involved, and thousands of dollars being spent. You see a little glimpse of "Oh, I see why wars occur: deep

10.4. Adrian Tomine, *Scenes from an Impending Marriage* (Montreal: Drawn & Quarterly, 2011), 38. Used by permission of Adrian Tomine.

down in people they really think their culture's the best, and the others are wrong," which for most people living a nice comfortable life in America never comes up on a regular basis, especially with something that's supposedly such a polite, elegant affair. When you start getting that glimpse into it, it's not exactly nationalism, but it's some sort of, what's the word . . .

HC. Some sort of chauvinism?

AT. Cultural superiority, and xenophobia, and all in very tiny degrees. Not like "We should kill everyone who's different from us," but like, "Our way is the better way" and "We must honor our way, and who cares—theirs isn't as important."

Sarah and I both had plenty of those moments where we said, "Wow, up until that very moment I had no idea that you really care about that," or "You're really gonna stand your ground about that silly thing?" And

then: "Why is it silly?" and then suddenly everyone has a vision of their dead grandmother and is thinking, "I wouldn't want to hurt her feelings, and this would be so meaningful to her." I think I could have done a really dark and scathing book about the process of getting married. There's not a lot of market for it . . . people aren't going to want to go into Kate's Paperie and buy that. We got through it pretty unscathed, but every day there was this little glimpse, seeing how one step further could be really dark.

HC. One of the things I love about your letters section is that I feel like you often put in a lot of letters that are pretty critical about race in your work.

AT. Really?

HC. You have ones in the current issue of *Optic Nerve*: "Your character Ben is a total asshole. He's rude, racist, insecure . . ."; "The p.c. bullshit in your latest story really annoys me . . ."

AT. I obviously was courting that a little bit with the *Shortcomings* book, and if I didn't get that kind of reaction I'd be sort of surprised. But even before and after, the topic of race does hover over my career way more than I would have ever predicted.

HC. People react more strongly than you anticipated?

AT. I was very ignorant and naïve about the world when I started working as a professional cartoonist and going out and promoting my work. I grew up in pretty white atmospheres. I didn't think of myself as an Asian American cartoonist ever. And I started noticing that there were a lot of Asian people in the audience who were at my signings who were about my age, and I was getting asked to speak to Asian American studies classes.

HC. What was it like visiting classes?

AT. The funny thing is, again I naïvely thought that I would be sort of celebrated, like, great for you for being this Japanese American cartoonist who's doing this work. But it was often a very very quick turn into being criticized and questioned, and I felt anger towards me a lot of the time. I felt this even more when *Shortcomings* came out and I had to go out on the road and promote it. I had to sort of skew my story as not at all autobiographical, that the character is a complete fictional character, and of course I don't agree with the things he says.

HC. Because everyone's saying he's such an asshole?

AT. I thought people were going to react kind of like the way people react to *Curb Your Enthusiasm*, like Larry David's an asshole but he's still my hero. But there was no hero, it was just the first part.

HC. I think Ben is a very likable character.

AT. Well, you're the only one, I think.

HC. Even for people who aren't only part of the community of people who showed up at your readings, there's so much texture in that book about desire and race that's so interesting. I still think about a lot of those episodes a lot: like, OK your boyfriend watches pornography featuring people who are ethnically different than you. Well, it's just pornography, but how does that make you feel? Or this episode with Ben and his friend Alice Kim: is it worse to be Japanese at a Korean wedding or to be gay?

AT. Which is the more evil, yes.

HC. Do you have the sense that people wanted it to be more of a celebration of Asian-ness and that's what they're upset about?

AT. I've met a handful of people who, like you, took it more as I intended, as: here's a handful of interesting conversations on this topic, think what you want. And I think there were people who wanted it to be like a celebration of Asian American-ness without any kinds of dirty laundry being aired, or anything negative at all. It's hard, especially being from the Bay Area, to think of Asians as a minority, but there are people who think, "We're trying to be accepted; don't embarrass us in any way, or don't put anything negative out there." My sense is also that unless a slightly offensive line of dialogue is coming out of the mouth of, like, a mustache-twirling villain who then gets shot in the head as punishment, it's offensive to some readers. Not that that character's sentiment within the story is offensive, but that the whole work is offensive, and I am the one who committed it.

I think of my work as being so tame and so mild and so restrained, and there were people who were angry with me. I think that there were times where even if I admitted, "Yeah, a lot of that Ben Tanaka character does come from me, and a lot of those thoughts are things that I've thought or conversations I've had," it would be very troublesome.

HC. So it was like you weren't the right kind of Asian American cartoonist?

AT. I feel like if anything I was overly rewarded for that book. In sources outside the Asian American press it was praised in a way that I appreciate, like in the *New York Times Book Review*, so I can't complain about it. But it was definitely an interesting experience to see, within this Asian American community, the reaction to my book versus some of these other books by Asian American cartoonists that were a lot more upbeat and positive about being "proud of who you are."

HC. Was the thing that felt taboo an Asian American man's desire for a white girl?

AT. That was hard. And there were people who came right up to me during that *Shortcomings* tour, and said, "Is your wife white?" or "Is your

10.5. Adrian Tomine, *Shortcomings* (Montreal: Drawn & Quarterly, 2007), 26. Used by permission of Adrian Tomine.

10.6. Adrian Tomine, *Shortcomings* (Montreal: Drawn & Quarterly, 2007), 54. Used by permission of Adrian Tomine.

wife Asian?" just in the middle of a book signing, which is very strange to me.

HC. And the "good" answer was supposed to be that she was Asian?

AT. I would just say, "That's kind of private," but that was sort of my hunch. There are some interesting things that I think someone who is a better cultural analyst could look into in terms of specificities about Asian American culture. It's not just being some ethnic minority or something like that, because that is not specific or exclusive to Asian Americans—an interest in being likable and good and nice and sort of the model minority thing. You know, it's hard to be indignant about race-based offenses that you've endured if you're then exposed as having your own racist thoughts yourself. But I also think that it's a culture that isn't

always comfortable with sex-related topics. I don't want to hang myself in terms of cultural stereotypes, but there are groups of people for whom sex is thought of as a more natural part of life; it's more celebrated, it's more out in the open. You don't think of that that often in terms of Asian American culture. There isn't even that much in this book. This would be an R-rated movie if it were a movie: there are some conversations, there's a little bit of nudity shown, but nothing too crazy. But I think a lot of people were uncomfortable with the idea of Asian American characters having some of these conversations, or an Asian American cartoonist coming up with these conversations and committing them to paper and publishing them. Again, I am looking at these reactions through a very small pinhole.

You know, artists always find many ways to justify the negative reactions that their work gets, so it could be partially that. But I will say there was definitely a turn in the tenor of my experiences out in public after *Shortcomings* was published. Prior to that, I'd look out in the audience and there'd be so many Asian people, particularly women, and I'd think, "God, this is such a proud moment compared to the stereotypical comic book store"—

HC. That's so great!

AT. And then to see that thin out and to go through several instances where I felt like someone had come and endured the Q&A to have their moment of angrily expressing something to me and then leaving. It was a new experience for me.

HC. Do you feel like *Shortcomings* was kind of like "coming out" as an Asian American cartoonist or something?

AT. It was a conscious choice. I was very taken aback when I first did an interview and someone asked me, "Why are your characters all white?" It hadn't even occurred to me, but I don't know, they're just characters. People said, "But you're Asian, so why aren't you writing about your experiences?" and I felt, these *are* totally autobiographical; these are about my experiences. And as time went on and I did more interviews with AA [Asian American] press or met people at events there was the sense that people thought that I was sort of disguising my true identity in a bid for a wider mainstream appeal. As if anyone really discriminates, like, "I'm not going to support that Asian guy"; it's not exactly like Pearl Harbor just happened and it's this dangerous topic or something.

So I think that there was some sense that "oh, he's finally being real and he's got some Asian characters and he's addressing these issues," and then these people read the book and thought, "Oh, this is kind of weird." So it was kind of a double disappointment, like I'd resisted that subject matter for so long, and then I finally did it, but I did it in this hor-

rible way that made them angry instead of happy or something. It's far enough in the past now, but I had to definitely do this strategic move to get through some of those book tours, of being in on the joke of what an asshole this character is that I'm lampooning in this scathing indictment of a book. Because there were people who came up to me at readings and pointed at specific panels and asked, "Do you agree with this?"

HC. I wonder if prose authors have to do that as much. . . . I wonder if there's something about visualizing people on the page that elicits that sense of [the author's] responsibility.

AT. It was funny because when that was all going on I was thinking about *Stardust Memories*, the Woody Allen movie. That to me is the most clearly brutally autobiographical movie where he was very contemptuous of his fans and accumulated this database of types that he wanted to lampoon in this movie, and of course people picked up on that and were very offended and he quickly responded, "Oh no! I'm just an actor! Why was that autobiographical?" To this day in interviews, he'll say that people misunderstood that movie. And I'm like, "Nah, I understood it, I got it."

HC. Are there people who have influenced you as just writers?

AT. There are many more memorable instances in my life of opening up a Jaime Hernandez comic next to my sketchbook and trying to literally copy it, versus cracking open a novel and thinking, "Let me write a sentence like this guy." But I realized that throughout the year leading up to and through the process of working on *Shortcomings* I was basically reading every Philip Roth novel that had been published. There's definitely some kind of influence, but I didn't get anywhere near—and if I had one-tenth of the sexual content of a Philip Roth novel, I would have had like zero audience members at that point.

JAPANESE COMICS

HC. What about Japanese comics? I know you're editing Yoshihiro Tatsumi's work.

AT. I'm so ignorant about pretty much any kind of cartooning outside of North America. I can't read any other language, so I'm really limited. It's just a very slow, long-term project that I always had hopes of someone else doing. I didn't realize how obscure [Tatsumi] was, and just basically it became clear that no one was ever going to do it unless I forced the issue. And very quickly, especially once his autobiography *A Drifting Life* came out, Tatsumi developed an audience and a fan base in North America.

I did a couple of signings with Tatsumi; we did one in LA and one in San Diego, and it was like five people who I see every year standing

around talking to me. And he had this line out the door of people whose arms were loaded up with other Japanese comics that I wasn't familiar with, and had all these traditions that I wasn't aware of, like fancy gold-edged illustration boards to present to him, that he would then do a really nice brush drawing on, and they would then bow as they received it. There were white guys from La Jolla who just know all about this whole manga culture.

HC. What do you like about his work?

AT. The qualities that I like best have to do with realistic but dark subject matter about sort of . . . just the idea of zeroing in on some average guy who you would never notice and just going deep into his life and behind the closed doors and not flinching at what you see and most of it being pretty dark and kind of disconcerting. Very different from most of the American comics that I'd grown up with, and totally different from most of the Japanese comics that I'd been exposed to.

HC. It's striking that you're doing comics—words and images—then you're doing illustration, then you're also sought after for writing jobs. It's like you're doing the full spectrum of words and images.

AT. Obviously the one that I seem to have done the best at is the combination of it. There's no way for me to step out of my real life and say "What if," but I do feel like there's no coincidence that comics, way more than screenwriting or illustration or anything, is the one art form that I've been totally obsessed with since a preliterate stage of my life, ever since I was a kid. I couldn't even read, but something about comics was just magical to me.

HC. What is it that you like about comics?

AT. Aside from playing with my daughter, it's the only thing where that I can still have the experience of, "Oh, four hours went by?" I can just get into that zone. Even watching a movie that I love, or any kind of experience other than drawing comics, I'm in the correct time frame—I know how much time has passed by. So when that happens at the drawing board it's still exciting and surprising to me. There's something about it that's just still more enjoyable to me than any other art form.

11

Art Spiegelman and Chris Ware

Born in Sweden in 1948 to Polish survivors of the Holocaust, Art Spiegelman is a theorist and historian of the comics form as well as of one its most globally famous practitioners. In 2005, he was named one of *Time* magazine's 100 Most Influential People in the World, and he is the recipient of many prizes and honors. It is hard to overstate Spiegelman's role, from the 1970s forward, in expanding the field of contemporary comics. In addition to the Pulitzer Prize–winning *Maus: A Survivor's Tale*, perhaps the most famous graphic narrative in the world, the trenchant underground comics work that preceded it opened up the arena for what literary comics could do, and Spiegelman's subsequent comics works have reinvented the possibilities of the form at every turn.

Spiegelman's terrain-shifting collection *Breakdowns*, from 1978, was republished in 2008 by Pantheon along with the new work *Portrait of the Artist as a Young %@&*!*. His numerous books include *Maus I* (1986), and *Maus II* (1991); *The Wild Party* (1994); *In the Shadow of No Towers* (2004); *MetaMaus* (2011), for which I collaborated with Spiegelman; and the new *Co-Mix*, a retrospective book that was published in French and then expanded in English in the wake of his exhibit of the same title, which has been traveling from the Pompidou Center in Paris.

A hugely influential editor, Spiegelman has edited and published work that helped to create the comics field we have today. Among other titles, he founded and edited, along with Bill Griffith, the important underground comix magazine *Arcade* (1975–1976), and in 1980, along with Françoise Mouly, he founded and edited the groundbreaking avant-garde "comix and graphix" magazine *RAW*. From 1993 to 2003, Spiegelman was a staff artist and writer at the *New Yorker*, for which he has contributed many covers, including the famous black-on-black 9/11 cover.

Spiegelman is interested in putting the language of comics into conversation with other forms. He has collaborated with avant-garde jazz

composer Phillip Johnston on *Drawn to Death: A Three Panel Opera*, bringing comics and music theater together; and on the 2013 multi-media show *Wordless*! With Pilobolus, an experimental dance company, he created the piece "Hapless Hooligan in 'Still Moving.'" Spiegelman's stained-glass installation project for his alma mater, the High School of Art and Design in New York City, went up in 2012.

Cartoonist Chris Ware's work found a large readership in the pages of Spiegelman and Mouly's *RAW*: his first piece, "Waking Up Blind," featuring a potato-shaped protagonist, appeared in *RAW* 2.2, in 1990; in "Thrilling Adventure Stories (I Guess)," from *RAW* 2.3, in 1991, we start to recognize the clean, bold pen line that characterizes his work—as well as themes that carry forward across his oeuvre—family displacement and filial perplexity. (Ware specifically asked me not to reprint any part of "Waking Up Blind" here.)

Ware went on to serialize his work in Chicago newspapers *Newcity* and the *Chicago Reader*, among other venues—and created his own *Acme Novelty Library* serial, in which he publishes his work across many different formats. While the Jimmy Corrigan story line first appeared in *Acme Novelty* booklets, when Ware issued *Jimmy Corrigan: The Smartest Kid on Earth* as a book with Pantheon in 2000, he helped to redefine by example, as Spiegelman had done, how comics could function as literature. *Jimmy Corrigan* made a large splash, winning the American Book Award and the Guardian First Book Award. Ware's work has been included in many national and international exhibitions, including the Whitney Biennial in 2002, and he is a regular contributor to the *New Yorker*.

Building Stories, Ware's most recent book, was released in October 2012. It is a large box that contains fourteen different narratives in discrete formats of all sizes, from the small foldout pamphlet to the gold-spined hardcover book. There is no correct order in which to read these connected stories. When Ware unveiled slides of *Building Stories*, a ten-year project, on a panel at the "Comics: Philosophy & Practice" conference at the University of Chicago in May 2012, the room produced a collective gasp. Ware's fellow cartoonists were not shy about expressing how impressed they were. The acclaimed cartoonist Seth, to many laughs, simply stated, "That makes me feel really shitty." Charles Burns piped in, "Can we leave now?" *Building Stories* is a feat of narrative intricacy and is also, in its very form, a print-culture manifesto. The back of the box reads, "With the increasing electronic incorporeality of existence, sometimes it's reassuring—perhaps even necessary—to have something to hold on to."

This conversation with two comics masters—close friends, but also separated by a generation—took place in April 2008, to a sold-out crowd

at the Jewish Community Center in San Francisco, which titled the event "Serial Boxes." It is edited and condensed here.

HILLARY CHUTE. I want to ask the two of you what you each think of the term "graphic novel."

ART SPIEGELMAN. Well, you know it's a marketing term and it seems to have stuck so I'm trying to get used to it, but it was actually originally just a bid for respectability because *graphics* are respectable, *novels* are respectable—at least in the twentieth century they are respectable. So it was a double respectability, and it never came out of my mouth easily. I don't think of it as what I do, because "comics" is fine. I thought it was a matter of making more interesting comics rather than making a more interesting word about them.

CHRIS WARE. When people ask me what I do, I'll say I'm a cartoonist, and they'll say "Well . . . uh . . . can I call you a comic—uh, a graphic novelist—?" It's almost as if they want to ask if it's all right to use the word "African American."

AS. I'm surprised that this phrase actually stuck and worked—because it did work. When I used to say I was a cartoonist, it was like I was saying I was a plumber for most of my life and you know, it was fine.

CW. Right. "Graphic novelist" is a more noble word.

AS. A fine thing to do, but it wouldn't win you a lot of dates especially. And on the other hand, I have compared it to a Negro friend in high school who then became an African American, an Afro-American, a black man, trying to outrun the cultural problem that came with [terminology]. This was easy—somehow it just happened within the last few years. "Oh, graphic novelist, that's as good as being a writer or something."

CW. Well, as Dan Clowes has pointed out, "graphic novelist" makes it sound as if we write books like *Story of O* or *Lady Chatterley's Lover*.

HC. One thing people sometimes misunderstand about comics is they think comics is a *genre*, and they don't recognize it as a medium.

CW. For decades, I think it's fair to say that the word "comics" was irrevocably associated with superheroes, at least until the advent of the undergrounds.

AS. I mean that's just what became so associated with comic books that it was hard to remember that there were also things like *Railroads*, a picture story about freight service, or *Your Friend Wheat*, which was one I remember from my childhood. But this at least just proves that all it is is a medium that can be used for pernicious ends, for propaganda, for entertainment, escapism, maybe even art, but it's not a given that it be any one kind of thing.

HC. How did you two meet?

CW. In 1987, I was living in a crappy one hundred and ninety-five dollar a month apartment in Austin, Texas, and one day the telephone rang. I picked it up and Art Spiegelman was on the other line.

AS. You almost hung up on me. So freaked out by it. What happened was I had been interviewed by some college newspaper in Texas, and I was sent the clipping, and the article was stupid and I began doing the usual thing of trying to correct it. You know, "They got *that* fact wrong," and then I turned it over and there was a little piece of a comic by Chris on it, and that looked really interesting. [Françoise Mouly and I] had just been doing *RAW* for a while, and it was like: this person, we need this person in the magazine. So I asked the paper to send me some more examples of your stuff, and I asked for your number and gave you the call. Chris basically said: "But I'm not ready; I wanna be in *RAW* but when I grow up."

CW. You were my hero. I'd been reading your stuff ever since I was in high school, and I didn't feel like I was ready to appear in *RAW* magazine. I still don't think I was ready, actually.

AS. It was already clear that you had thought through comics way more than most people had, and usually what we were doing was trying to beat people off. Our rejection slip that I was eventually sending out thousands of recommended sending [the submission] to the Star Waste Paper factory. We just never knew what to do with all the stuff that was coming over the transom, but when there was some new artist who had a singular voice, it was a reason to do another issue. We did the first issue of *RAW* primarily as a demo, just to show what should exist in the world, and then we figured it was just a one-off. I had been asked by *Playboy* to help them with their comics, and then much to my shock [*laughter*] I found out that they just wanted sex comics, and then *High Times* wanted some comics, and they just wanted drug comics. So just to show what comics could be, we did one issue of a magazine and then, by popular demand from the artists and no one else really, we had to do it again, so we did another issue, and it began. Each issue would coalesce around one or two artists that we hadn't shown before but who we really wanted to bring to the fore.

CW. I discovered Art and Françoise's magazine while looking for pornography in the back room of my local Omaha comic shop, which is where the owner (understandably) kept the undergrounds and 1970s sex and drug comics. I guess at some point he deemed me sufficiently old enough or eligible for corruption, because one day he started letting me back there, and eventually I came across a big magazine sticking up out of the bins that I'd never heard of before called *RAW*. Thrilled, I thought, "Wow! That must be really filthy!" So I pulled it out and thumbed through it, but of course I was immediately disappointed because, well, it wasn't

really that filthy. So I put it back. But something about it stuck with me, and a couple of visits later, I ended up buying it, and then it . . .

AS. Ruined your life.

HC. I want to shift a little bit to talk about some formal issues. So, Chris, in the [2004] issue of *McSweeney's* that you edited, you wrote: "A cartoon drawing lives somewhere between the worlds of words and pictures." Can you two talk about words and pictures in comics?

CW. Whenever I hear my own words thrown back at me it's so painfully clear what a hopeless, pathetic pedant I am. On the airplane on the way here I read a book of Art's interviews published last year by the University of Mississippi cover to cover, and I realized that pretty much everything I've ever done, or believed, or I'd thought had come out of my own brain came out of Art's brain first. I stole it all.

AS. I learned it all from [*Nancy*'s] Ernie Bushmiller basically. It's all you need to know about words and pictures, I think.

What's interesting about the whole thing is: when it's done badly, like Al Feldstein's scripts for the old EC comics . . .

CW. Feldstein draws pants pretty well, though.

AS. He's great on the wrinkles around the breasts also, but the thing that's really kind of bizarre is that he was so much a writer who drew, he would just write everything out and then just illustrate the text, rather than add to it. It just seemed like, there must be other ways to go about this. Things I ended up really admiring were by Chester Gould and the guy who did *Dick Tracy* in his senile period, who just had the words and pictures each on their own journey, you know?

CW. So this slide is one of the many self-consciously complicated strips I've done over the past few years based around a Chicago apartment building—which is the focus of an ongoing graphic novel called *Building Stories*—and this second slide is a bona fide drawing of the building after which I vaguely modeled the fictional setting, where my wife and I lived before moving to Oak Park in 2001. I'm including them both here only to show the difference between an actual drawing and a cartoon as I understand it. In the case of the "real" drawing, I was actually trying to *see* the building—I was standing in front of it, looking at it—whereas in the case of the cartoon, the drawing is more reduced, more to the level of how one remembers something—a sort of platonic ideal, condensed to its barest visual essentials, so that on the page one "reads" this image instead of looking at it. Comics are that medium in which, ideally, a series of pictures operates more as words than as pictures.

AS. Well, what it is, is just—your drawing is very self-awarely turned into a picture-word. When you're drawing in your sketchbooks, it's obvious that you have a spectrum of about thirty other ways you could approach the

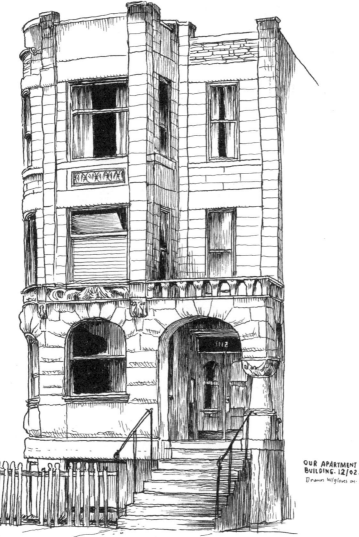

OUR APARTMENT
BUILDING. 12/02.
Drawn W/gloves on.

11.1. (Opposite) Chris Ware, apartment strip from *Building Stories* (New York: Pantheon, 2012). Courtesy of Chris Ware. Used by permission of Chris Ware.

11.2. Chris Ware, apartment drawing (December 2002). Courtesy of Chris Ware. Used by permission of Chris Ware.

drawings if you were trying to do that, but it sometimes looks almost templated, because you're trying to make it as if it was a typeface of some kind.

cw. I try to apply the same approach to drawing that a typographer would use to hand-letter a font, using a brush and a pen to delineate everything as cleanly and clearly as I can. I want the black lines of the strip to have the same clarity as typography, because I think that a typographical approach more accurately reflects the way we remember and abbreviate reality as ideas rather than as images. I underlay this black line with naturalistic colors so the end result more or less hopefully approximates the way one's perceptions are modified and filtered through the template of memories and abbreviations one is perpetually

interposing on the world. And I should mention that while I'm talking about it all in this fancy way, it's no different from the way that most cartoonists, like Bushmiller and Hergé, approach what they do; I'm just thinking about it too much.

When I was at my last high school reunion sitting around with all my friends, we all agreed that we couldn't see each other as the pathetic, dissipated, forty-year-old men we were; we still saw ourselves as eight-year-old boys. I realized that because we were superimposing the memories of our childhood faces on what we were actually seeing, our perceptions were being drastically affected, almost distorted. It's kind of disquieting, when you think about it. I also believe that it's one of the reasons that life seems so hopeless sometimes.

AS. I like the fact that we're sort of wired to understand cartoon pictures. I was trying to get to the root of the "have a nice day" face, where it seems that babies can recognize a "have a nice day" face about the same time they can recognize their mother's smiling face. And then [The Beguiling Books and Art bookstore owner] Peter Birkemoe was telling me that he read that the "have a nice day" face was developed specifically as a perception test to see what infants could recognize.

CW. How do the researchers know?

AS. The babies gurgle.

CW. They gurgle? OK . . . yeah . . . but don't they do that anyway?

AS. Um, louder. I was just always interested in the fact that the words and pictures are each like other avenues toward surrounding an event or a reality.

So recently, I just finished a long introduction, *Portrait of the Artist as a Young %@&*!*, to my first book of comics that will be coming out [again] in October, and it has a sort of pornographic-looking strip in it. In the introduction, which is in comics form, there's one sequence about words and pictures. The strip had been called "Little Signs of Passion," and so I got to use some of the images again. Here it is: "'Words do speak louder than pictures. Captions do tend to override the evidence of our eyes; but . . . no caption can permanently restrict or secure a picture's meaning'"—as Susan Sontag said.

HC. Another formal question. It's often said that the procedure of comics is to represent time as space. I was wondering if you could explain that.

AS. Is it often said, or is it that you just heard me say it too often?

HC. Well, I've heard you say it a lot.

AS. Well, let me start because this example is about as good as any could be. It's a two-page strip by Jules Feiffer that I found while doing some research in *Playboy* magazine, and uh, it goes:

"Oh God!"

"Oh God! Oh God!"

"It's wonderful. Oh God, it's wonderful!"

"Dear God! Dear dear God!"

"God! God! God! God!"

This is why we're doing it at the JCC.

"Oh God."

"God. God."

"God."

"God."

click *click* *click*

"Joyce?"

"Joyce? You allright?"

"Wonderful."

"Me too, wonderful."

"Just wonderful."

click

"Joyce?"

"Yes, darling?"

"Joyce—I love you."

"Joyce?"

"Are you crying, Joyce?"

"Yes, I'm crying."

"Oh Bernard, why did you have to spoil it?"

And, the thing is, this is about as reduced down as a comic gets, but it makes the point as clearly as it can be. Those three boxes of silence are what makes that whole strip happen. And actually, I was doing a talk with Jules and he pointed out that it had to be three. He tried it with two. He tried it with four. It had to be three pauses, and it came from his then-interest in blackout comedy sketches and stuff. That kind of timiness of the Jack Benny was a really important influence for him, and to me, it's just about as clear as it gets. What you're doing is you're taking these things, these little annotations, and making the strip have the equivalent of what he described in the past as a musical score.

cw. I came to a similar conclusion when I was trying to do wordless strips, because early in my efforts I found I was simply relying on words too much to tell the story. Curiously, however, I found that when I read these pictures-only strips, I still heard sounds in my mind, which I hadn't expected at all. So I tried to kind of "listen" to them. Later, when I started adding words back in, I was more attuned to these "sounds," and I tried incorporate them into the storytelling.

There are just so many different ways of just putting comics together.

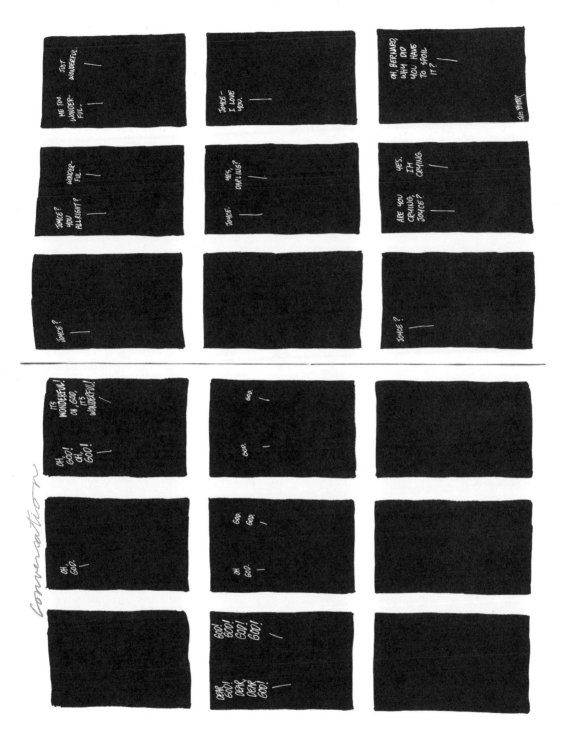

11.4. Jules Feiffer, "Conversation," from *Playboy* (April 1964). Used by permission of Jules Feiffer.

11.5. Art Spiegelman, from *The Complete Maus*, 25th anniversary edition (New York: Pantheon, 2011), p. 211. Vol. 1 © 1973, 1980, 1981, 1982, 1983, 1984, 1985, 1986 by Art Spiegelman. Vol. 2 © 1986, 1989, 1990, 1991 by Art Spiegelman. Used by permission of Pantheon Books, a division of Random House, Inc., and used by permission of the Wylie Agency LLC.

The cartoonist can use long pieces of text that don't have anything to do with the internal rhythm of a story and still have the strip work really well. Depending on how you're writing your way through it, whether as a third person or as a single narrator or something else, there are many ways of compressing the narrative time, or compressing the sense of consciousness in the strip.

AS. For me, it's useful to think about when I was trying to organize pages of *Maus*. [On page 211 of *The Complete Maus*] where Vladek and Art are sitting in the Catskills and talking, I'm asking my father where my mother was when he was in Auschwitz, and he's explaining that it was Birkenau. And basically the little units of time that are moving forward in the most traditional and therefore invisible way are these little boxes that are continuous, and are kind of palimpsests on top of this map of Auschwitz, and where Birkenau is in relation to it. That is both underneath the temporal movement and also this big chasm that you have to jump to, to get from one of those boxes to another, so it's very specifically making something spatial.

CW. More things I've stolen from you.

There's sort of a received idea in comics, I think, that a larger panel somehow holds more time, as if time is some sort of medium that we can ladle out and dollop, but I don't really believe it. I think you can actually have just as much time, say, in a large central panel as you do in the four little ones, which maybe are even of the same image—it just depends on how they're composed on the page and, more importantly, how they relate to one another.

HC. Well, this is maybe a related question. Both of you do work that isn't possible to read too quickly, and I'm wondering if that's part of your intention in crafting the page.

CW. I just don't want the reader to feel cheated. I get criticized, sometimes, for my comics being too small or too hard to read, but that comes of my not wanting to waste paper. There are even a few "graphic novels" available now that have only one panel per page. So if these books are seventy pages, that's only seventy panels, which is really just one Sunday page, as far as I'm concerned. I mean, if one is structuring a story like that there should be a very good reason for it; otherwise I think the reader is going to feel cheated.

I'd like the panels to have the same sort of organization on the page that I feel that certain events have in my mind, where certain things kind of swirl around or connect in ways that I don't quite understand. So when I'm working on these pages—I guess it would be admitting too much to say that I make it up as I go along, but that pretty much comes down to what I do. Things happen on the page that I simply would not be able

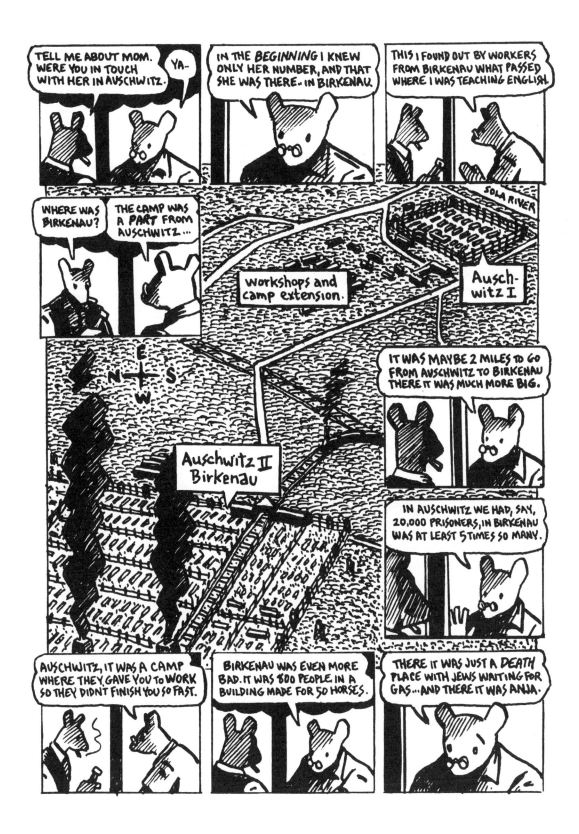

11.6. Art Spiegelman, from *The Complete Maus*, 25th anniversary edition (New York: Pantheon, 2011), p. 34. Vol. 1 © 1973, 1980, 1981, 1982, 1983, 1984, 1985, 1986 by Art Spiegelman. Vol. 2 © 1986, 1989, 1990, 1991 by Art Spiegelman. Used by permission of Pantheon Books, a division of Random House, Inc., and used by permission of the Wylie Agency LLC.

to plan if I was plotting it out very carefully or scripting it beforehand. Oddly, this approach also helps to control the flow of the stories, I guess since they are all fiction anyway.

AS. Well, I try to figure it out, to make it as rational as I can, knowing that it's hopeless, that "rational" barely exists. So I have to go as far as I can toward that, and as far as reading slow goes, what I was realizing fairly recently is I'm not interested in anybody reading the comics. I'm interested in them *re*reading them, so you've got to offer a delivery system that lets somebody go through it, but presumably, the way that one avoids ripping somebody off is to give something that has enough density, so that it rewards going back over after you've got the overview of the terrain.

CW. Occasionally somebody will tell me that one of the things they like most about comics is that they can read them at a leisurely pace, that they can linger over certain pictures and spend time studying how carefully they were drawn, sort of meandering over the whole page, but this always leaves me thinking, "What are you talking about? That's totally wrong! You can't read a comic that way . . . you have to go straight through it, at a very mechanical rate, and pay attention to the rhythms I've built into it!" Which is when I realize I'm completely out of my mind, because you can't make anyone read a comic strip a specific way . . . which I think in a way might be, you know, one of comics' hidden secrets of which I'm clearly not taking advantage.

AS. Well, when you're talking about panel size, I was using it really traditionally in *Maus*, like in the sense that I thought the panels should be used frugally. I was using small ones most of the way through, but it was really important to me to keep certain things large enough to make you think about them. Here [on p. 34 of *The Complete Maus*] is an example of pretty much the biggest panel, in the first volume of *Maus*, which is where the swastika first comes in. And I was aware, after having had all those, as Tina Brown used to call them, squidgy little boxes, whenever I proposed comics to her at the *New Yorker* . . .

HC. Squidgy?

AS. Squidgy. I think it must be British for shitty, but I'm not sure. But, in any case, here was a place where I wanted you to know that this was a moment, and let it slow down. And it turns out that the only bigger panel was one of the last pages of the first volume, where it's a similar structure, but it actually bleeds off the page, and it was genuinely a similar structure because we start with the transportation, the train, then Vladek and Anja looking out the window of the train, seeing the swastika—and then being brought by trucks to Auschwitz.

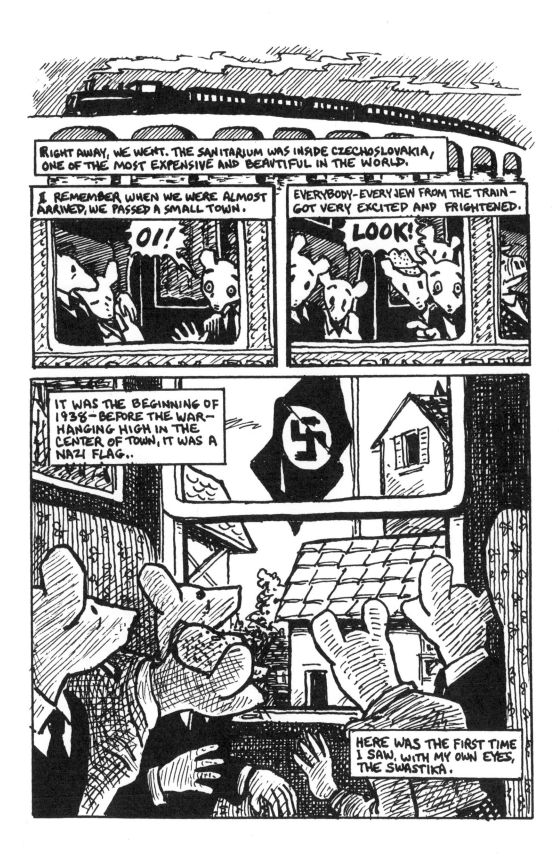

cw. Do you remember at what point you were working on *Maus* you realized you were going to use this consistent page structure?

AS. Before I started the book.

cw. Well.

AS. That's the difference between the improvising and the—what it is, is that I'll plan everything out incredibly carefully, and then just ignore my plan for the most part, but I have to have planned it before I can ignore it.

HC. Well, so both of you have talked about comics as a kind of architecture, and to me this seems something that is made evident even in some of your titles, like *In the Shadow of No Towers* and *Building Stories*. Could you talk about that concept of comics as architecture?

AS. Somebody that Chris and I both admire is Frank King. This is the perfect example of something I discovered decades ago while sleuthing through a dictionary, which is that "comics" are a narrative series of pictures. A "narrative" is a story, I found out when I looked it up in the dictionary after, and "story" comes from the medieval Latin word *historia*, which refers to the picture windows in churches, so those were those early comics before they had newsprint, and the superhero could walk on water, and turn it into wine or whatever it is he does. [*Laughter.*] It's why the word "story" refers both to the layer of the building and to narrative, and it was a real clue for me as to what could happen on a page. In this series of three weeks of *Gasoline Alley* the kids find an empty lot, and then it's being built up and they are still playing in it the next week, and the week after, it's a building that they're playing on. It was really making that as manifest as it could be.

cw. I'm pretty sure King was looking at Japanese prints when he did these; he and his wife both dabbled in Japanese pottery and they had books of Japanese prints. These strips are not drawn in a strict isometric perspective—what one generally thinks of with Japanese prints, etc.—but they have a similar feel.

AS. Well, this kind of structuring is what I look at and look for first when I'm just thumbing through a comic. It's not necessarily this particular device, but that feeling that boxes are thoroughly linked together. That there is some kind of visual coherence between the boxes as well as within the boxes—so that there is a reason for it to be on the page, because that's what makes me stay doing comics rather than illustrations or something like that.

cw. That's so true, and such a perfect way of putting it. One of the real advantages to comics is that one can look at a book or a strip and in half a second decide whether it's any good or not—which sounds kind of like a dictatorial judgment on my part, but there is genuinely something

about the page structure that communicates an overall, governing intelligence: all the artist's relative disposition, care, and thoughtfulness (or thoughtlessness) that's gone into their work is sensible in a microsecond. I don't mean to imply that I'm simply thumbing through everything or not reading it, though. . . . I guess that sounds horrible, doesn't it?

AS. But it's actually true.

CW. My friend Ivan Brunetti has wisely said that comics are the one art where you can actually see a person's mental state change or deteriorate over the time that a story is drawn. This notion is best exemplified by Charlie Brown's magically changing head from the time Schulz started in 1950, when it was a big, kind of bloated-tick oval to when it became a sort of thick, marshmallowy block. Now, clearly Schulz's mind did not deteriorate, but this was all indicative of something profoundly changing and shifting inside of him that maybe he wasn't even aware of; it's a very curious and strange thing. The same phenomenon happens to me. I'll find that my characters' hair will get longer as my hair gets longer and that they'll get fatter as I get fatter.

AS. I'm still multiphrenic. I don't know that it's a problem for you, with your very template-like approach, but sometimes my problem is I'm always going off-character from panel to panel. . . . It's really hard to keep the body the same number of heads high or something.

HC. Well, if I could press on the architecture question. Because I know both of you have works that look very architectural.

AS. Well, I mean, this image [p. 76 of *The Complete Maus*] was very directly built on that notion of the window. I should say in *Maus*, one of the problems was to stay in service to a deposition even though I was having to mold it and shape it, and that meant occasionally wanting to jettison the whole comics idea because there were things that just weren't that visual. I literally had to buy the space to give certain kinds of information. So here, Vladek's on his exercise bike, but he's telling me about who was living in a given household that [he and Anja's family] lived in before they were moved to the ghetto, so I have to introduce quite a number of characters, and I had to find some way of doing it so it just wouldn't be ongoing small mouse head, twenty-foot-high balloon, small mouse head, twenty-foot-high balloon. And here, you enter the household through this grid of windows on the top half of the page, and then on the bottom half of the page, that grid is repeated essentially, almost directly, so that you get little clusters of the smaller family units that are living in the house, and I've bought enough visual space to put in two or three lines of text to explain who these people are that will be interacting in that chapter. That was one version of the same.

Another was where we're being told by Vladek how to build a bunker

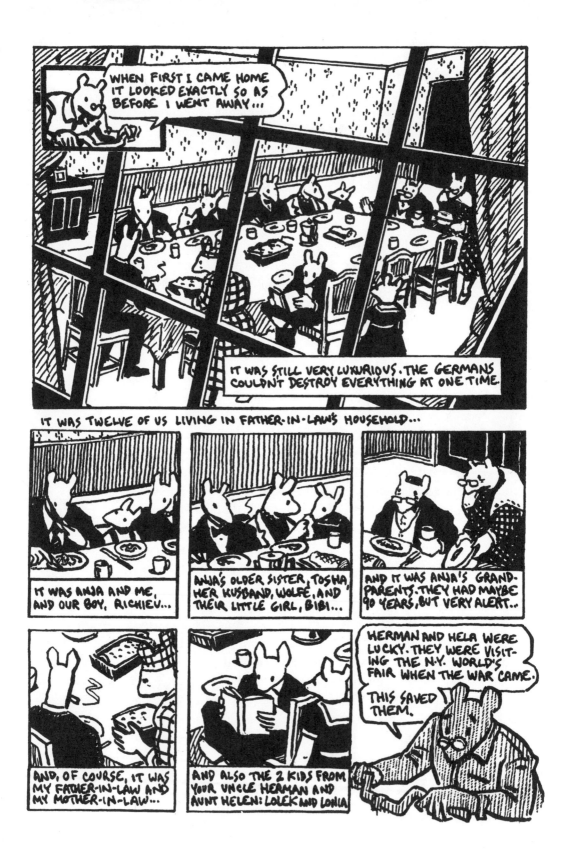

beneath a coal bin, in case Nazis ever came to Queens and I needed to do something beneath my coal bin. I got a very specific diagram of how to put it together that he drew, and I used that as the way to reenter the story where the page after this one—which has just regular beats divided by that diagram—is then a cutaway of that same diagram, so you can see it more clearly. It then becomes a panel that's beginning to move you forward in time again, but everything sort of freezes, to become that architectural unit.

HC. What about *In the Shadow of No Towers*?

AS. In the first of the *No Towers* pages, basically what I needed to express was my own inner confusion. Although, every once in a while, Chris seems to be slipshod about the responsibility of making sure you know what panel you must go to next, usually when you're doing comics it's your responsibility, it's the organizational job of the artist to figure out, to take the eye from here to here, now over there, and on this page I very specifically had both. You read from left to right, and you see this picture that says "Synopsis: in our last episode, as you might remember, the world ended," and then you slide down along this burning tower, at which point you fall off the page, and you have to go back and maybe start over here, or over here. That disorientation was something I very specifically needed to have happen, and I know that when I'm reading your strips, Chris, there are a number of times where it's like: all right, this is not linear. This is going to be moving backwards steps to move forward again.

CW. Well, it's purposeful because I want it to read as clearly as possible, but also to have the same sort of lack of certainty that I feel about, and within, my own life. I mean I don't really have any problems discerning tables from chairs and seeing my hands, but I have problems deciding whether or not I'm a good person, so I think that's what I want my stories to reflect.

HC. That uncertainty is something that you want to preserve in terms of where the eye goes next?

CW. Well, it depends. I mean, sometimes it's a function of how I'll structure a page, especially if the story's being told within the consciousness of the character and there's a certain ambiguity that I want to maintain in the story as I'm writing it. I'm not thinking that, "Ooh, I want more ambiguity here, and less here," though—it just happens as I'm working on it. I want it to feel "right" when I read it back to myself. I want it to have that same feeling of doubtfulness that I have in my own brain.

AS. Well, what it does is it definitely works towards what you were asking about before, about reading slow, or rereading. It makes you really enter into that reality because you can't do this thing of, "Alright, I get it.

11.7. Art Spiegelman, from *The Complete Maus*, 25th anniversary edition (New York: Pantheon, 2011), p. 76. Vol. 1 © 1973, 1980, 1981, 1982, 1983, 1984, 1985, 1986 by Art Spiegelman. Vol. 2 © 1986, 1989, 1990, 1991 by Art Spiegelman. Used by permission of Pantheon Books, a division of Random House, Inc., and used by permission of the Wylie Agency LLC.

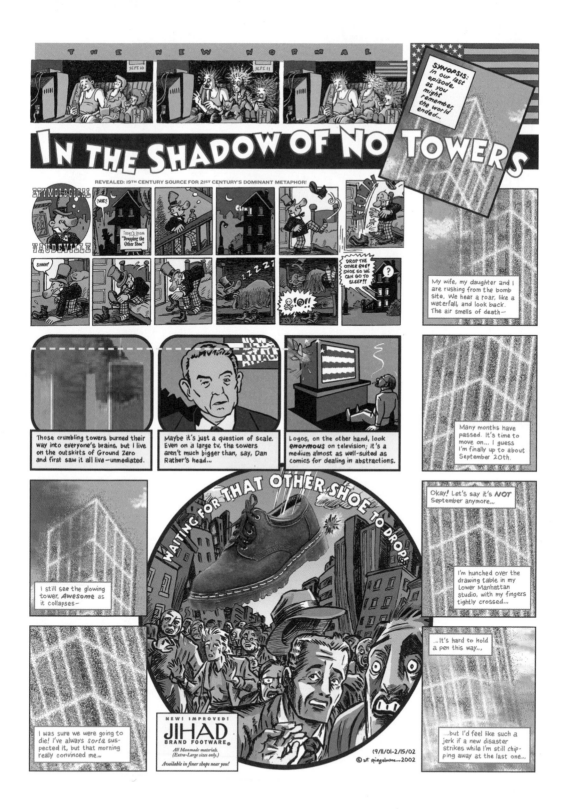

I get it. I get it." Because when I was reading comics as a kid, trained by [*Mad* editor] Al Feldstein, I learned to never read the words, because the words say, you know, "The Aryan arzac leaps at the man with the space gun," and then you see a guy with a space gun being leaped on. You learn to avoid those words at all costs just to get through, and flip through the pages, and get your story. Here, you're asked to engage and enter and stay in that soup for a while.

cw. I did a book about three years ago [*The Acme Novelty Library Report to Shareholders*] which was a collection of—as we call it in the "biz"—"one-shot strips," which are really just single-page gag strips. In putting it together I didn't want to just throw them together randomly, or even put them in the order that I drew them, so I tried to organize them in a way in which hopefully the sum was greater than the admittedly pretty lean bits and parts. I'd noticed that all of the strips ended up being, more or less, about disappointment, or expectation being thwarted, or—uh—reality somehow being screwed up by ideas, so I linked it very self-consciously to the ideas of light and dark, seeing and thinking, and experience and imagination, since I didn't really care whether I was being overly or overtly pedantic—I mean, there's no way of really directly talking about the ideas of seeing and imagining other than by being pedantic, so I decided to go ahead and be as pedantic as I could. It's just a book of jokes, after all.

So structurally, the closed book itself is, of course, flat, and the most prominent word on it is one-half of the word *ACME*, so it looks like it's a book about *ME*. But opened up, the spine divides the cover and the word, and if the band over the middle is removed there's a little tiny character there—God, one learns in the book—who's in the act of creating the universe. All of the swirly stuff that's around him—it's supposed to look kind of like the tracings after particle collisions—are the letters A, C, M, and E, which spell out the fictional title of the company that supposedly also created all of the stupid gag strips in the book itself. And as one then opens and pages through the first part of the book, there's a history of the company itself, organized again around a single point in the middle of the globe (which also lines up with the tiny God on the spine) and that point is Chicago, Illinois—where I live—which conveniently also falls right at the very midpoint of the United States and right in the middle between the centers of publishing (New York) and moviemaking (Los Angeles)—or reading and seeing, which, of course, represent the fundamental artistic AC/DC poles of comics, reality versus imagination, or images versus ideas. This introduction winds up with a sort of Aztec-y map of the different pieces and parts that can go into creating a human being—or, more properly all the characters in the book—sort of like a mandala that can rotate back and

11.8. Art Spiegelman, from *In the Shadow of No Towers* (New York: Pantheon, 2004), unpaginated [p. 1]. © 2004 by Art Spiegelman. Used by permission of Pantheon Books, a division of Random House, Inc., and used by permission of the Wylie Agency LLC.

11.9. Chris Ware, progressive take-through of ACME book (New York: Pantheon, 2005). Courtesy of Chris Ware. Used by permission of Chris Ware.

forth, and which also lines up with God and the ACME company history. Finally, this mandala then finally lines up with a map of the actual night sky, all the stars in their proper places with their Greco-Roman names, but with the moon blotting out a few of the central stars.

I don't exactly know how to put this, but, in putting a book together that, essentially, has to do with light and seeing and thinking and darkness (and reality versus imagination, the present versus the past, etc.), this theme goes through the whole book.

Now the moon is something that we use not only to gauge the passage of time by both its lightness and darkness, but it's also one of the first real mysteries that compels us as children. Aside from the moon being almost a main character in the book, there's also a part in one story where a younger character asks an older one if he sees a face in the moon as she does, which is really what and how language and perception begins—seeing patterns in things that aren't there—and he says he can't. This refers back to the previous diagram, because of course there's no face in the moon, but we as human beings try to see faces in everything, which Art already pointed out earlier. The constellations are a common example of this tendency; we're told at an early age that they signify the beginnings of storytelling, the beginnings of literature, because the ancients looked up and saw pictures in them. Finally, if the reader takes this page spread of the night sky into a dark closet or wherever, it's imprinted with glow-in-the-dark ink that then redesigns the night sky to suit all of the characters in the book, leaving behind Ursa Major and Ursa Minor for God and Quimby the Mouse. I figured "what the hell," you know? This is like the one chance I'm going to get to completely make dumb jokes about how ideas destroy reality, though maybe I took it a little far.

AS. But it also means that structure isn't just a page structure, but the book itself has a structure.

CW. Right. I guess that was the point about my pathetic meandering: that the architecture of the book itself was—I mean the whole book was designed specifically as a unit from beginning to end. On the side of the edge of the book, as well—I could add, though I shouldn't, because I've already gone on way too long—there's a diagram of the cycle of human life that goes around in a circle . . . and, this is most important: the interior of the book is organized around the seasons, which of course have everything to do with the sun, and its revealing and hiding of the world, giving us time to think about it, remember it. Sometimes I wonder what we'd be like as organisms if we didn't have darkness, actually; maybe we wouldn't have language at all.

HC. Art, there's a quote of yours which I've always liked in which you say, "The surface of the page is a problem to solve." Any comments?

AS. Well, only in that, with the question of what we were talking about before: it takes you a fraction of a second to decide whether a comic is something you're going to dive into or not. Whether it's worth the time, entering into it—and every strip has its own logic system. Oddly enough, before I started working on *Maus*, every strip I was drawing had a different surface style, a different look to it, and it remains more or less true that I don't have an especially consistent way of going about it. So when I was working on *Maus*, for example, I had to find a way to draw it, which is a problem I was trying to solve while I was interviewing my father, while I was making rough notes and breakdown sketches, and I couldn't find anything that was quite right. In one of the failed attempts at finding a surface for the book I figured maybe I'd make it look like an Eastern European illustrated children's book style or something.

HC. Can you explain why you think it is a failure?

AS. Well, for one thing, it doesn't let your eye flow from box to box; it asks you to stop and look at each picture. For another thing, I thought that, it's not that it's drawn all that well, but by being drawn with so many lines and so carefully in some ways it was too authorial. Or authoritarian, maybe both, and that it was saying, "Look, I can use scratchboard and you can't, so shut up and listen," and that wasn't at all what I wanted from the work I was doing. I also thought that there was a problem having the Nazi looking like Marlon Brando in *The Young Lions* [*laughter*], and so, while I was trying to figure these things out, I was also just doing sketches that were just the note-taking of what should be happening in each box, how should it happen. And for a while it seemed like the only way to draw *Maus* was as those rough sketches, and leave it as rough-hewn as that, and then that had a problem because the drawing had too much personality in it. It was just trying to annotate, and then you could get interested in it as if it was Cy Twombly marks or something like that, and so, eventually, I had to go back to my rough sketches and find something that was just a cleaner version of those rough sketches, and that would both have the clarity that would move you from box to box and still have the really-needed intimacy and humility that would come from something that was more direct. So, all the drawings in *Maus*, finally, were drawn the same size that they were printed as a way of maintaining that one-to-one relationship with the work and with the reader.

HC. Chris, do you have a sense of that through your own work?

CW. Well, I guess. Here's another part of *Building Stories*, a substory about a bee who tries to be a really good honeybee, which means that rather than let all the female workers do all the work (which, apparently, they do), he tries to help out a bit. I tried to write this somewhat stupid story from the viewpoint of a bee, and how a bee might actually interact

with the world, so rather than moving around in the world, he thinks the world keeps coming *at him,* or that it's actually his own desire that makes the world come to him. In this particular case—in every case, actually—I strive to create an overall, coherent composition so that certain things will draw the reader in and take one across the page rather than just being a jumble of individual pictures.

AS. Sometimes the graphic design is so dauntingly beautiful that people aren't aware that most of these strips have a really strong emotional resonance, because the visual surface actually takes you towards something like, "Oh, I see, this guy's a graphic artist making comics," as opposed to somebody writing and drawing and trying to get at actual content through these things.

CW. It's kind of the main formal conceit of *Jimmy Corrigan* that the story was one of—not really hopelessness, but of the tension and doubt and inability to confront the world, versus the innate beauty of the world itself. In other words, I wanted to make the book as beautiful as I possibly could to make it almost something of a counterargument to the story itself. I mean, we're always trying to find out how to make ourselves happier, or to be happier, but, meanwhile, you know, the flowers are blooming. It sounds really sappy, but to a certain degree I think such self-obliteration is valuable, almost necessary. And I think that aesthetic tension keeps the book, hopefully, interesting. If I just wrote a story that was depressing and looked depressing too, then what would be the point of that?

AS. There are a lot of those around too, of course.

HC. Well, my next question is actually about packing . . .

AS. Ah yes.

HC. Art, you've explained that when you were small, your father insisted on teaching you how to pack a suitcase.

AS. Right.

HC. And you have a quote in *In the Shadow of No Towers*, and you write that 9/11 left you "reeling on the faultline where world history and personal history collide, the intersection my parents, Auschwitz survivors, warned me about when they taught me to always keep my bags packed."

AS. I didn't want to conflate these two events, but I was aware that morning that [my family was] under the tower when it fell, pretty much. That this was a moment where whatever was going on in my own personal trajectory was like running smack into something way bigger than me, like, in this case, a hundred and ten stories high, that was tumbling around me, and it did bring my father's and mother's experiences to mind. They're not of the same dimension, but inevitably, because of my

11.10. Chris Ware, Branford Bee strip from *Building Stories* (New York: Pantheon, 2012), unpaginated. Courtesy of Chris Ware. Used by permission of Chris Ware.

background, those things did conflate. The specifics of that quote I actually made as part of the long introduction to the new version of *Breakdowns* [*reading from the comic*]:

> "Come Artie—help me to pack for our vacation!"
> "Aww—I'm learning how to draw Tubby. I'll help later!"
> "Don't be always so lazy! Better that you learn something useful!"
> "Groan."
> I hated helping him! It mainly consisted of him explaining that I did everything wrong!
> "First we choose what absolutely we need and fold, so the big pieces don't take extra room."
> "Uh-huh."
> "The shoes you put into the corners. With small things in the shoes, and—Acch! It's important to know to pack! Many times I had to run with only what I can carry! You have to use what little space you have to pack inside everything what you can!"
> This was the best advice I've ever gotten as a cartoonist! [*Laughter.*]

And basically it's true. The way I approach things is not through metaphors with music or time, so much as: there's an incredible amount of content that I want to express. And with comics, if you don't do it right, it takes pages and pages to get these things to happen, and because I don't draw as happily or comfortably as I want to draw, the way to do it is to get everything as compacted as it can be, so that there is a lot of information distributed efficiently in a reduced-down way, with reduced-down pictures, and with as few words as will possibly do the job, you know?

CW. Yeah, I admire that.

AS. For instance, I gave myself this rule that I wouldn't let my balloons be over four lines long and I wouldn't letter small. It meant rewriting everything so that it would get down to fewer and fewer words.

HC. OK, well since we're talking about process, I was wondering if each of you could walk us through your process on a page of a project.

AS. I don't really have a consistent process, and it's one of the reasons I'm not so prolific. Every time I start I sort of have to reinvent the wheel again for that particular round of work. In *Maus*, what eventually became the process was starting with the transcript that I made of my various conversations with my father, and then trying to get one unit of that that could become like a paragraph, a thought, a visual thought, that would hold the page.

Like I said, all of those drawings are the same size as they are in the

book—which might, for a large panel, be six inches wide, by two or three inches high at the most. And the way I would do it is I would start by roughing in the drawing in yellow, and then just to block out the composition, and then using darker and darker color inks as I brought the drawing into focus, and then using that to trace over directly in ink, and then, if it had too much personality, I might do it again, to lock it better.

CW. Now when you say it had too much personality, what do you mean?

AS. I meant I didn't want you to get lost in the line gesture, but rather what we were talking about before, about a panel having a typographic aspect to it. I was dealing with something that's so difficult for me to understand, and so difficult to communicate, that I thought that the best thing I could do was try to clarify as much as possible without simplifying it, and that meant moving it to that zone where you would understand the image as soon as you looked at it, and not get lost in hand gesture.

CW. Right. Well, a lot of comics have such a flippant calligraphy that it would be completely inappropriate for this to . . .

AS. I needed to just get past that stage, even though in other cases I just admire people who have that kind of flick of the wrist, like Milt Gross. I just keep staring at these original drawings by a very-popular-in-the-twenties Jewish cartoonist named Milt Gross who looked like he drew everything in the ten minutes while his friends were coming around saying, let's go play golf, and he got the whole strip done, and it looks just so . . . alive.

HC. Chris, what about your process?

CW. Mine's pretty dry.

AS. Yours makes it look coherent.

CW. I went through a lot of different ways of working when I started doing comics in high school and in college. As I mentioned earlier, I started scripting my stories very carefully and then, for lack of a more incriminating word, illustrating them. When I realized that approach wasn't working, I started drawing directly in ink on the page, and even tried doing some collage, doing this stupid thing where I drew on tracing paper and spray-glued it to illustration board, then hand-typesetting the balloons and rubber-cementing those down on top of the tracing paper—really dumb. Fortunately I finally arrived at a way of working where I still work out all the kinks, like Art's talking about, but on the board as I'm working. I basically just start on the upper-left-hand corner or sometimes in the middle, drawing in blue pencil. I know basically what's going to happen, but I'm not always sure, and as I draw, ideas come to me suggested by how the panels come together. But since what I'm trying to write is fiction, not autobiography, it's completely synthetic and so

11.11. (Overleaf) Chris Ware, uncorrected progressive construction of two pages from *Rusty Brown*, chapter 3, "Jordan Wellington Lint." Blue pencil, ink, and white gouache on bristol board with final mechanical coloring, 2009. Courtesy of Chris Ware. Used by permission of Chris Ware.

should look like it—lying, basically, on the page. I want to feel the same distance from the story that the reader feels, so that I can offer the same kind of harsh judgment of it in its believability, empathy, and emotional truth, or lack thereof.

So basically, crap accumulates on the page, sort of like leaves in a gutter, and probably about four days into it I'm done "writing"—this is the part at which I can kind of relax because I've gotten it all worked out—and I do the panel borders and then the lettering in a kind of mechanized way. Though in my early years as a cartoonist I experimented with lots of different drawing styles, combining and shifting between them on the page, more recently I've stopped, because I want to experiment more with the storytelling, and I want to have a way of working that's as unself-conscious as possible. Finally, I draw in all the figures with a brush, and then do all the backgrounds using pen, because I want the backgrounds to feel slightly different from the people. When I look at the world, human beings seem to almost kind of stand out or shimmer a little bit away from their backgrounds. And because pretty much all of the backgrounds in our modern lives are completely man-made, I use a lot of rulers. Then there's the final coloring stage, which actually is where most of the content, and where the emotional feeling, of the drawings finally comes to "life."

HC. Would the two of you run through some of your influences?

CW. I discovered Frank King's *Gasoline Alley* when I was an undergraduate. At the time, I was trying to figure out a way of telling stories that had a very slow, quiet mood to them because the comics I grew up reading—with the exception of *Peanuts*—were superhero comics, and superhero comics are anything but quiet and slow. They're in fact very loud and crass, and if one tries to tell a story about real life using the mechanisms of superhero comics, it's like having somebody scream in your face for twenty-four pages about going to the grocery store or something, which might be interesting as an avant-garde experiment, but it doesn't really communicate the timbre and tone of everyday life.

But King was a cartoonist who managed to do this apparently effortlessly, as if it was a part of his disposition. And he didn't do it with, you know, mushy pastels, or smushy water colors or some sort of blurry, fey touchy-feely drawing. He used a very simple, sharp ink line and heavy bright colors just like every other cartoonist. His pages appeared every week, in a Sunday newspaper, and some of these strips are simply about the colors that the main character Uncle Walt and his adopted son Skeezix see in the autumn landscape. Sometimes there's no punch line. This is, somewhat, a far cry from *Dilbert*. I've been involved in a reprint project of this with Jeet Heer and Chris Oliveros, because I really think it's one of the great unreprinted comic strips. He and I got in touch with

Frank King's granddaughter Drewanna, who, out of great largesse and generosity, opened her grandfather's archives to us.

But the most amazing thing—and this was a fact known to readers of the strip at the time that has since been lost—is that almost all of the characters in the strip are real people. Frank King's brother-in-law, Walter Drew, with whom he grew up, is Uncle Walt, and Frank King's son Robert served as a model for Skeezix. So the strip suddenly takes on this profundity when one realizes that these are real people he's writing about and putting into these fictional settings that were kind of autobiographical, kind of not. It was obviously a very personal strip for him. By the time King started *Gasoline Alley,* he was nearing his fortieth year, and he'd already tried dozens of different strips, trying to catch on with the readership, but none really did. *Gasoline Alley* began as a topical one-panel about a group of bachelors tinkering in their back alley with cars, which were essentially a new fad at that point (1918). But all that quickly changed—uh, shifted gears—when Uncle Walt discovered Skeezix on his doorstep.

The real story of all this is that apparently, according to Drewanna, King's wife Delia was a banker's daughter, and despite having already lost one child early on, was none too pleased at having a child around her house. She apparently felt that Robert should be sent off to boarding school when he was about maybe ten years old. Frank, however, loved kids. According to Drewanna, King was kind of, you know, heartbroken at Robert being sent away to school, a fact which lends a certain poignancy to not only the whole strip, but also even these autumn pages, which, as Jeet once pointed out to me, "Well, that would have been when he would have been going back to school after summers off, right? In the fall." So in some way, the strip is almost the story of Frank King's relationship with the son who was no longer around; it was an imaginary childhood for a son that wasn't there.

HC. Art, do you have one person who comes to mind who you want to talk about?

AS. For me, the one person that made me a cartoonist was Harvey Kurtzman and my mad love for that. *Mad* really shaped me.

The [May 1954] cover of *Mad,* which was drawn by Basil Wolverton, but planned by Harvey Kurtzman, was a really remarkable thing at the time—ten-cent comics, comics in great disrepute, imitating the most authoritative voice of the culture at the time, *Life* magazine, combining a drawing and a photo. It really was making something new. And Kurtzman was a great drawer as well. What Kurtzman basically did was he offered an antidote to the bland American 1950s. So we have Norman Rockwell subverted by Kurtzman (working with Will Elder), into a boozing family with beer in the fishbowl, the dog sipping beer, the baby being fed beer, just a slice of American life, and for a generation, it offered a

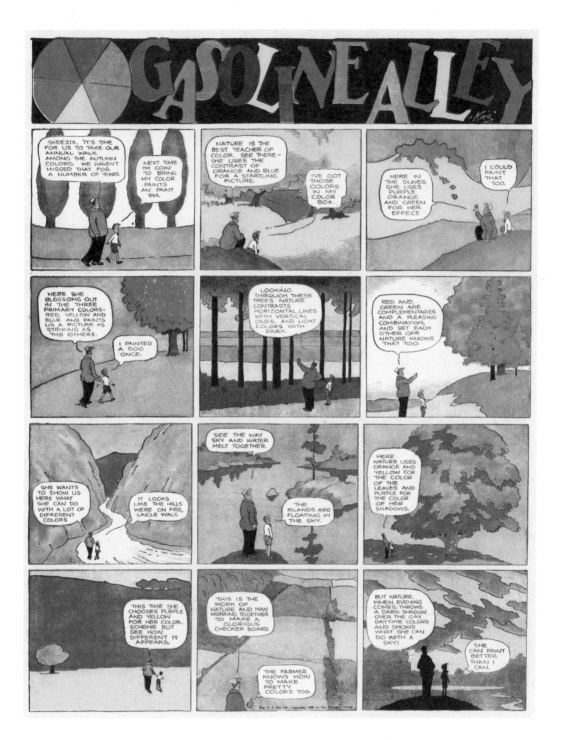

kind of ironic distance to the surrounding culture. It was like penicillin, to be able to not get overwhelmed by it, and that lasted for a couple of generations, as a useful way of holding the world at enough of a distance to look at and analyze it. Of course, in the recent decades, things have changed, and maybe we should just leave it at that.

AUDIENCE Q&A

AS. We've got enough for the next four nights basically. Thank you.

CW. This is when we get asked about health care or NAFTA.

AUDIENCE QUESTION. Hi. I appreciate you guys coming out. It was great to hear you speak, and I'm a fan of both of your work, and my question is, both of you made highly successful and kind of landmark-type works, with *Maus* and *Jimmy Corrigan*, among your other work. Having made that type of work and having the kind of reception that you've had over the years, has that affected your motivation at any point, or, how have you kind of dealt with the success that you've had as artists personally? Has it made it difficult, to proceed further past that?

CW. Well, I didn't win a Pulitzer Prize . . .

AS. For me it's an ongoing issue. As I say in *Portrait,* "It's no use . . . No matter how much I run I can't seem to get out of that mouse's shadow." I could go on, but . . . [*turning to Ware*] and you?

CW. It's very dangerous when as an artist you place your sense of self-worth in anybody else's hands. You have to really try to keep a firm grip on that. It can get very slippery.

AUDIENCE QUESTION. I was just wondering if you could address the topic of humor, because you talked a lot about narrative, and it seems to me—

CW. Isn't that what we've been talking about?

AUDIENCE QUESTION. I mean, it seems like the distinction between the words and the visual is sort of a perfect formula for the punch line, and so I'm just wondering if humor is the priority, or is the deep narrative, or . . . ?

CW. It seems to me that comics are the perfect medium in which to tell jokes. That's kind of what they're built for. They're little boxes in which you can safely watch people beat up on each other or do stupid things. They go by quickly. They're punchy. So it's pretty easy to write funny comics. In fact it's almost mind-numbingly easy. But it's much harder to make funny comics that have some resonance with the depths within yourself.

Acknowledgments

I would like to thank my editors at the venues in which many of these interviews were first published. Thank you to Ed Park, a writer, editor, and person I admire profoundly, for bringing me to the *Believer* in the first place (and for giving me the opportunity to first meet Alison Bechdel for a feature in the *Village Voice*). Huge thanks also go to the *Believer*'s fantastic Vendela Vida, along with Andrew Leland, Sheila Heti, and Andi Mudd, for shaping and shepherding my interviews, and for being so sharp and so encouraging. I am deeply grateful! Thank you to Michael Miller, now at *Bookforum*, who was my editor at *Time Out* (and came up with the title, which I knew he would!); John Duvall, the editor of *Mfs: Modern Fiction Studies*; and Elizabeth Taylor and Jennifer Day at the *Chicago Tribune*. I would also like to thank Stephanie Singer at the Jewish Community Center of San Francisco, where I spoke with Art Spiegelman and Chris Ware, and Polly Rosenwaike, along with Francis Levy, Ed Nersessian, and the whole staff at the Philoctetes Center in New York, where I spoke with Françoise Mouly and others.

For facilitating images, thank you to Alvin Buenaventura; Peggy Burns and Tracy Hurren at Drawn & Quarterly; Christopher Moisan at Houghton Mifflin Harcourt (via Alison Bechdel); Peter Maresca at Sunday Press Books (via Chris Ware); Mina Kaneko at the *New Yorker*; Hannah Manshel; and Emmalee Brown. I particularly want to acknowledge the kindness of Jules Feiffer, along with Tula Holmes, for giving me permission to reprint "Conversation"; and Bette Graber at Random House and Lauren Rogoff at the Wylie Agency, along with Ronald Hussey at Houghton Mifflin Harcourt, for their assistance. Thank you, too, to Peter London at HarperCollins for granting permission to reprint from Scott McCloud's *Understanding Comics* and *Making Comics*.

Bill Kartalopoulos, C. Ché Salazar, Isa Haviland, and Hannah Manshel did transcription: thank you for being so patient, and so meticulous.

Thanks particularly to Bill for all the conversations about comics over the years, and to Hannah for being a wonderful assistant on this project. I am indebted to Jonah Furman for his cheerful help in the last stages, including the index. I would also like to acknowledge my friends at the American Academy of Arts and Sciences, who I met at the time I started putting this book together.

A big thank-you to Eric Slauter for helping me conceptualize this book at the proposal stage. I am grateful to Noah Feldman, Anna Henchman, Ben Katchor, Hannah Manshel, Lindsey Shaw, and Eric Slauter (from China!) for giving feedback on drafts—and to Noah for listening to me talk about this book a lot. Thank you also to the readers for the Press for their comments and suggestions. At the Press, it's been a pleasure and honor working with Alan Thomas. Thank you also to the Press's Randy Petilos, Carol Fisher Saller, Michael Brehm, and Levi Stahl for all your work to make it happen. I am hugely obliged to Ivan Brunetti and Chris Ware for being my first friends in Chicago, and *a lot* else; I appreciate your support more than I can say. I am especially grateful to Ivan for the interview frontispieces and his beautiful cover. To my parents, thank you for always being curious and kind about my work.

The people who made this book possible are its subjects: I could go on about the perspicacity and generosity of each one at length. Lynda Barry, Alison Bechdel, Charles Burns, Dan Clowes, Phoebe Gloeckner, Aline Kominsky-Crumb, Scott McCloud, Françoise Mouly, Joe Sacco, Art Spiegelman, Adrian Tomine, and Chris Ware: *thank you*. It has made my life immeasurably better, and more interesting, to be in your orbit.

Earlier, shorter versions of the interviews with Scott McCloud (April 2007), Charles Burns (January 2008), Lynda Barry (November/December 2008), Aline Kominsky-Crumb (November/December 2009), Phoebe Gloeckner (June 2010), and Joe Sacco (June 2010) first appeared in the *Believer*. A shorter form of the interview with Daniel Clowes (26 April 2010) first appeared in *Time Out New York*. I thank Michael Martin at *Time Out* for permission to reprint. The interview with Alison Bechdel is drawn from two earlier, shorter versions that first appeared in *Mfs: Modern Fiction Studies* 52:4 (Winter 2006), published by Johns Hopkins University Press, and in the May 20, 2012, edition of the *Chicago Tribune*'s *Printers Row Journal*.

Index